A LIFETIME OF SECRETS

Also by Frank Warren

PostSecret

My Secret

The Secret Lives of Men and Women

A LIFETIME OF SECRETS

FRANK WARREN

A POSTSECRET BOOK

wm

WILLIAM MORROW

An Imprint of HarperCollins*Publishers*

Page 103, cartoon by Andrew Weldon, used by permission.
Page 116, San mother and child: photograph by Art Wolfe, used by permission of Photo Researchers.

HarperCollins books may be purchased for educational, business, or sales promotional use. For information please write: Special Markets Department, HarperCollins Publishers, 10 East 53rd Street, New York, NY 10022.

Designed by Amanda Kain

Library of Congress Cataloging-in-Publication Data

Warren, Frank (Frank C.), 1964–
 A lifetime of secrets : a PostSecret book / Frank Warren. —1st ed.
 p. cm.
 ISBN-10: 0-06-123860-0
 ISBN-13: 978-0-06-123860-4
 1. Self-disclosure—Miscellanea. 2. Postcards. I. Title.

BF697.5.S427.W37 2007
741.6'83—dc22 2007061233

09 10 11 RRD 10 9 8 7

To my mother and father

INTRODUCTION

When I told my father I was collecting secrets from strangers for an art project, he didn't know what to think. I tried to explain how the thousands of secrets that had been mailed to me were more than mere confessions. They could be beautiful, funny, sorrowful, inspiring.

"But, Frank," he asked, "why are you soliciting secrets from strangers, and why would anyone tell you a real secret?"

I invited my father to fly out for a PostSecret art exhibit in Washington, D.C., where hundreds of the postcards were on display. More than 15,000 people came to see the secrets, and my father was there, day after day, to hear many of their transformative stories. Some people told me they recognized a hidden part of themselves on a stranger's postcard. Others shared personal experiences of how talking about a painful secret had helped heal a lifelong relationship.

The exhibit came to an end and I took my father back to the airport to catch a red-eye flight home. During our drive we passed through a long dark stretch of highway when my father broke the silence by asking me, "Do you want to know my secret?" He bravely recounted a traumatic childhood experience. When he finished, we had a true talk that gave me a richer understanding of my father and recast our relationship.

• • •

For *A Lifetime of Secrets,* the fourth PostSecret book, I've selected postcards that show how secrets can reveal a momentary impulse or haunt us for decades and arranged them by age to follow the common journey we all take through childhood, adolescence, adulthood, maturity. Stretched over a full lifespan, the secrets expose the meaningful ways we change over time, and the surprising ways we don't.

The postcards narrate childhood stories that have never been spoken; they voice the guarded confessions of our parents and grandparents. They confirm that our rich interior lives are not defined by how old we are, and that with aging comes not only loss but also the possibility of grace and wisdom.

The following two secrets arrived in my mailbox the same week. The postmarks on each card were different, but when I posted them together on the PostSecret website (www.postsecret.com) they seemed as though they could have been written by the same person at two different points in her life.

> *I am a junior in high school. I have good friends and a loving family. I am smart. I am a good athlete and musician. But I would trade all that in if it meant I would be beautiful.*

I spent my high school years believing I was UGLY. I just went through a photo album that had pictures of me over the last 20 years. Turns out I was/am kind of cute. No more wasting time on thinking otherwise.

• • •

When I give PostSecret presentations at college campuses, my hope is that people I have never met will be inspired to change their lives through the secrets and stories being shared. Not long ago, at one of my talks, it was my life that was changed, and the secret that inspired me came from a stranger in the front row.

I began my presentation by handing out blank postcards to everyone in the auditorium. I invited each person to anonymously write down a secret on a card and then pass it on. For the next hour, the postcards circulated and were read silently multiple times. At the end of my talk, I asked if anyone would like to stand and read the secret they were holding at that moment. A man in the front row stood up and haltingly read:

I wish I could apologize to my younger brother for the way I treated him growing up.

He sat down and exchanged a long look with the young man next to him. After more volunteers read aloud some of the other secrets that had been passed around, I collected all the cards. The man in the front row handed me the postcard he had read from, and the two men walked out together.

His postcard was blank.

I have witnessed many times how the courage of sharing a secret can be contagious. When I realized that the man had been pretending to read someone else's secret and that the person he had left with was likely his brother, I was inspired.

Growing up, I was not an ideal older brother. As an adult, I have wished for an opportunity to apologize for some of my actions but did not want to open old wounds. I have not shared this secret with my brother . . . until now.

—Frank Warren

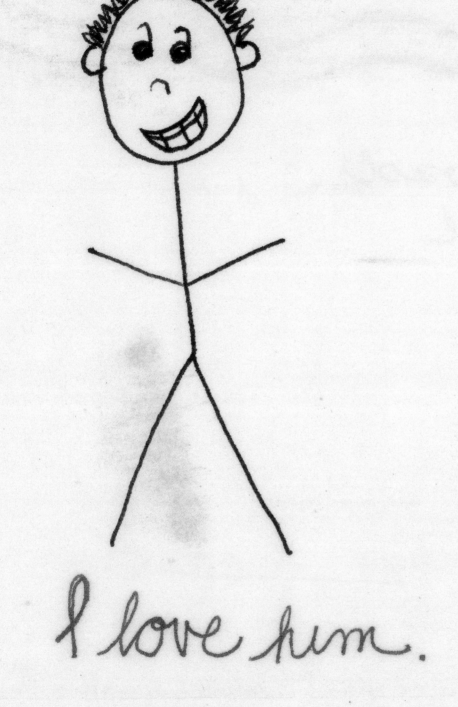

I love him.

He loves her.

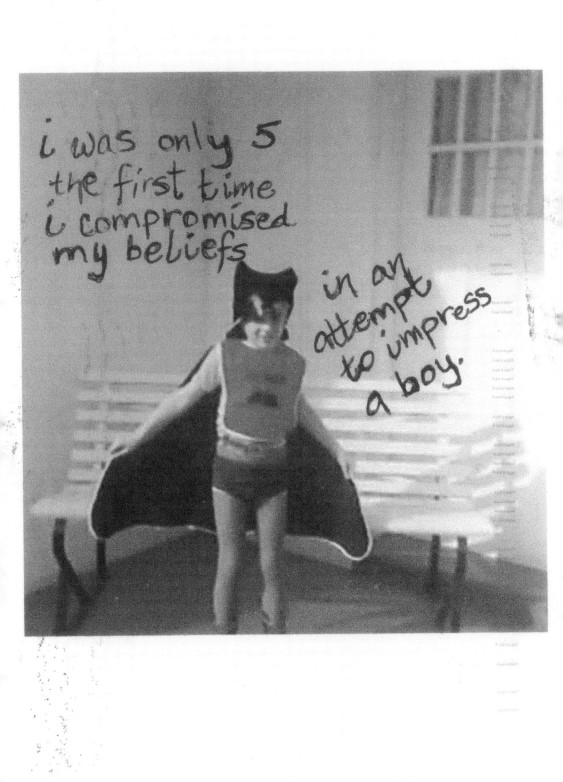

I Barrow other People's kid's on Halloween Just So I Can go Trick-Or-Treating

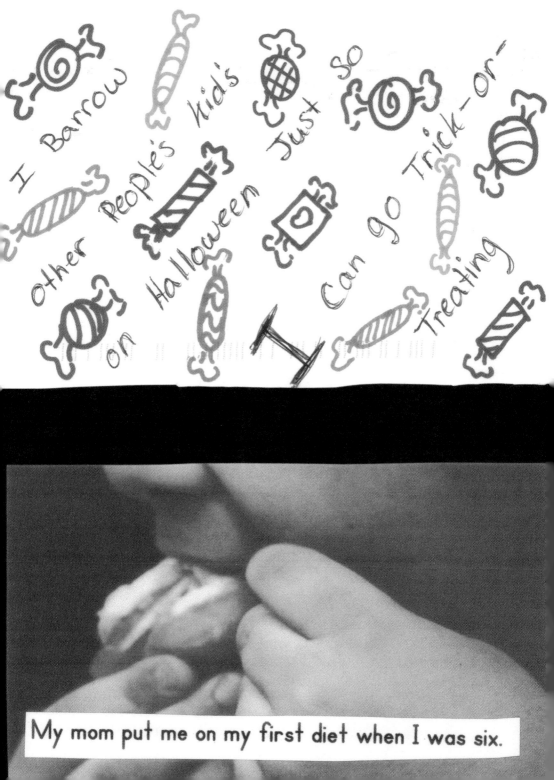

My mom put me on my first diet when I was six.

WALKER ART BUILDING. Designed by McKim, Mead & White, 1892-1894. Bowdoin College, Brunswick, Maine. Photograph by Mark Royall.

I loved her when

I was six, she threw my most valuebull ~~stuff~~ stuff out the window (I still love her.) and now I'm ten.

POStSecret
13345 copper Rige Rd
Germantown,
Maryland 20874

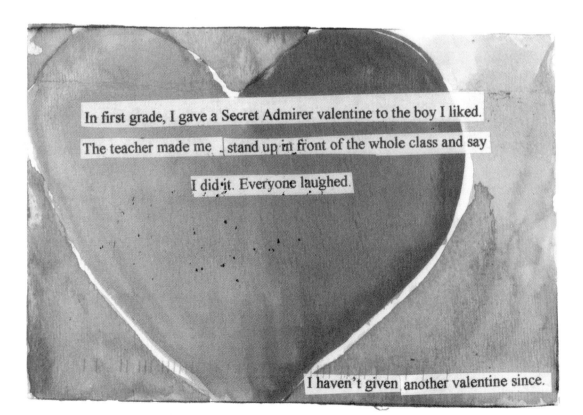

In first grade, I gave a Secret Admirer valentine to the boy I liked.

The teacher made me . stand up in front of the whole class and say

I did it. Everyone laughed.

I haven't given another valentine since.

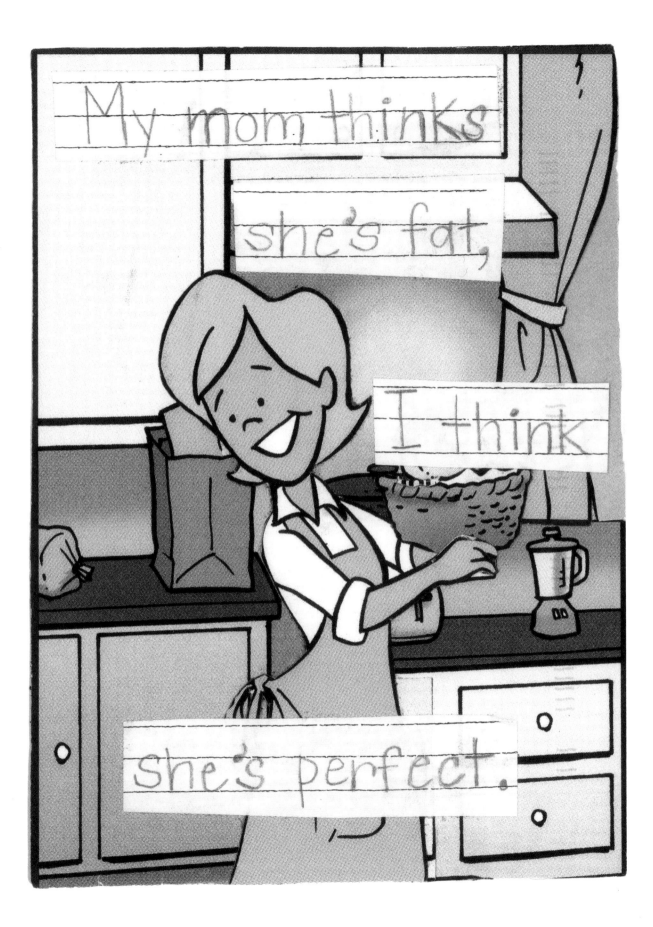

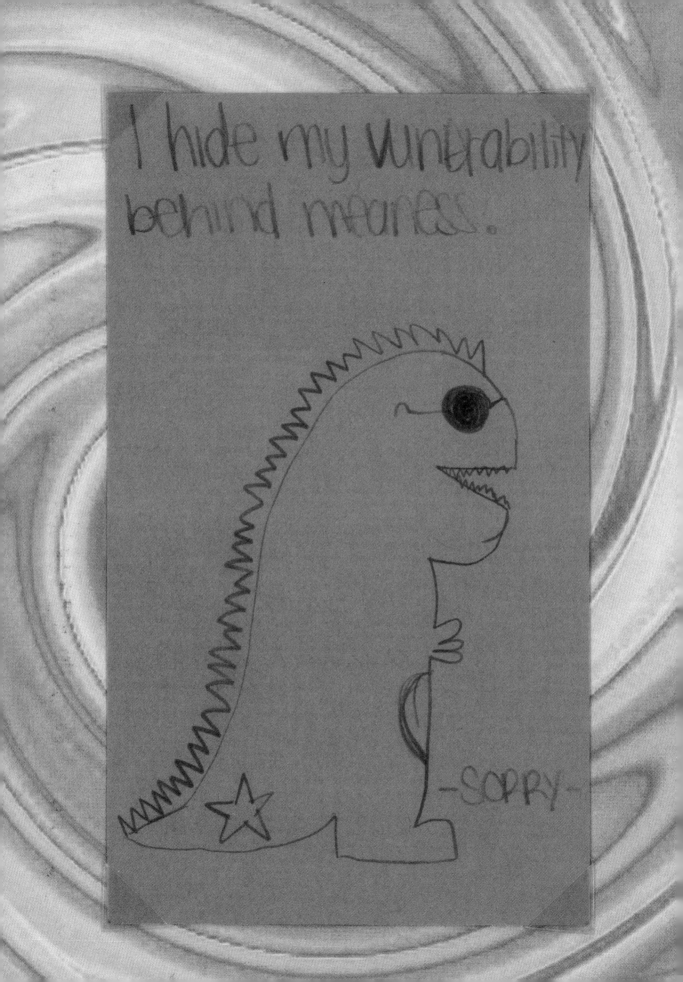

When I was in Kindergarden I thought that the overhead in our classroom was an x-ray machine.

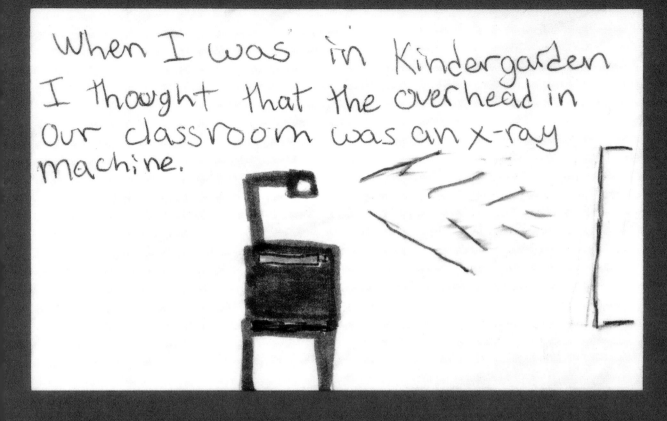

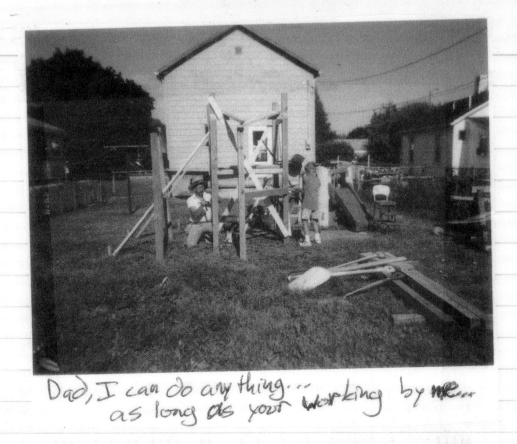

Dad, I can do any thing... as long as your working by me.

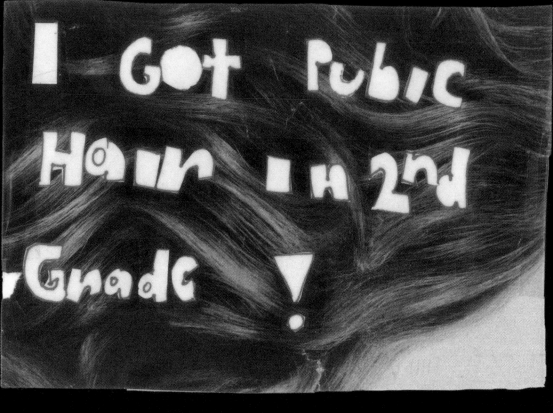

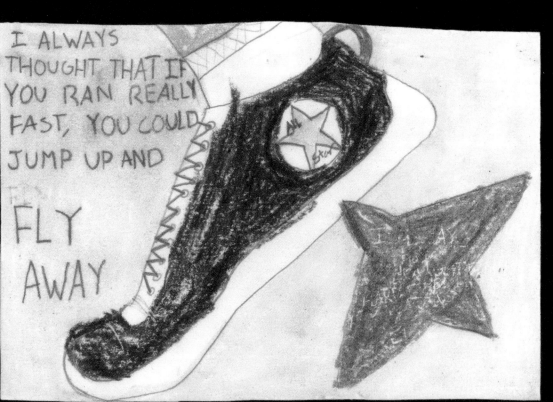

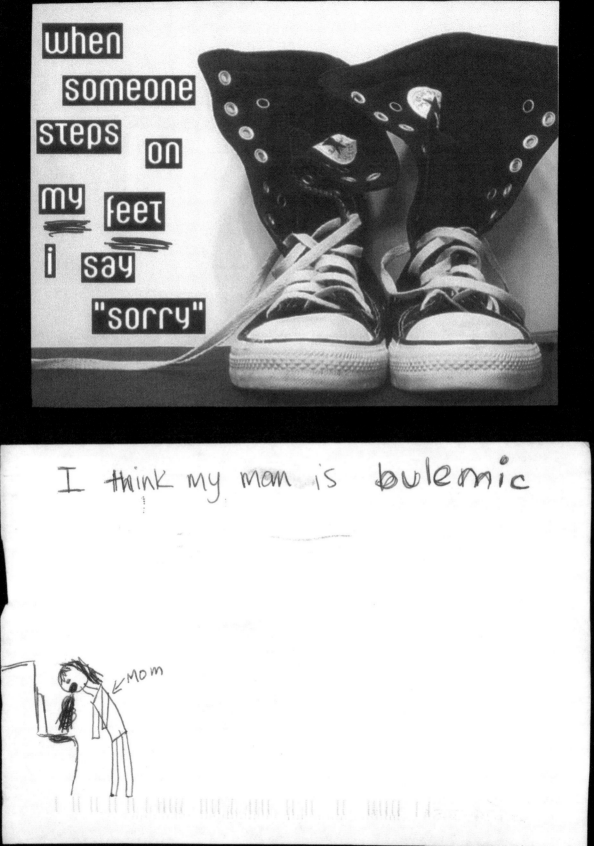

I save every
Card, note, letter,
picture, Drawing, and
e-mail my friends
send me so that
when I am old &
alone I will remember
how much I was
loved.

I'm scared to death that my son will grow up to realize I'm gay

And won't love me anymore

Until 4th grade I thought this was only a map of our side of the world,

and there was *another* side of the world,

on some other map, somewhere.

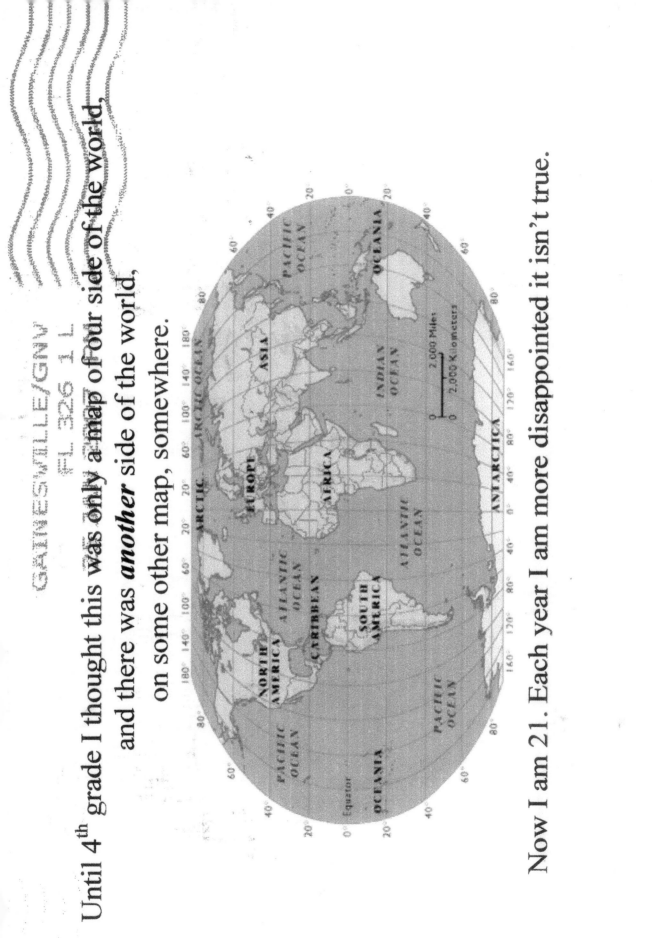

Now I am 21. Each year I am more disappointed it isn't true.

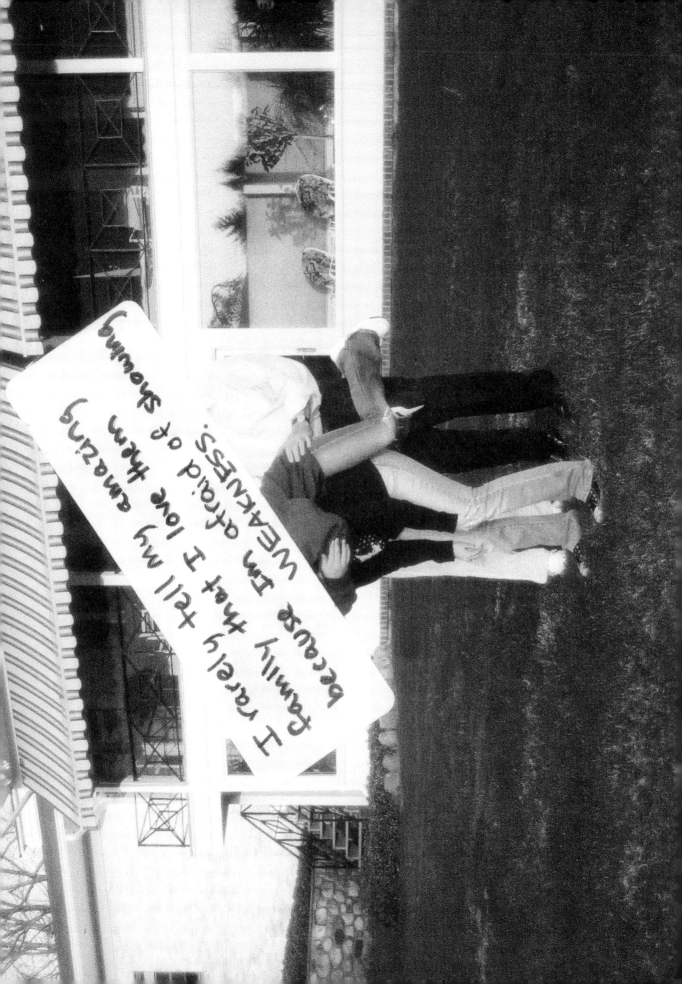

I'm the product of the Adultery of

Dear Postsecret,

　　The day I turned eleven, I waited all day for the letter written in emerald-green ink telling me I had been accepted to Hogwarts.

　　　　　Your's Sincerly,

　　　　　Alan.

I DESTROY VIDEOS OF MYSELF AS A CHILD BECAUSE IT PAINS ME TO SEE A TIME BEFORE I RUINED MY INNOCENCE.

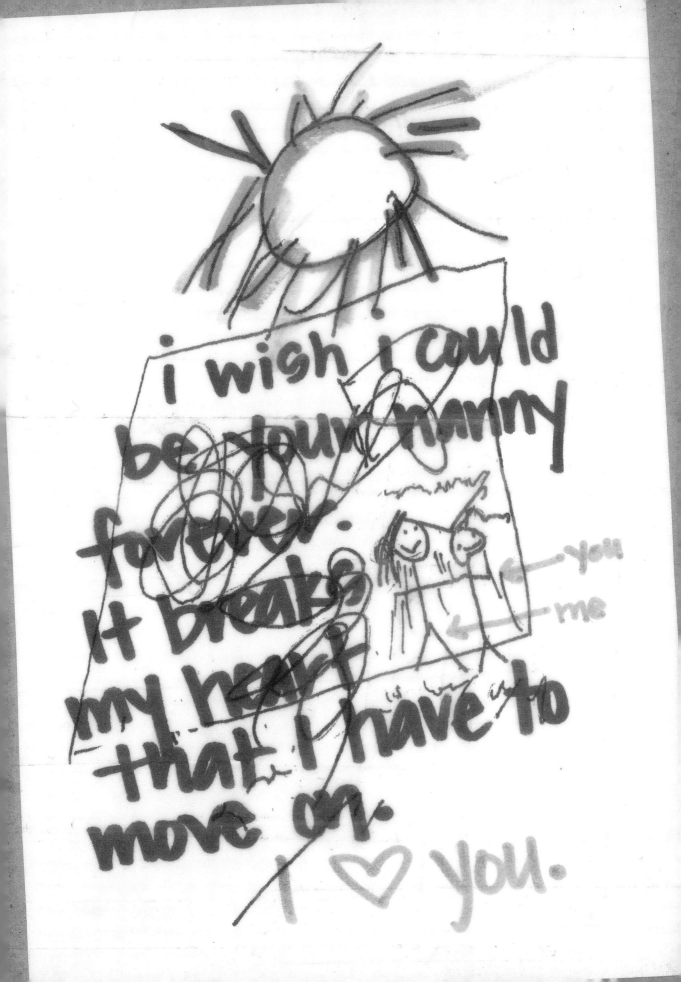

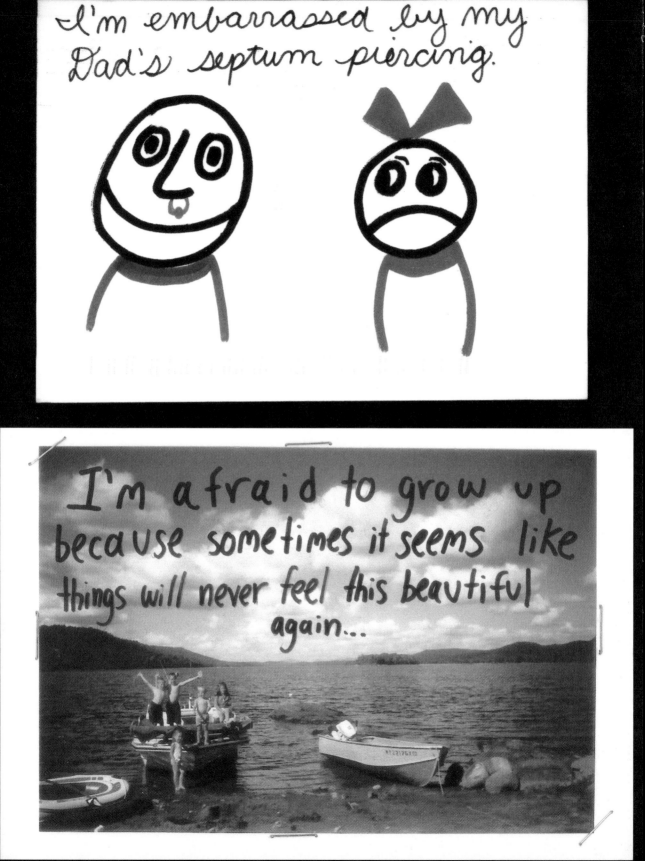

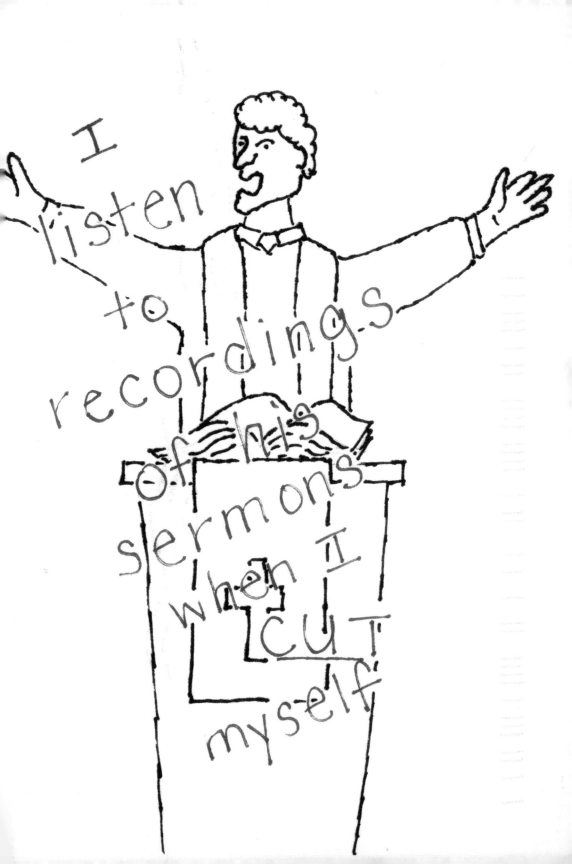

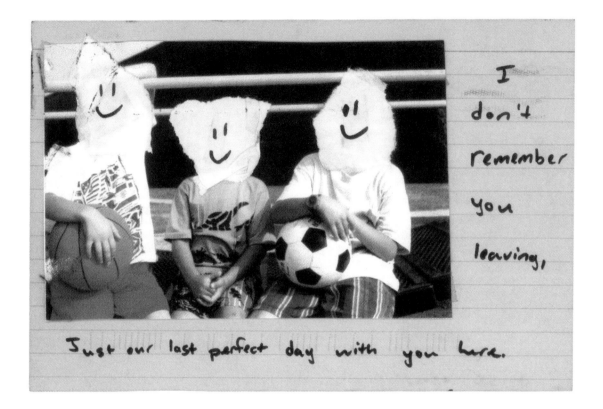

I don't remember you leaving,

Just our last perfect day with you here.

The first time I got drunk, my friends left me in an empty room because I blacked out. I woke up bleeding. I naked & was 12.

1 TEQUILLA
2 TEQUILLA
3 TEQUILLA
FLOOR!

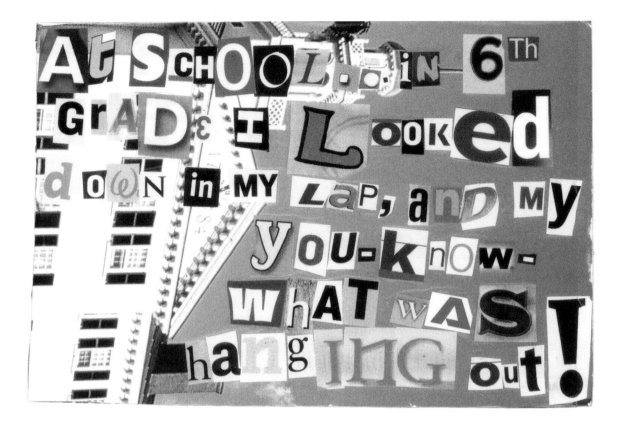

AT SCHOOL... iN 6Th GrAD& I Looked down iN MY LaP, anD MY you-know-WHAT WAS hang ING out!

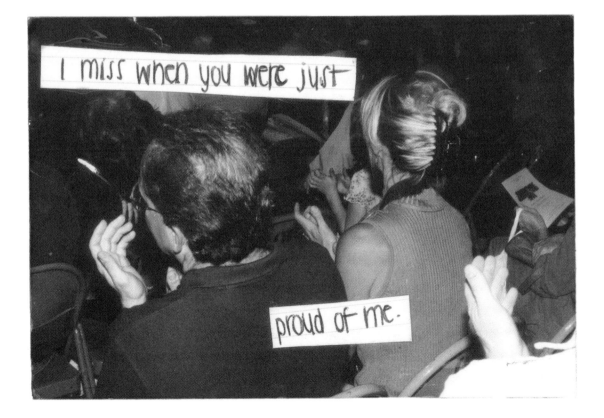

I miss when you were just

proud of me.

I'm only in 8th grade + 13 years old but my life is flying right before my eyes + I'm living it to the fullest + I'm terrified

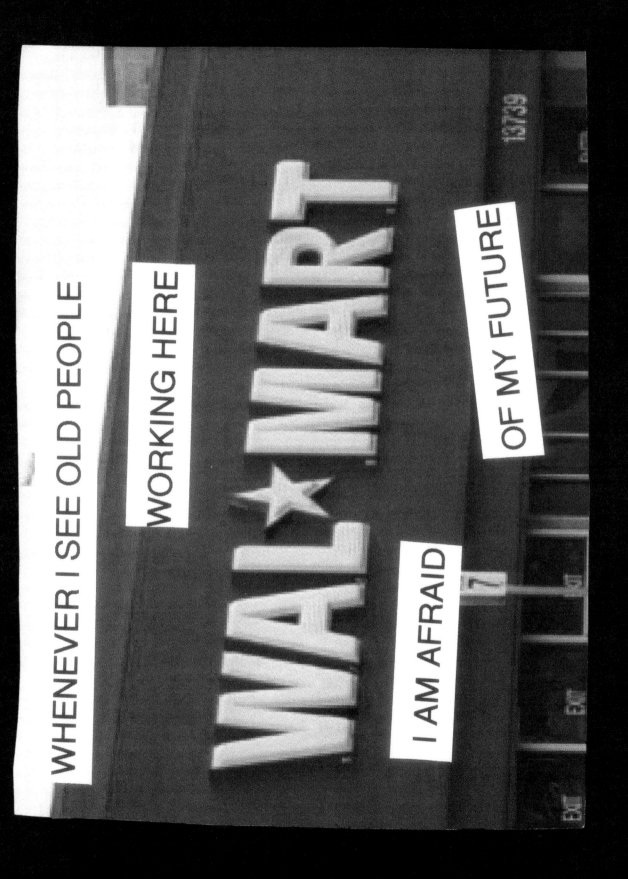

WHEN I WAS 14, SOMEONE TOLD ME:

"I'M EXCITED ABOUT YOUR LIFE!"

THANK YOU. THOSE WORDS HAVE STUCK WITH ME. THEY KEEP ME GOING. I WON'T DISAPPOINT YOU. AND I KEEP PASSING THEM ALONG TO OTHERS.

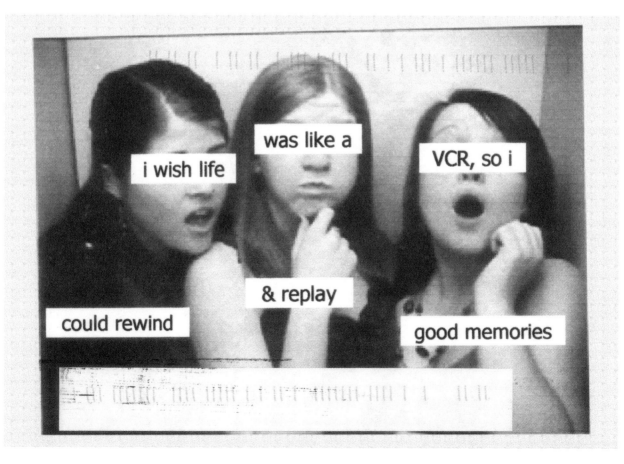

i wish life

was like a

VCR, so i

could rewind

& replay

good memories

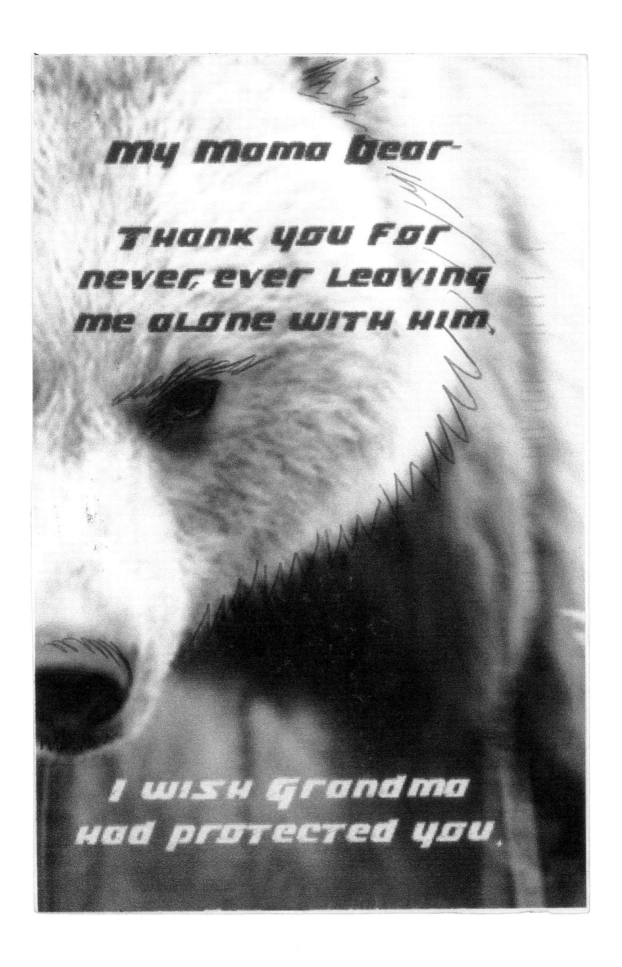

I LEAVE MY SECRETS

www.
postsecret.
com

www.postsecret.com

iN PUBLIC PLACES

www.
postsecret.com

ww. postsecre

FOR OtHERS tO FIND.

I wonder if my dad ever thinks "I'm home" when he pulls in the driveway to get me here at my moms.

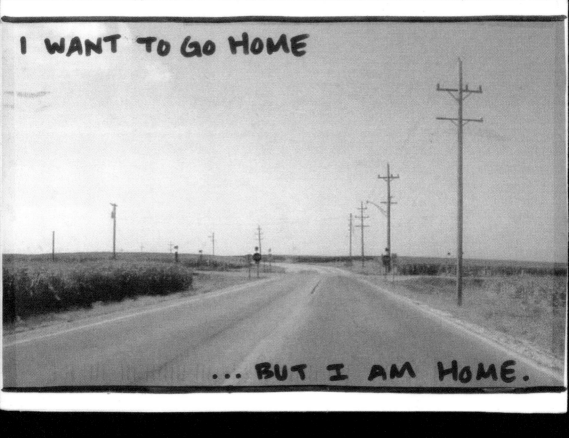

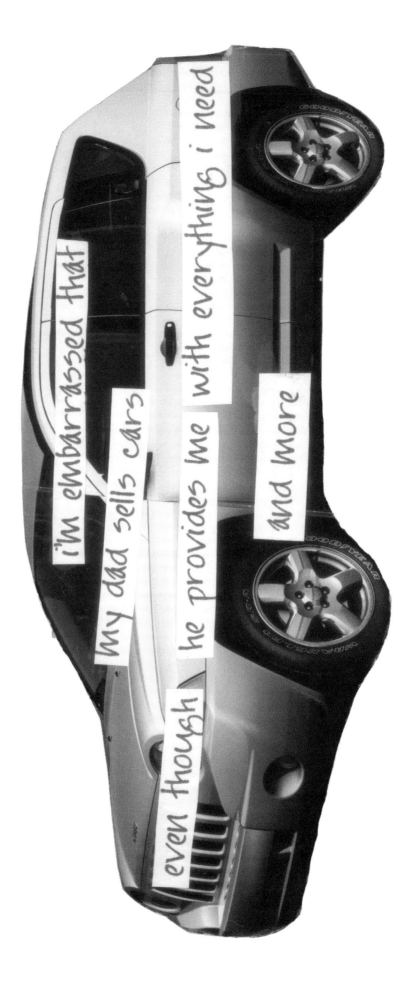

i'm embarrassed that my dad sells cars

even though he provides me with everything i need and more

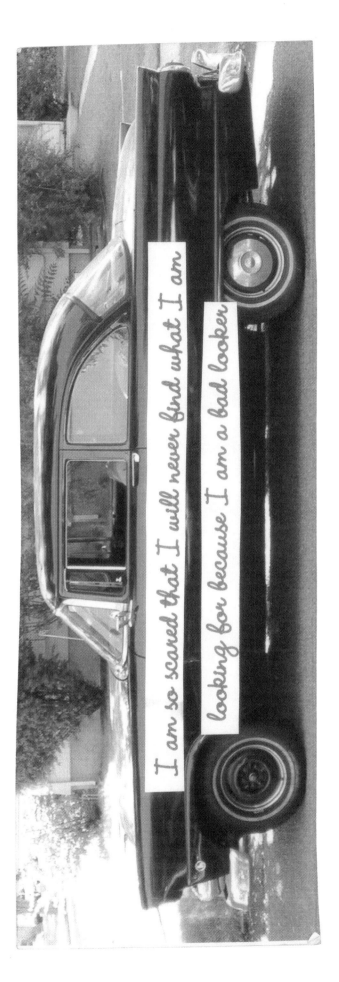

I am so scared that I will never find what I am looking for because I am a bad looker

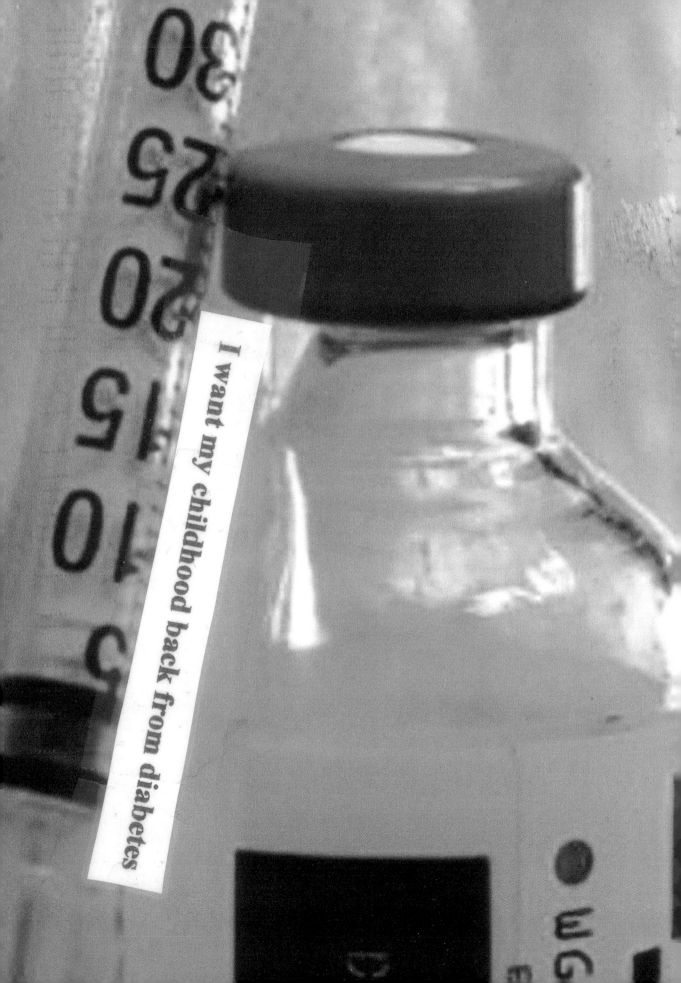

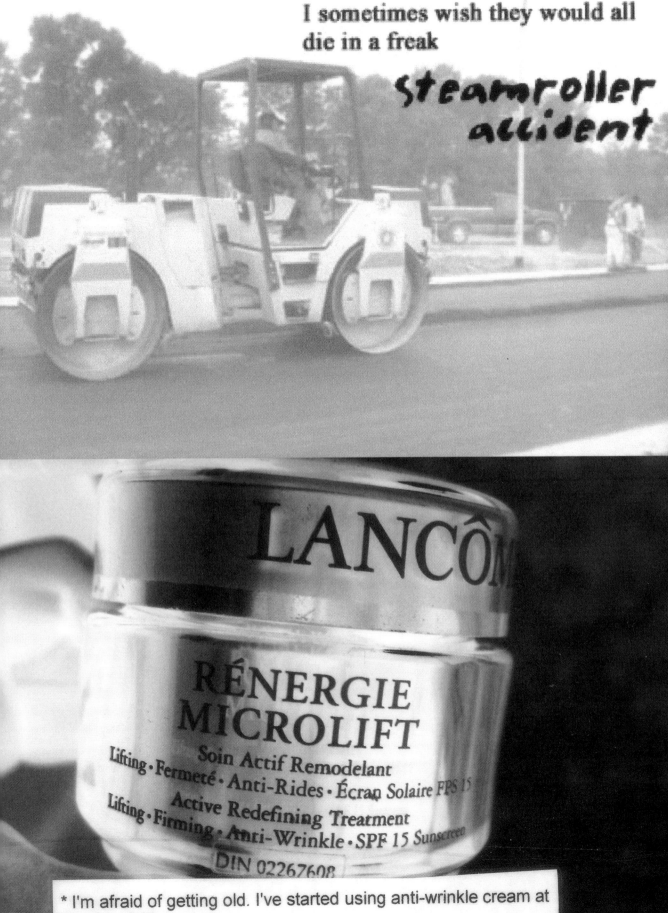

I sometimes wish they would all die in a freak *steamroller accident*

* I'm afraid of getting old. I've started using anti-wrinkle cream at the age of 15.

IT GETS HARDER TO BE THE GOOD GIRL EVERY DAY.

I still can't believe you died

so I pretend you are away

on a very long vacation

having the best time ever

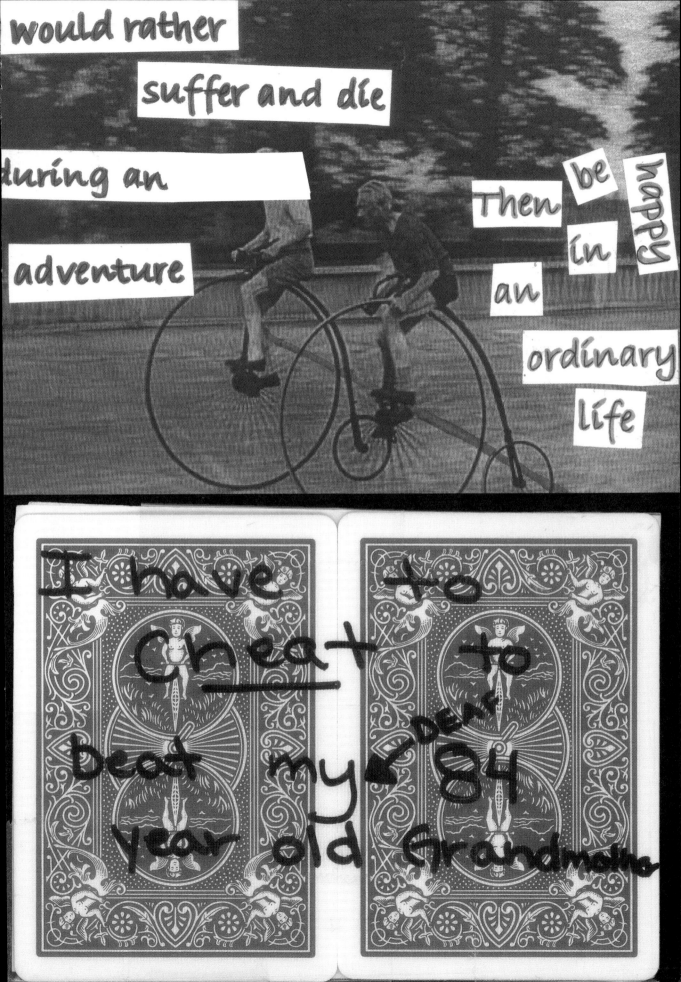

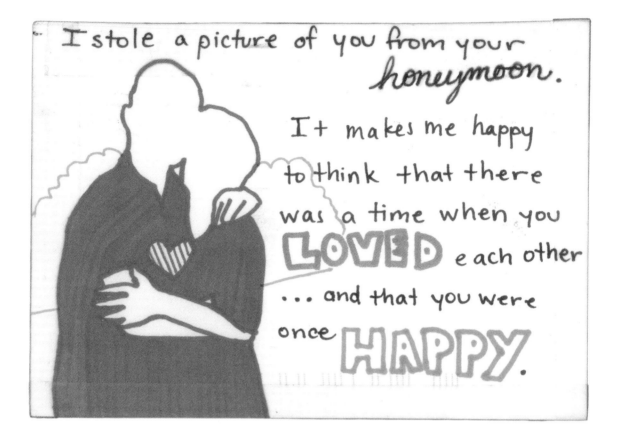

I stole a picture of you from your *honeymoon*.

It makes me happy to think that there was a time when you **LOVED** each other ... and that you were once **HAPPY**.

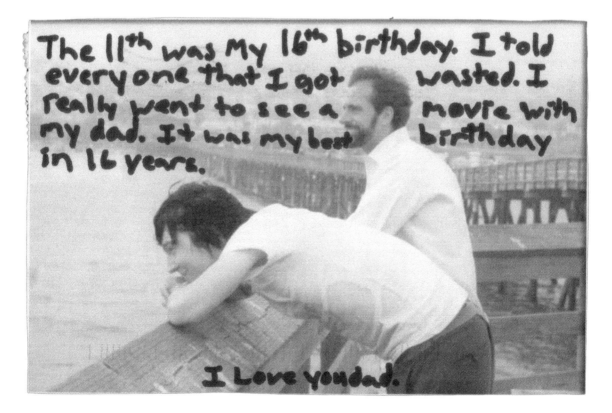

The 11th was My 16th birthday. I told everyone that I got wasted. I really went to see a movie with my dad. It was my best birthday in 16 years.

I Love you dad.

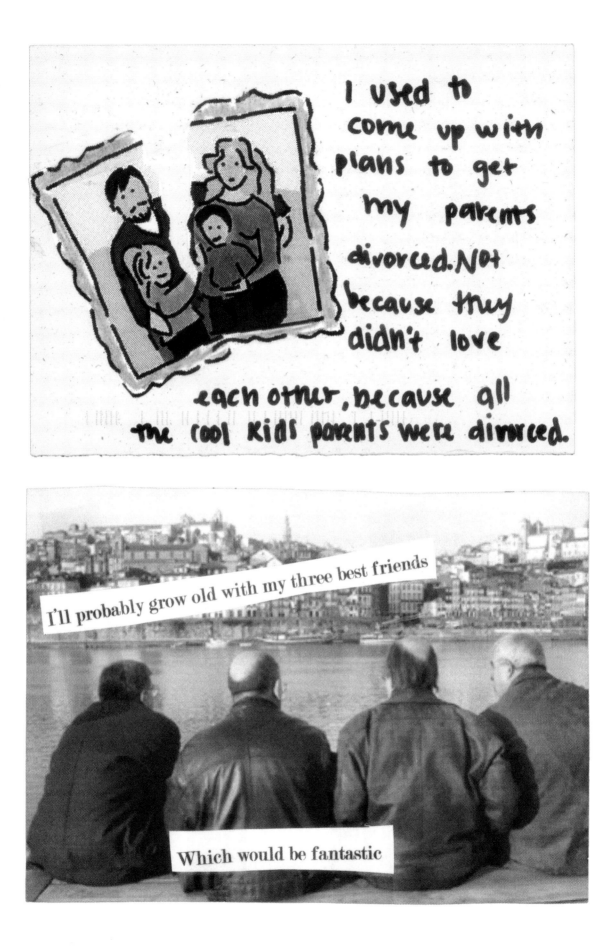

I used to come up with plans to get my parents divorced. Not because they didn't love each other, because all the cool kids parents were divorced.

I'll probably grow old with my three best friends

Which would be fantastic

I volunteer for a grief and bereavement camp for young people every summer. At this camp we have developed programs to help young people deal with their intense feelings of loss. On the last day, we take all the campers to a nearby rock pile. We pass out markers and invite them to pick stones and write their secrets on them. We then have them carry their "burdens" with them, in their pockets, in their backpacks, in

their hands for the rest of the day. When evening comes, we hike to a river and invite the campers to drop or throw their rocks into the rushing water.

Some campers become very emotional as they physically "release" their secrets. During this ritual I am always stunned by the few campers who refuse to let go of their stones. Tired from carrying them all day, they return to camp still clutching them. Some take them home on the bus the next morning as if the secrets are part of who they are.

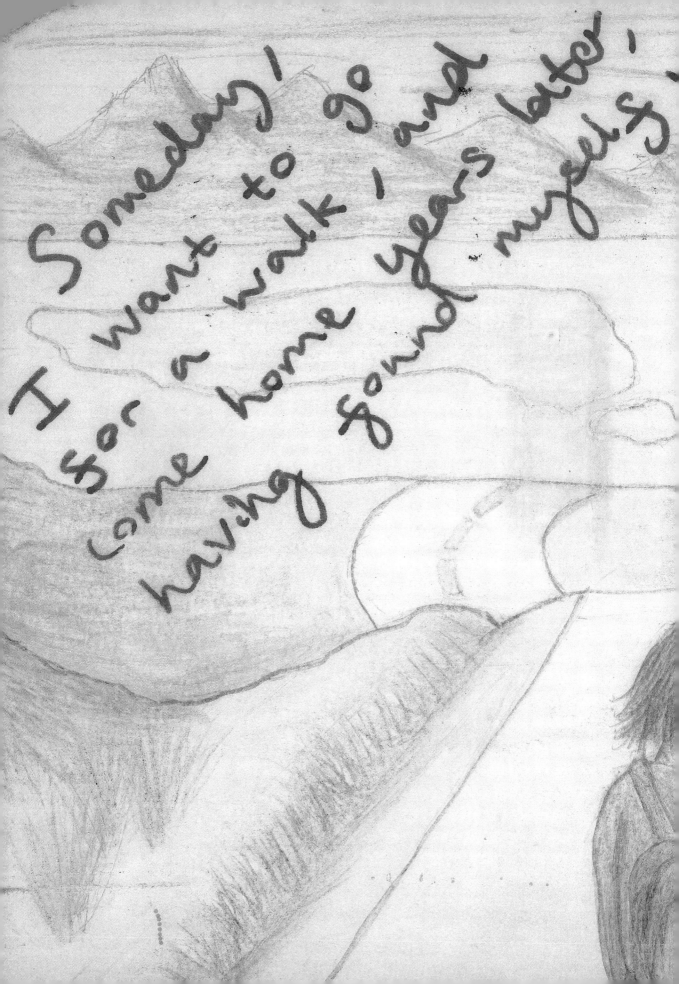

Someday I want to go and walk home years later, myself. I want to come home having found myself.

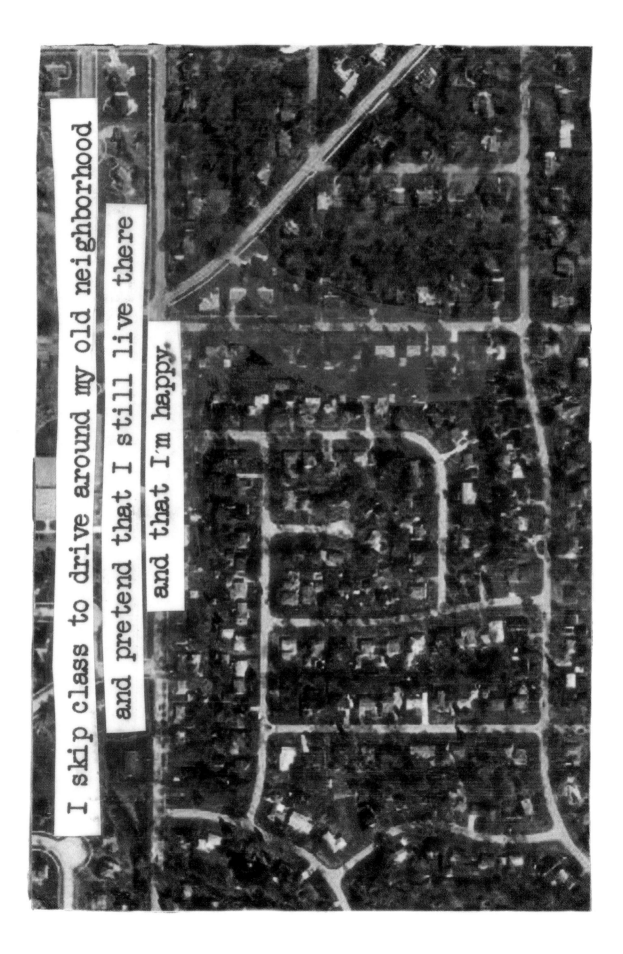

I skip class to drive around my old neighborhood

and pretend that I still live there

and that I'm happy.

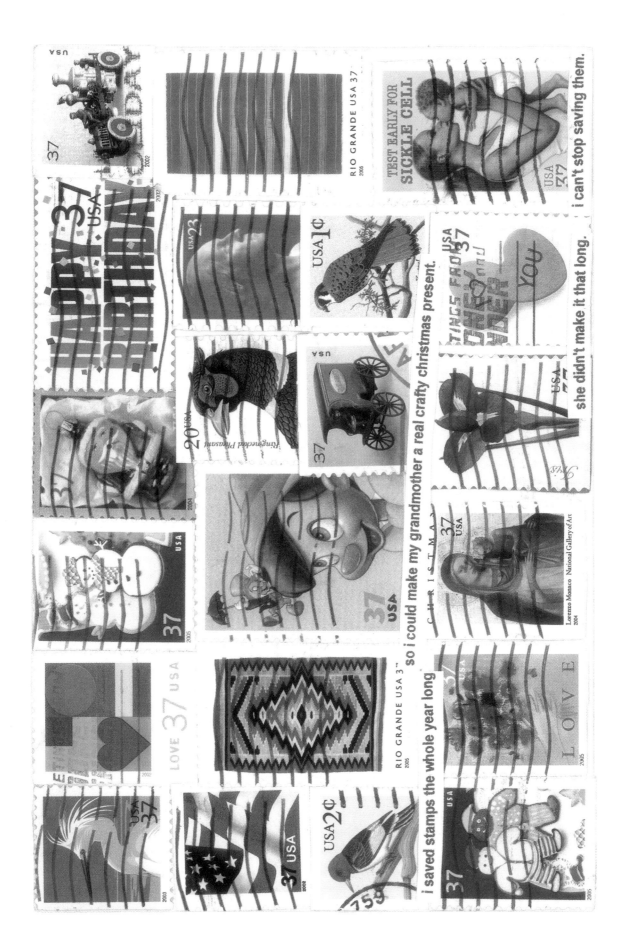

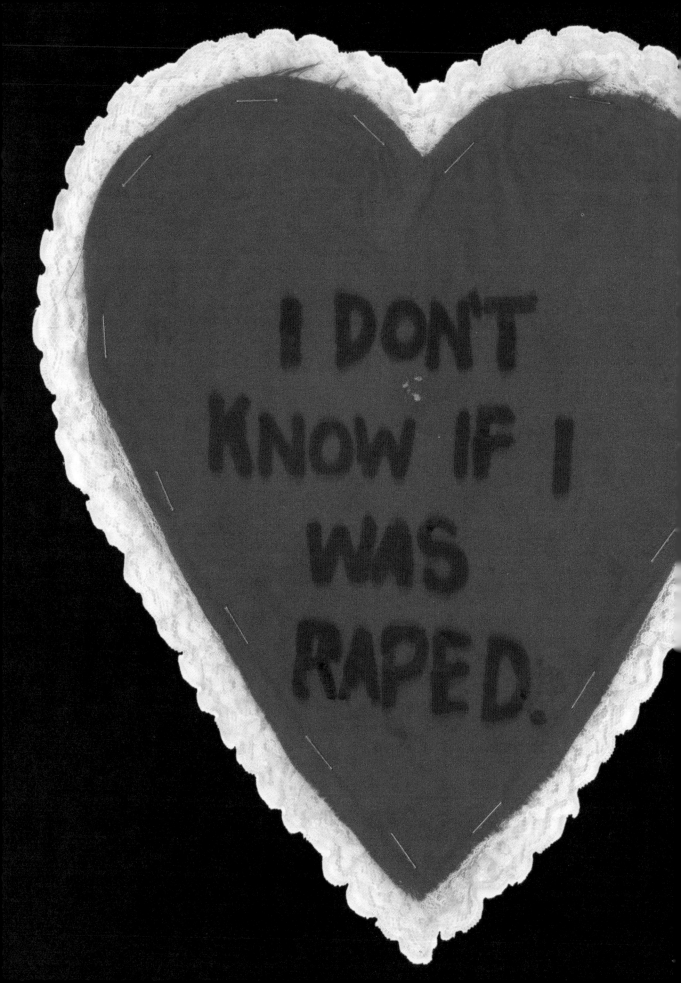

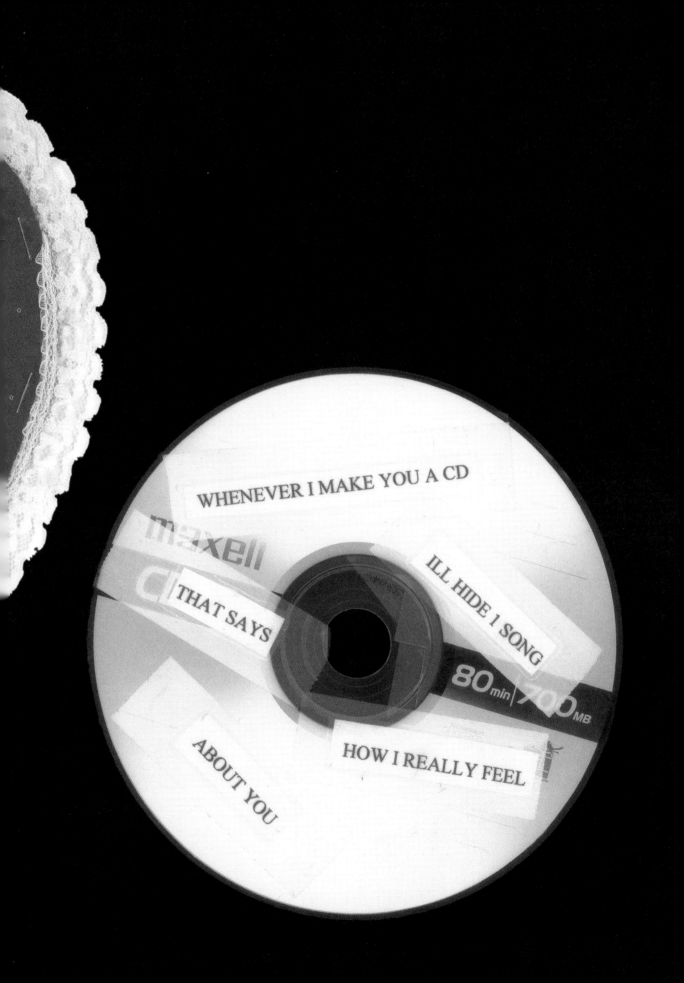

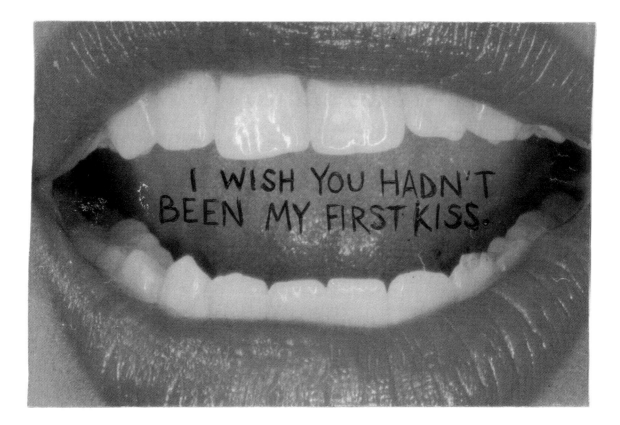

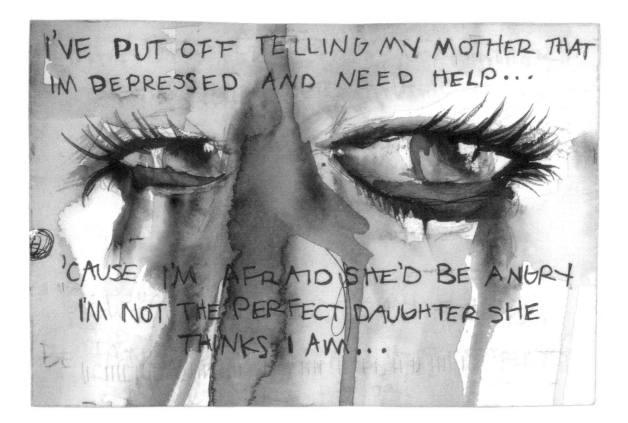

I was adopted. I've seen pictures of my birth mother but not of my birth father. I am terrified that he will recognize me on the street one day. Everytime I see a guy who looks about 35 I look for common features between us. It didn't used to bother me but somehow it has turned into my greatest fear. I'm only 18 but I'm afraid this will plague me the rest of my life...

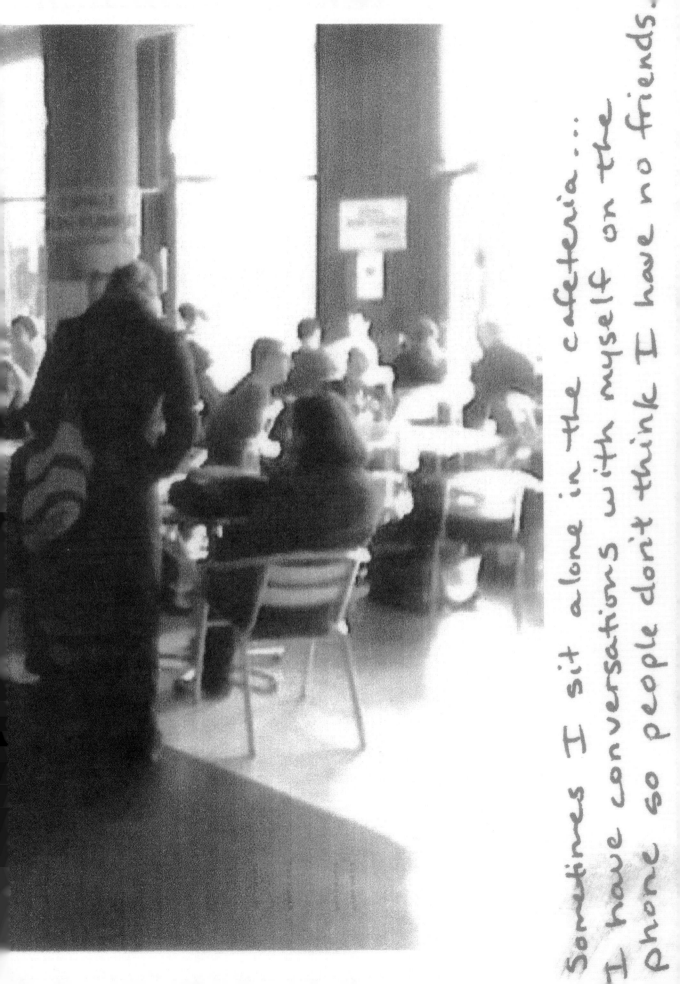

Sometimes I sit alone in the cafeteria...
I have conversations with myself on the
phone so people don't think I have no friends.

I hate knowing that I'm going to look back at my highschool years and say "I missed out"

If you'd like your book signed to you, or a friend, please PRINT the name ONLY on the lines above

BARNES & NOBLE

BOOKSELLERS

Montrose Crossing Shopping Center

Rockville Pike & Randolph Road

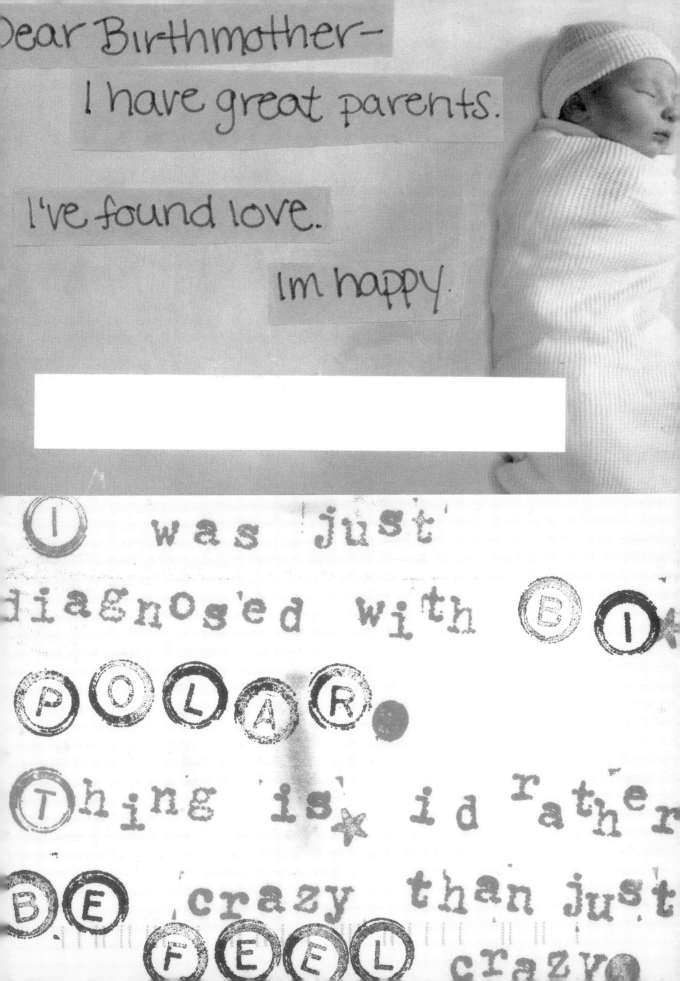

Dear Birthmother—

I have great parents.

I've found love.

Im happy.

I was 'just' diagnosed with BI POLAR. Thing is, id rather BE crazy than just FEEL crazy.

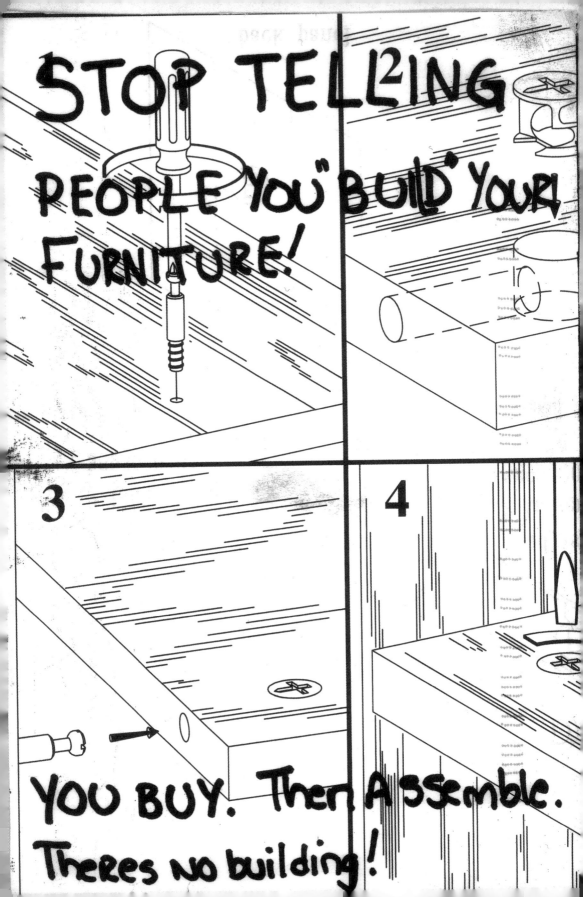

I spent my last few dollars on index cards + markers so I could send my **PAIN** to Post Secret. I got to the post office + I realized I forgot stamps. I sat outside + cried so hard that I couldn't breath. Then a guy came up to me to ask me what was wrong. I told him about every atrocity + showed him my cards. He gave me $5 for stamps so I could be **FREE**. He might not know it, but he saved my life. His name was Gabriel. I'm not sure if he was an **ANGEL** or a regular man, but I do know that my faith in both **GOD** and **HUMANITY** has been restored.

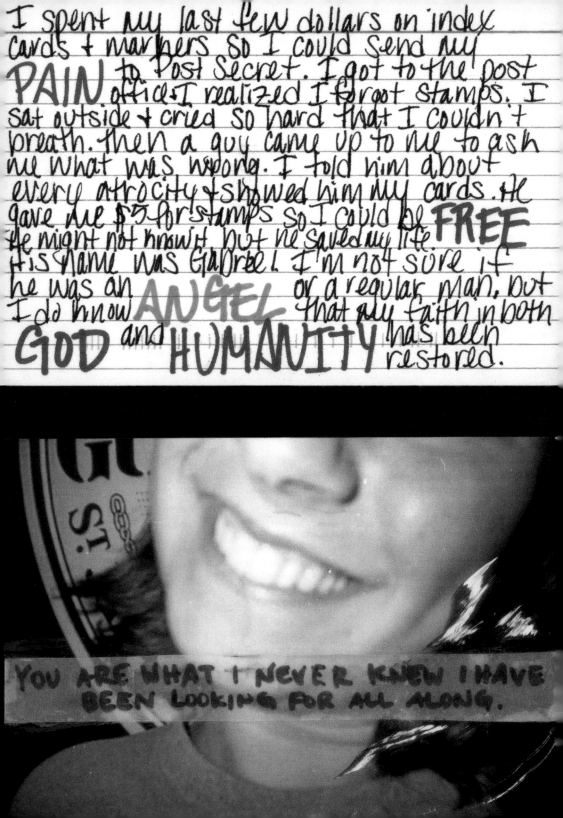

YOU ARE WHAT I NEVER KNEW I HAVE BEEN LOOKING FOR ALL ALONG.

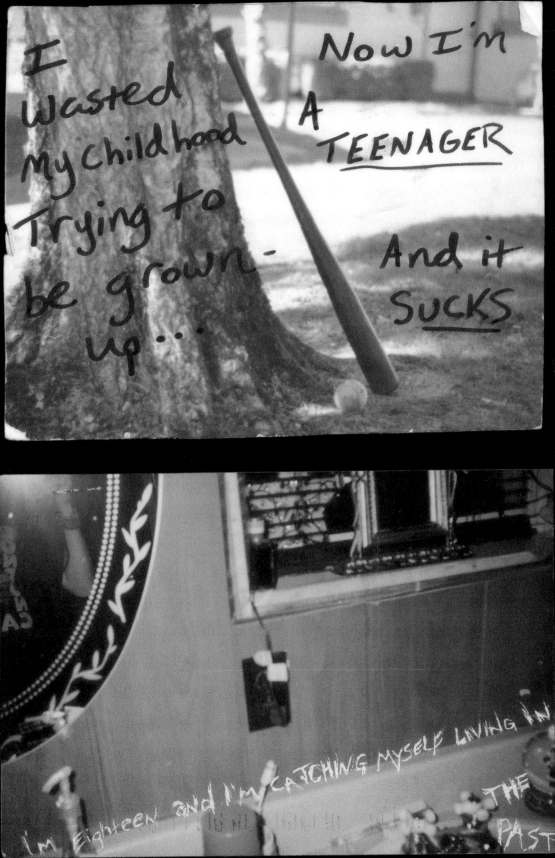

I am very afraid
that this is the
climax of my
life.

I want to be a spy.

I try not to tell many people this.

I would hate to go to my 25th

reunion and have to introduce

myself as an accountant and have

my former classmates ask, "What

happened to you wanting to be a spy?"

And I'd have to just smile and nod.

And then leave early to go on a

dangerous mission to save their

lives from a threat they never knew

existed.

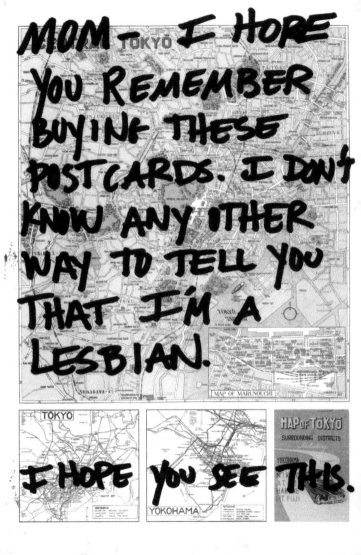

I don't believe in satan,

but once I prayed to him

and offered my soul

if he would make me pretty.

i am often sad
that i don't have
a gag reflex

sometimes, life is really rediculously repetitive.

I only allow myself to read your letters once a year (9/17). Then, I let myself fantasize how my life would be different if you were still around. Sometimes I find myself hating you because it's easier than missing you.

When I was younger,

I used to write letters to imaginary men ending affairs

that never happened.

I would address them to "resident" and mail them out

to addresses I picked at random.

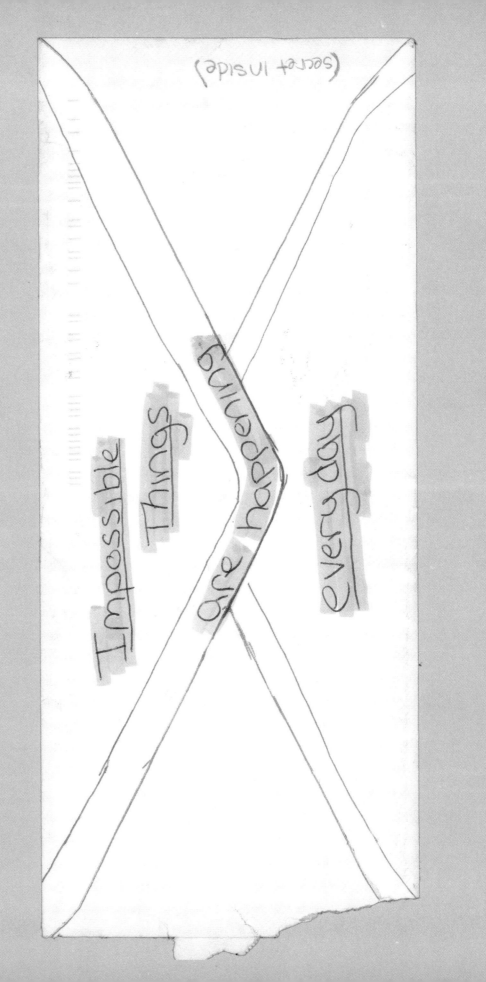

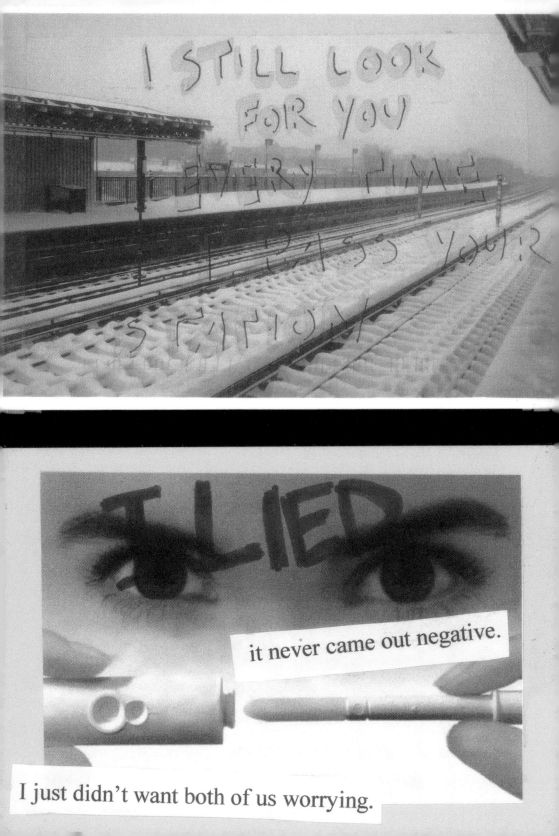

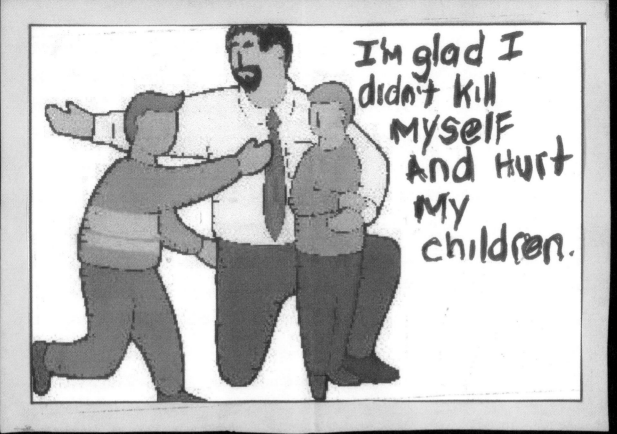

i wish my dad was still alive...
so he could scare away the boys.

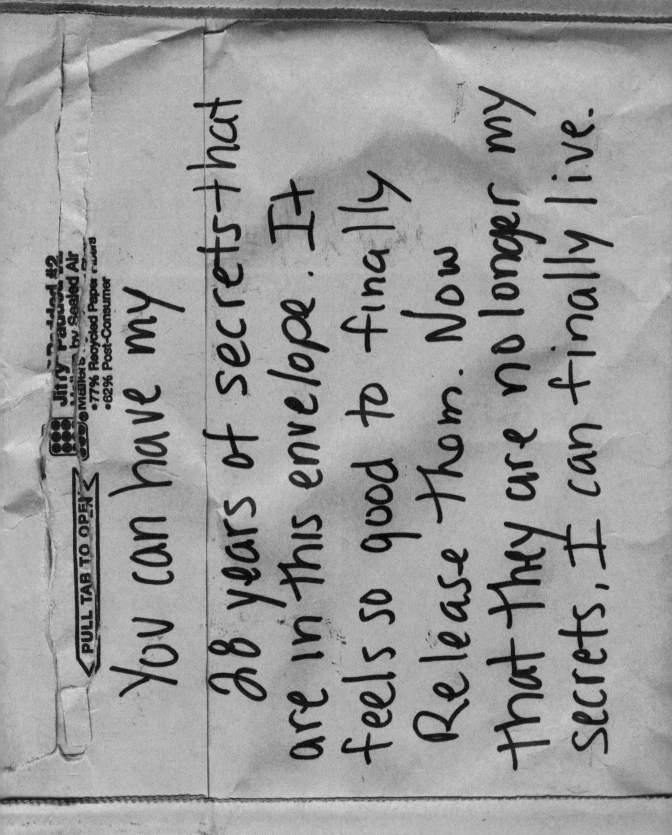

You can have my
28 years of secrets-that
are in this envelope. It
feels so good to finally
Release them. Now
that they are no longer my
secrets, I can finally live.

I WRITE POST SECRETS HOPING YOU WILL READ THEM & KNOW IT'S ME.

IT'S ME.

I want to find someone
who will still love me
after I've shared
all of my secrets.

I want someone, anyone, to look at my
secrets and feel
<u>something</u>.

I'm too afraid too tell.

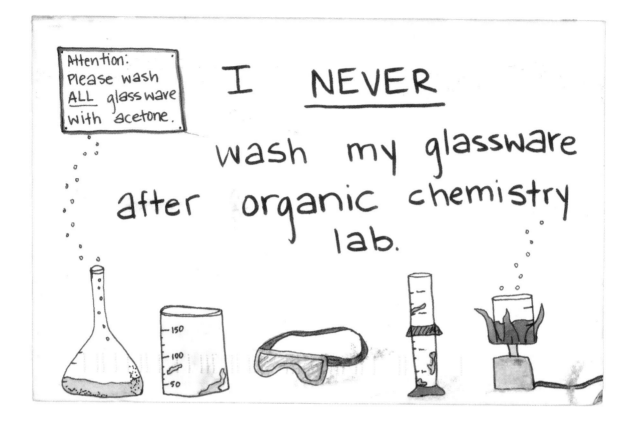

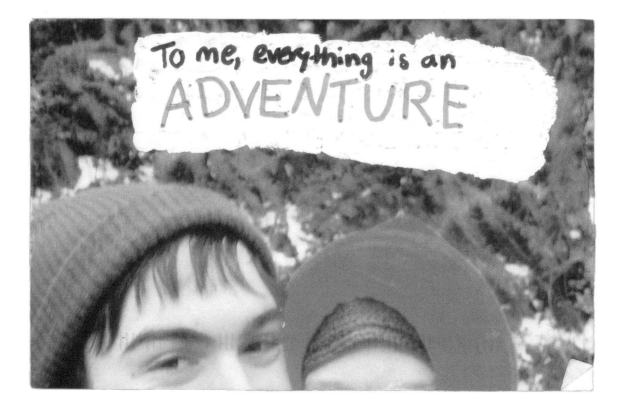

I CAN
ONLY
KISS
IN ONE
DIRECTION

I'VE ALWAYS KEPT THE THINGS THAT ARE MOST IMPORTANT TO ME IN ONE BAG SO I CAN GRAB IT QUICKLY IF MY HOUSE STARTS ON FIRE

Chapter 4 Review

i'm an atheist but i write notes to God on my math homework just in case.

Gorbiky, and then Gorny would come for the holidays, take her for walks in the garden, and flirt with her. And then Gruzdev would come. They would play croquet and bowls, and he would tell her funny stories and others that would leave her dumb with astonishment. Passionately she longed for the garden, the darkness, the clear sky, the stars. Once more her shoulders shook with laughter, the room seemed

i HANDED the MOST iMportant person iN MY life the drugs that Killed him.

After all this time

I am finally ready to let go.

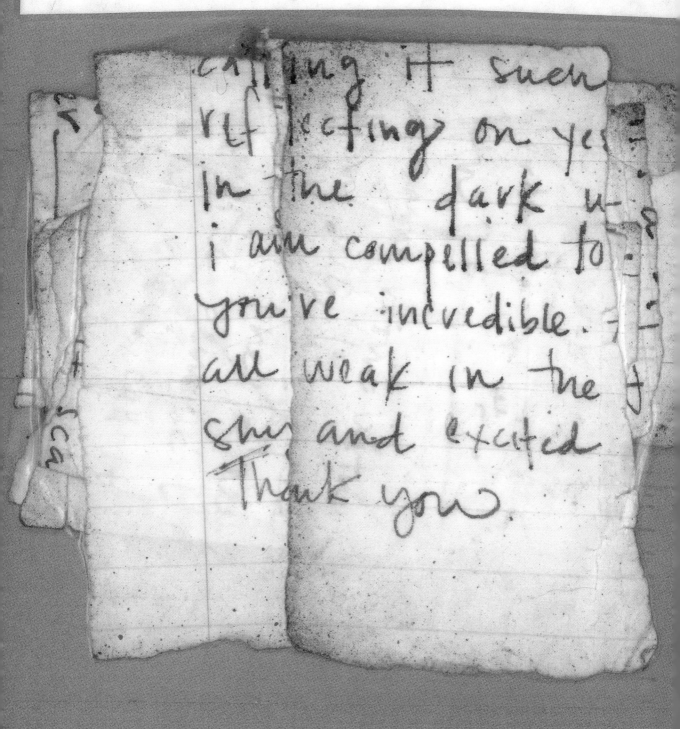

(Sometimes) when I see a relaxed looking police officer, I wonder if I could sneak up and grab his gun.

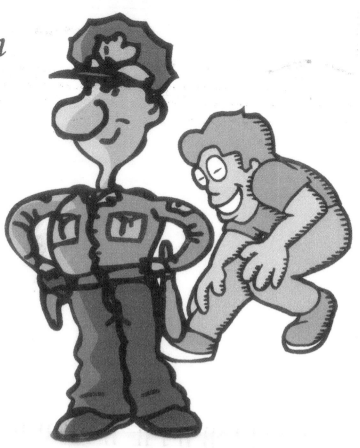

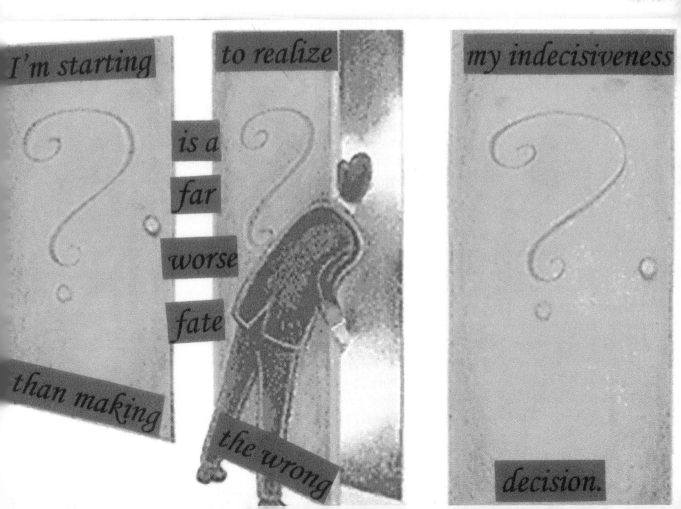

I'm starting to realize my indecisiveness is a far worse fate than making the wrong decision.

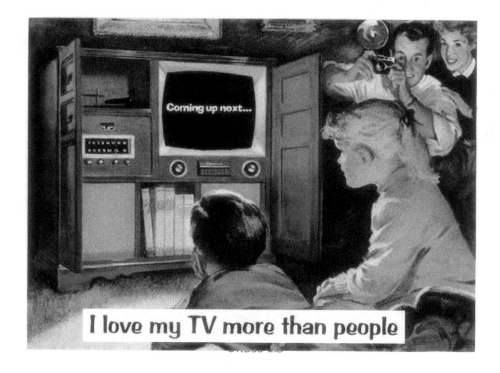

I love my TV more than people

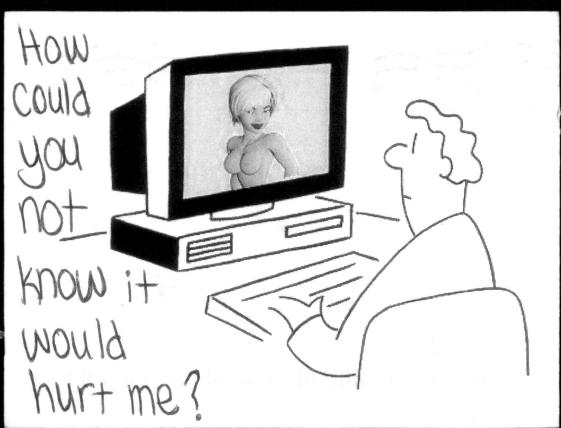

How
could
you
not
know it
would
hurt me?

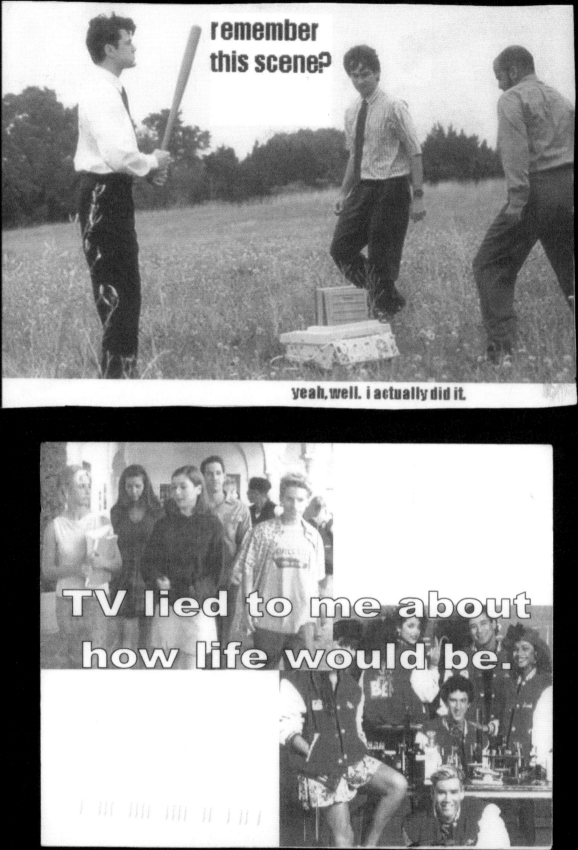

1 2 3 4 5 6 7 8 9 10 11 12 13 14

I have to count my
steps...
There has to be an
odd # at the end or
it's a redo.

OTHERWISE I will be raped
again

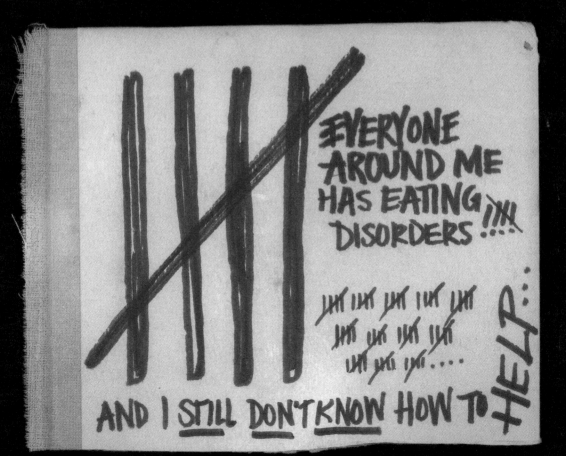

EVERYONE
AROUND ME
HAS EATING !!!!
DISORDERS !!!!

AND I STILL DON'T KNOW HOW TO HELP...

I leave encouraging notes
in open lockers.

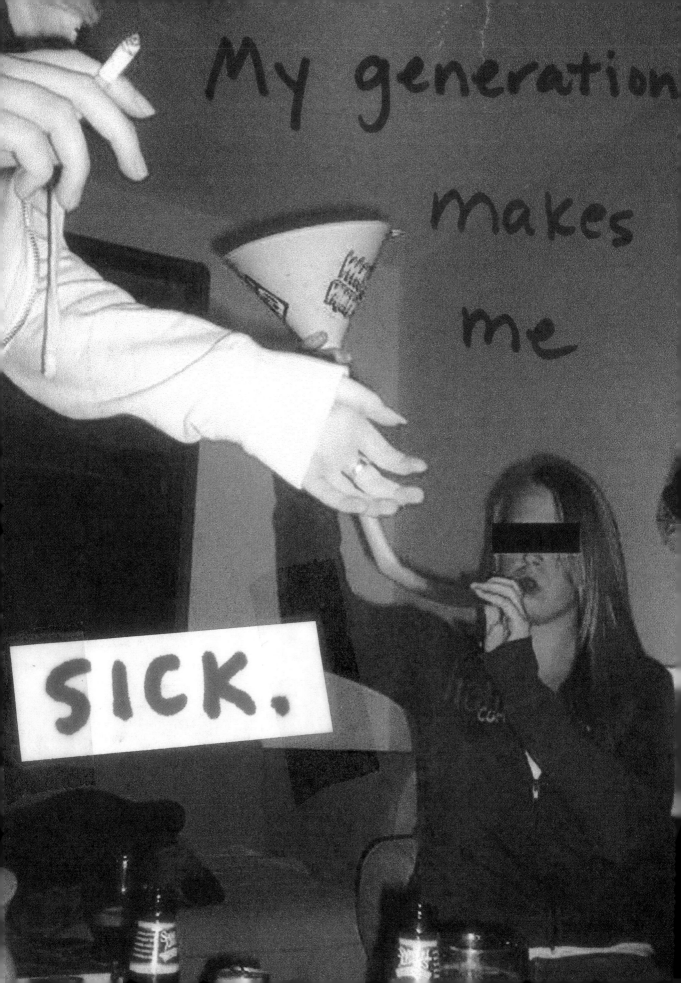

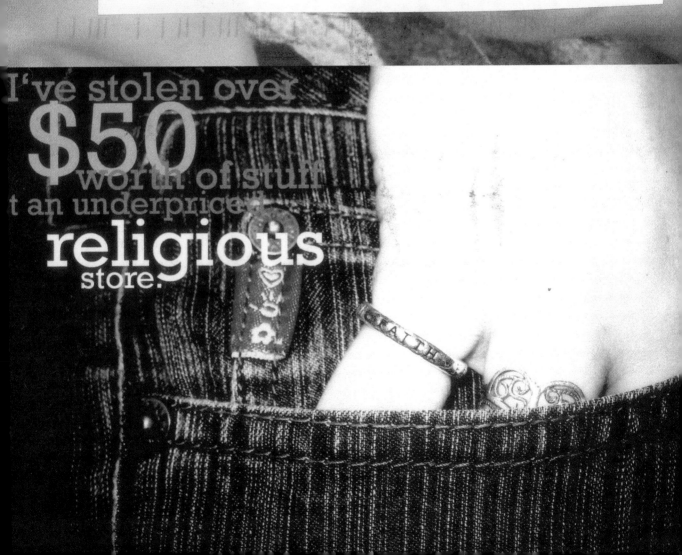

My mom has dedicated the past 18 years of her life to raising me. She's done such a great job.

I have no idea how I'm ever going to show her how much I LOVE&APPRECIATE all she's done.

I've stolen over $50 worth of stuff t an underpriced religious store.

...and that's how I learned that you can never be too careful.

I'M NOT AFRAID OF HAVING STORIES THAT I WON'T BE ABLE TO TELL MY GRANDCHILDREN...

...I'M AFRAID I'LL HAVE LIVED TOO CAUTIOUSLY TO HAVE ANY STORIES THAT WILL INTEREST THEM.

I'm 17, I don't believe in marriage, and I want to adopt

But everytime I watch the Dick Van Dyke show, my Estrogen kicks in and I feel an unbearable want for a husband and a child of my own.

When i do get to see her, We get in her car and I think how

my eyes feel tingly used to back when I meant to her...

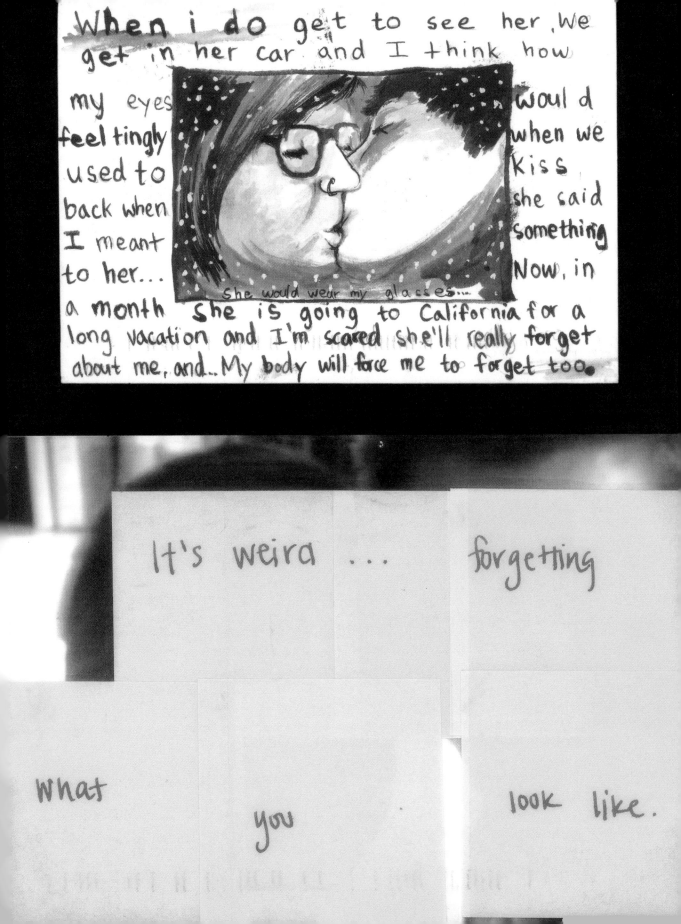

She would wear my glasses...

would when we kiss she said something Now, in

a month She is going to California for a long vacation and I'm scared she'll really forget about me, and... My body will force me to forget too.

It's weird ... forgetting

What

you

look like.

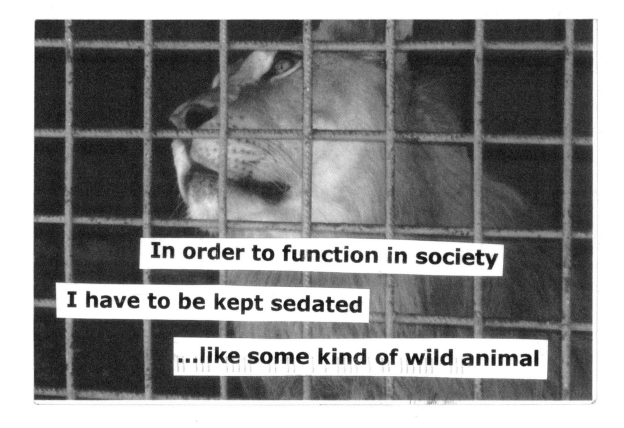

In order to function in society

I have to be kept sedated

...like some kind of wild animal

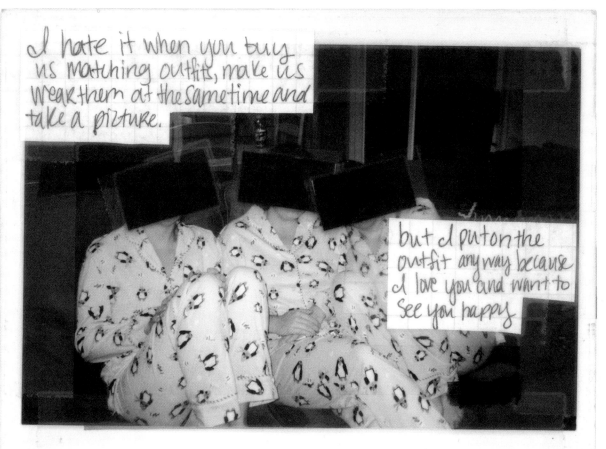

I hate it when you buy us matching outfits, make us wear them at the same time and take a picture.

but I put on the outfit anyway because I love you and want to see you happy

I wish this had contained a letter

Instead of a paycheck

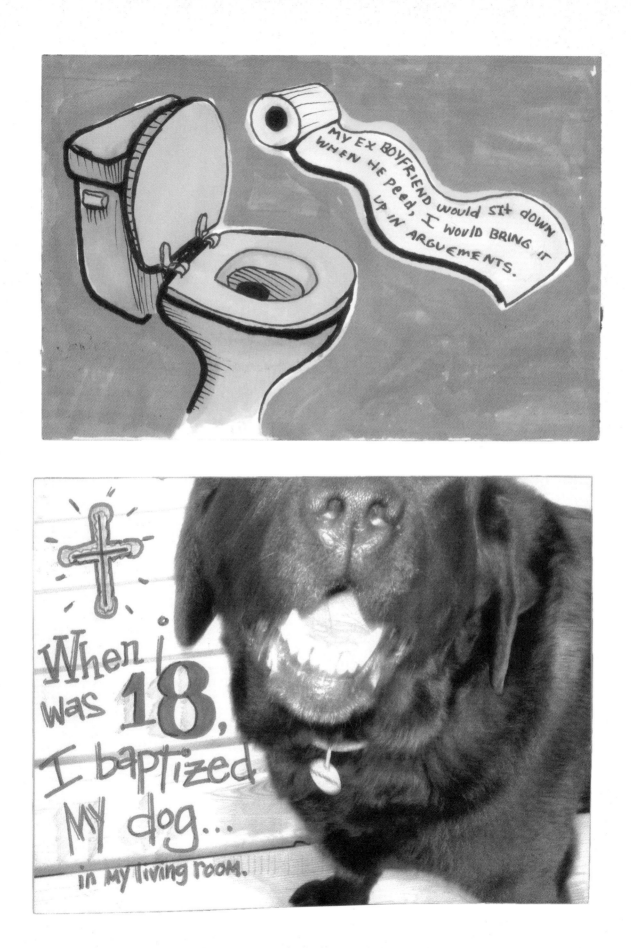

I hate lawyers but am starting law school in Jan. I hope to be a voice for the underdog. No aspirations for monetary wealth — just want to make a difference & leave this world a better place. I want the extent of my life to go past me, not merely just by procreating. I'm making a copy of this to read when I graduate law school.

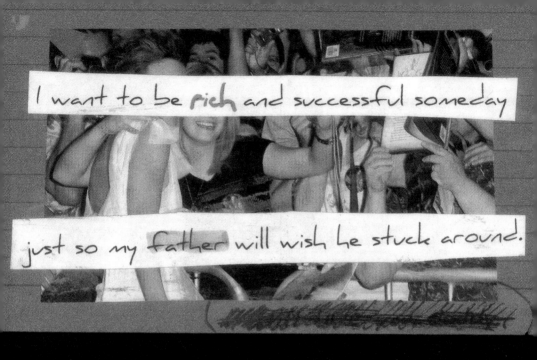

I want to be rich and successful someday just so my father will wish he stuck around.

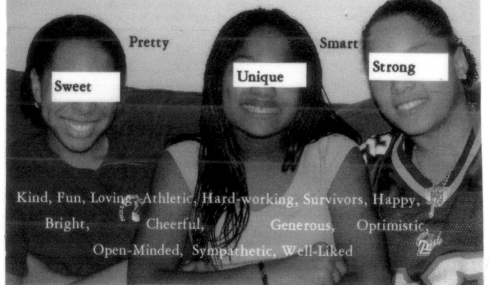

I adopted your daughters and I want you to know they're growing up to be terrific young women. Thank you, all three of you, for the greatest gift of all.

Pretty Smart

Sweet Unique Strong

Kind, Fun, Loving, Athletic, Hard-working, Survivors, Happy, Bright, Cheerful, Generous, Optimistic, Open-Minded, Sympathetic, Well-Liked

IM GOING
TO CHANGE
THE WORLD!

-----Email Message-----

Today I saw one of the PostSecret books in the bookstore. Looking through it, I felt inspired to write a secret about

something that happened to me today. I wrote it down and left it inside the book.

Now someone has one extra secret for their money.

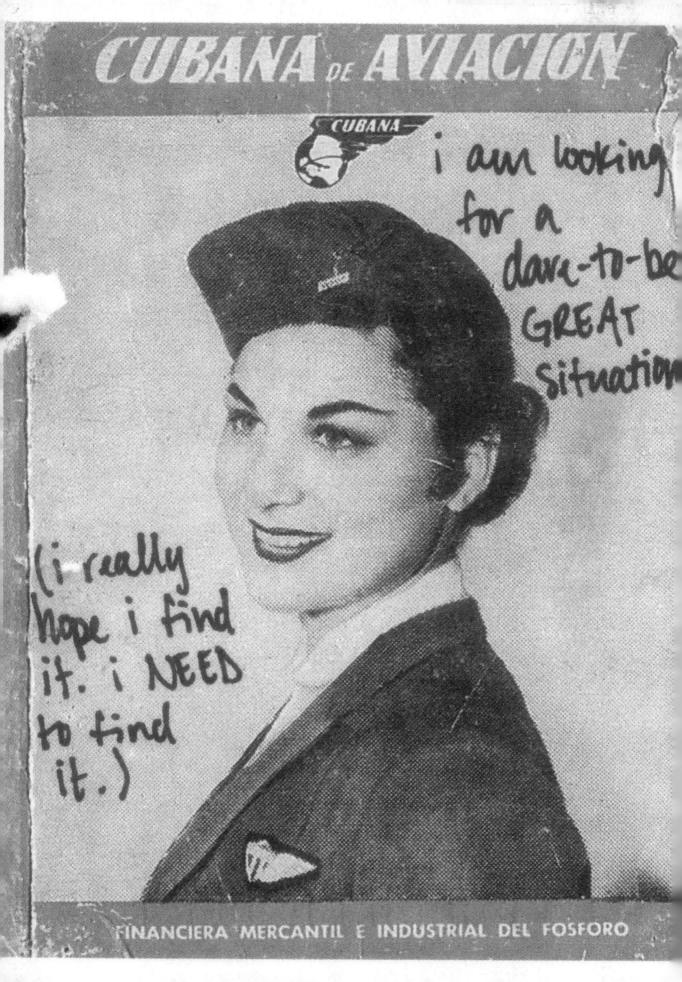

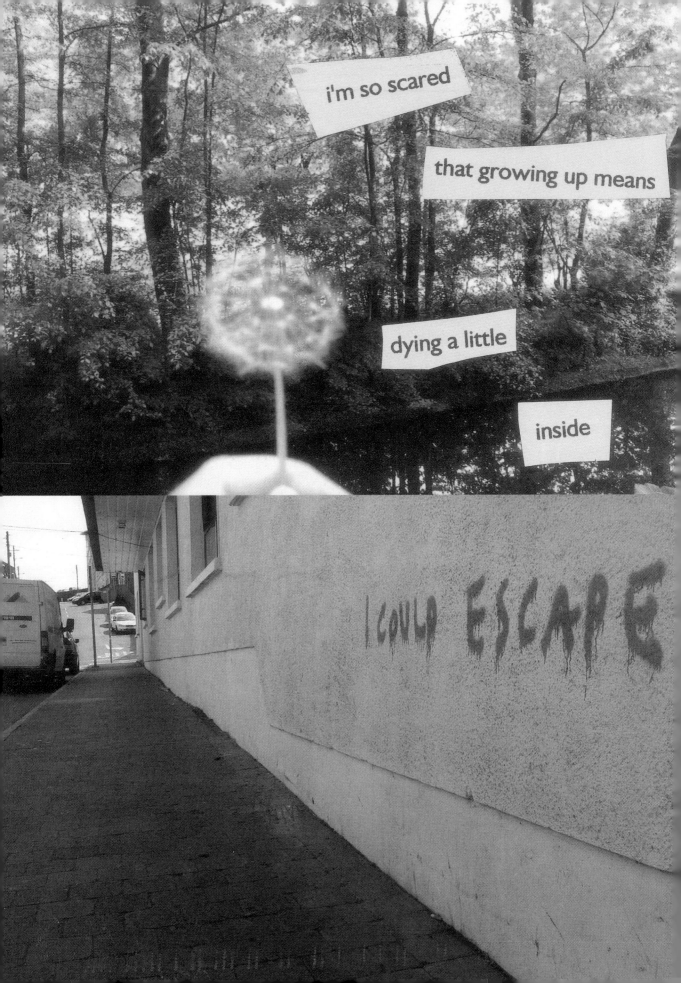

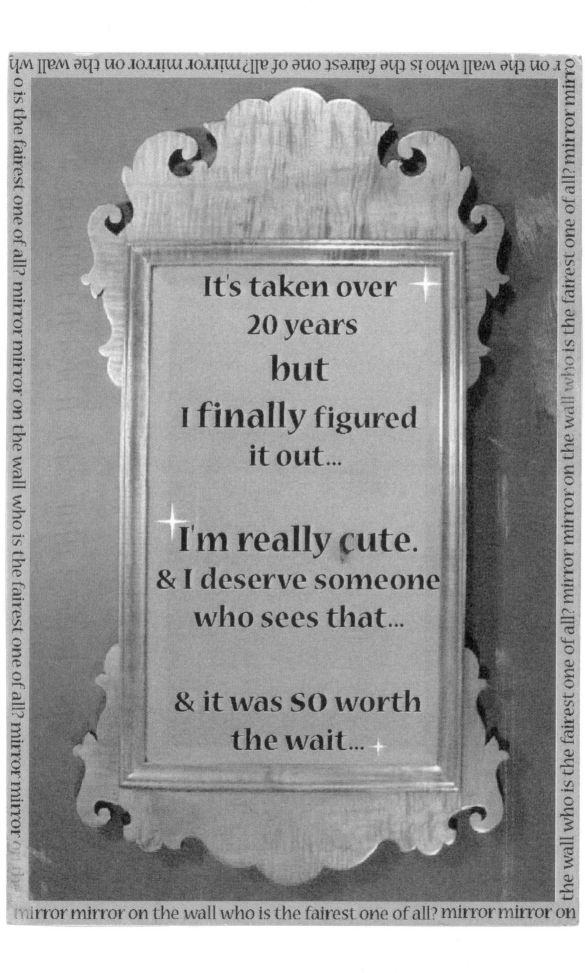

THERE WILL BE A DREAM THAT COMES TO EACH AND EVERY PERSON IN WHATEVER SHAPE OR FORM THEY BEST UNDERSTAND AND...

This Drea▮▮▮▮▮▮▮▮▮▮▮▮

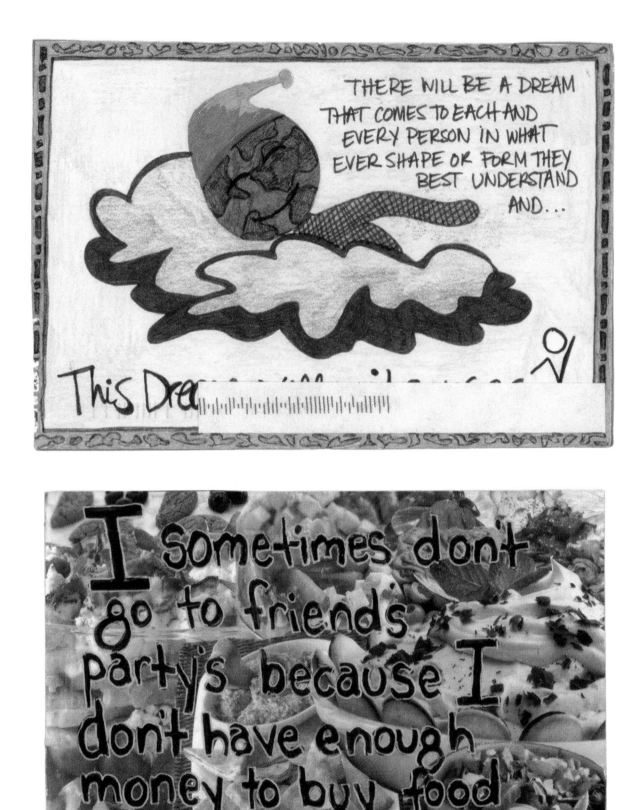

I sometimes don't go to friends party's because I don't have enough money to buy food to bring.

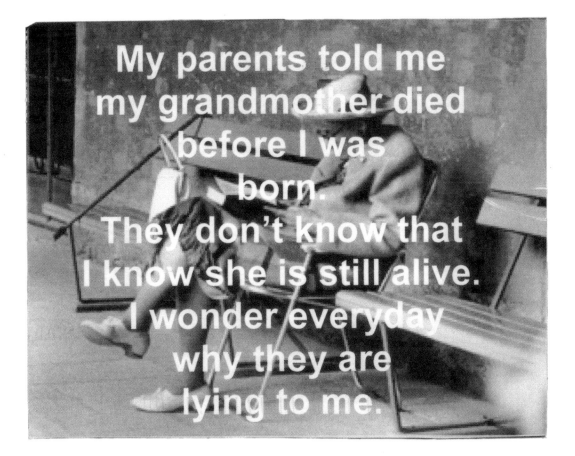

My parents told me
my grandmother died
before I was
born.
They don't know that
I know she is still alive.
I wonder everyday
why they are
lying to me.

I don't know you and I don't know if you read this, but I want you to know your mom loves you. I saw it in her eyes as she told me about you – She wants you to come home

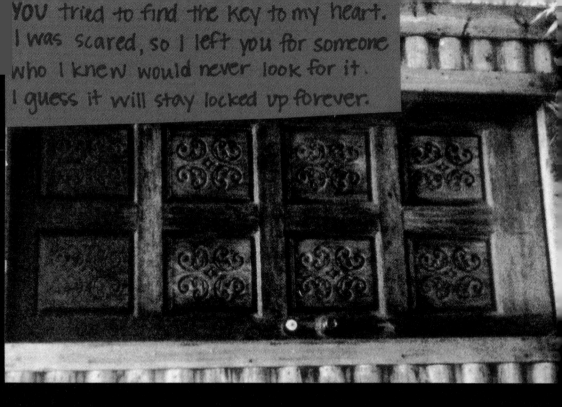

You tried to find the key to my heart.
I was scared, so I left you for someone
who I knew would never look for it.
I guess it will stay locked up forever.

I visualize locking
away my darkest memories
and biggest secrets in a
chest in my mind so I
don't remember them.

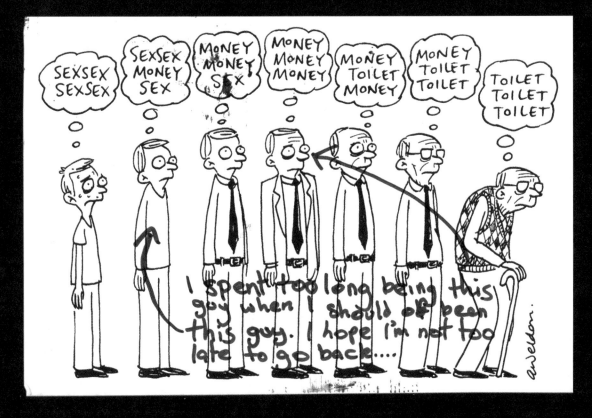

One day, this will all make sense.

It is this hope that keeps me going.

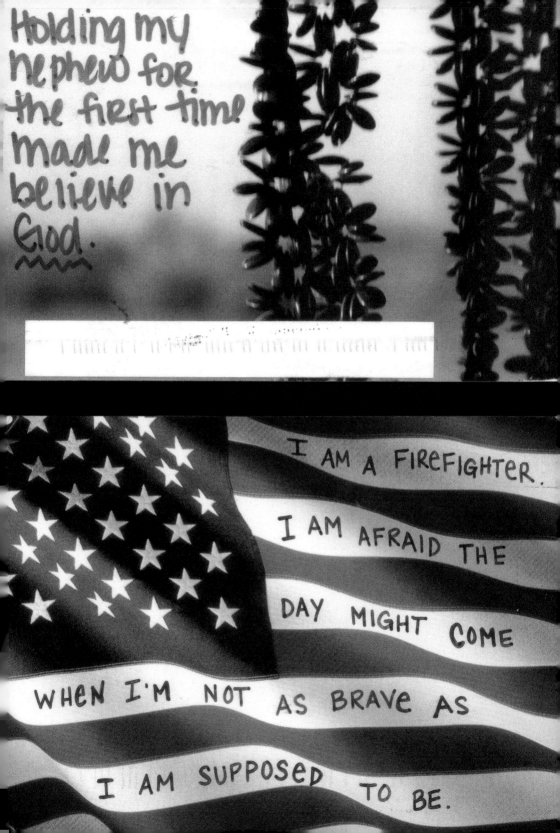

Holding my nephew for the first time made me believe in God.

I AM A FIREFIGHTER. I AM AFRAID THE DAY MIGHT COME WHEN I'M NOT AS BRAVE AS I AM SUPPOSED TO BE.

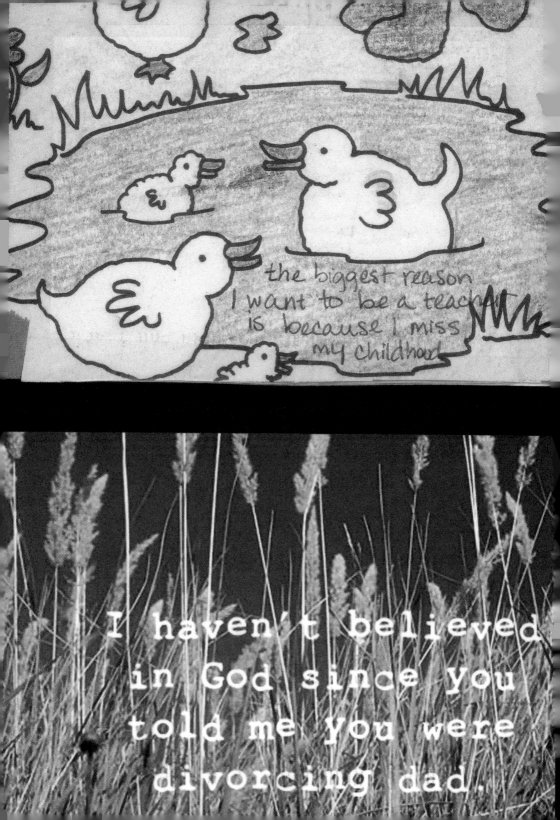

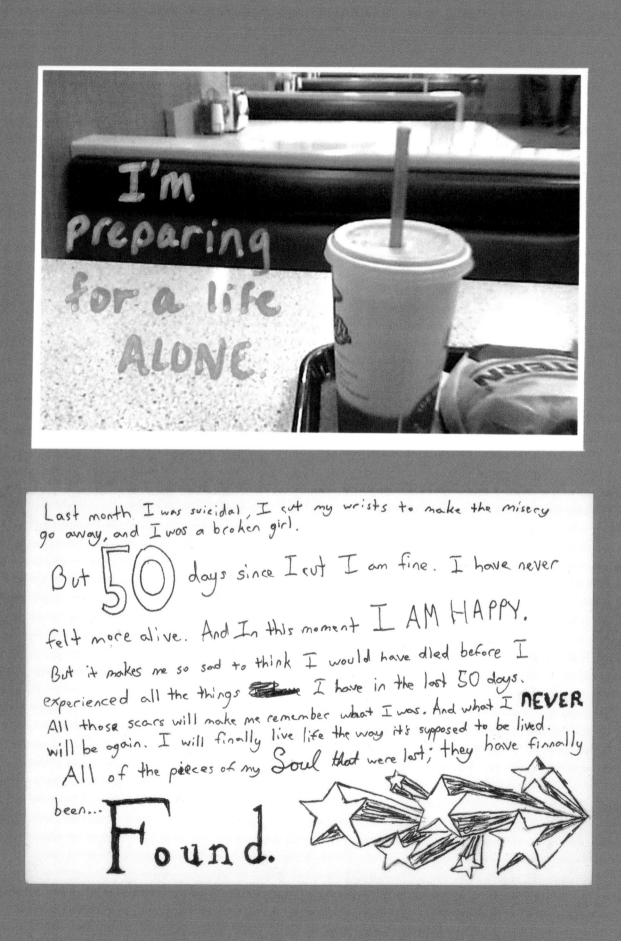

I'm preparing for a life ALONE.

Last month I was suicidal, I cut my wrists to make the misery go away, and I was a broken girl.

But 50 days since I cut I am fine. I have never felt more alive. And In this moment I AM HAPPY.

But it makes me so sad to think I would have died before I experienced all the things ~~things~~ I have in the last 50 days. All those scars will make me remember what I was. And what I NEVER will be again. I will finally live life the way it's supposed to be lived.

All of the pieces of my Soul that were lost; they have finally been... Found.

i cut out articles and save clippings i am certain you would enjoy. i put them in an envelope thinking that there will be a time when i will share them with you.

but i know there won't be.

I forgive the
Kid that ruined
my childhood.

"I LOST MY BULGES
and saved money, too!"

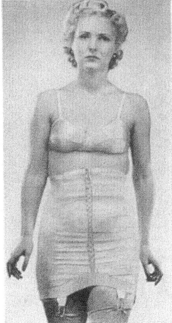

(Above) *Unlovely bulges and sagging figure lines resulted from wearing incorrect corsets.* **(At left)** *In her Spencer bulges are gone, figure lines lifted into youthful grace. She saves money on corsets now, because her Spencer is guaranteed never to lose its shape.*

Are you threatened with a bulging abdomen or a "spare-tire" around the waist? Are your hips beginning to spread? Then follow the example of this young woman and find out what a Spencer can do for you.

How to lose your bulges

Your Spencer corset and brassiere will effectively correct any figure fault because every line is designed, every section cut and made to solve your figure problem and yours only.

Spencers are light and flexible yet every Spencer is *guaranteed* to keep its lovely lines as long as it is worn! No other corset, to our knowledge, carries this guarantee. Prices are moderate—depending on materials. Stop experimenting with corsets that lose their shape after a few weeks' wear!

Have a figure analysis—free

At any convenient time, a Spencer Corsetiere, trained in the Spencer designer's method of figure analysis, will call at your home. A most interesting study of your figure will cost you nothing.

See your future beauty lines in fascinating free booklet

Send us the coupon below, or look in your telephone book under "Spencer Corsetiere" and call your nearest corsetiere, for interesting illustrated booklet, "Your Figure Problem." This will not obligate you in any way.

If you're waiting for a sign... this is it.

Do it.

It Will Be Amazing

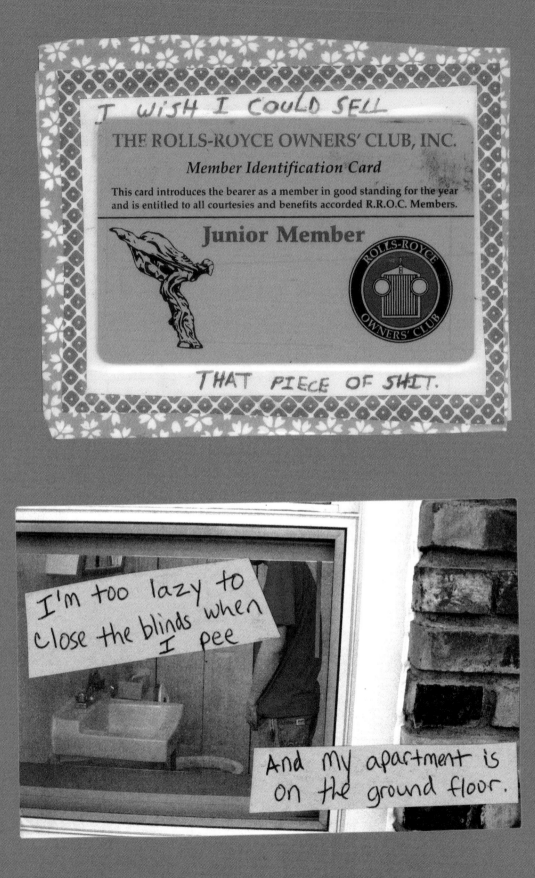

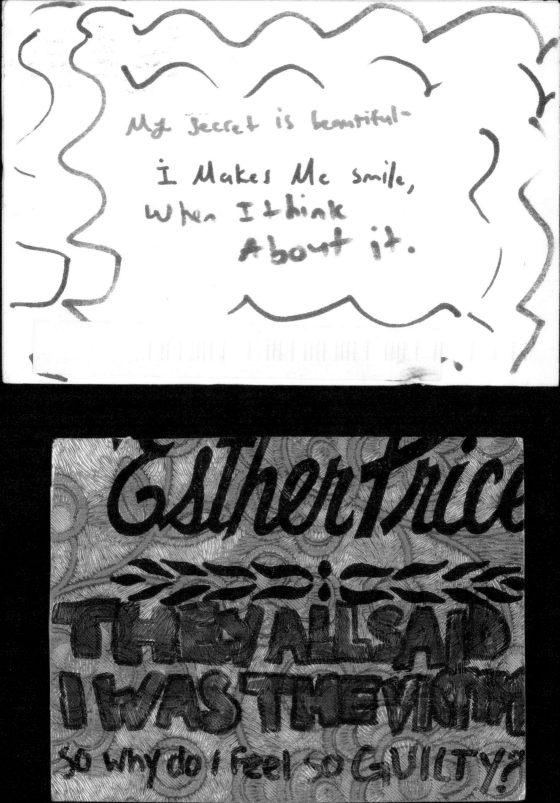

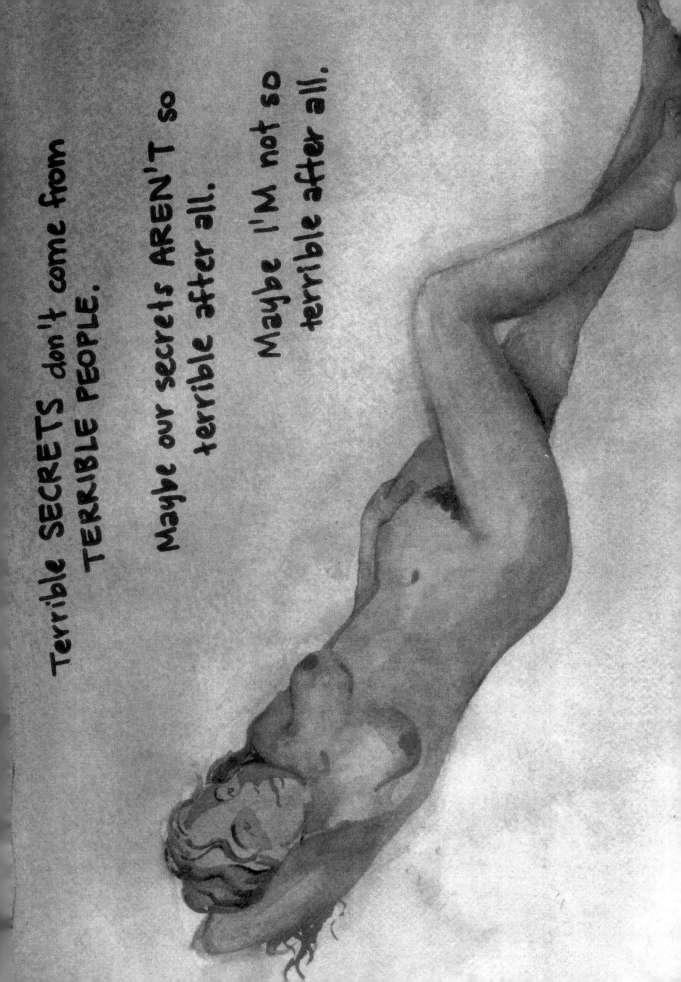

Terrible SECRETS don't come from
TERRIBLE PEOPLE.

Maybe our secrets AREN'T so
terrible after all.

Maybe I'M not so
terrible after all.

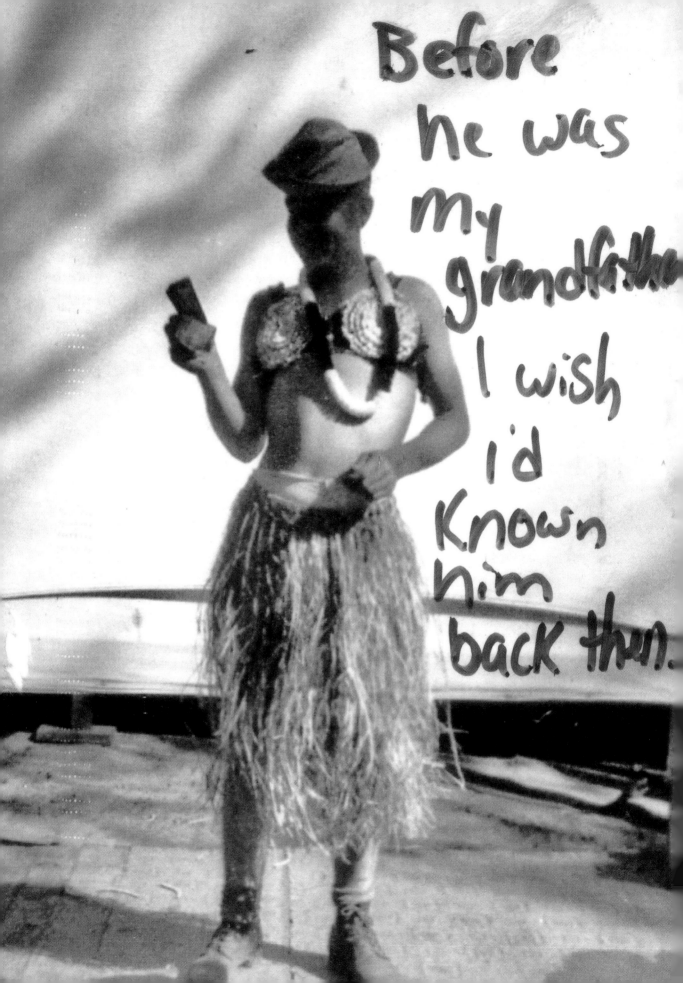

Before he was my grandfathe I wish i'd known him back then.

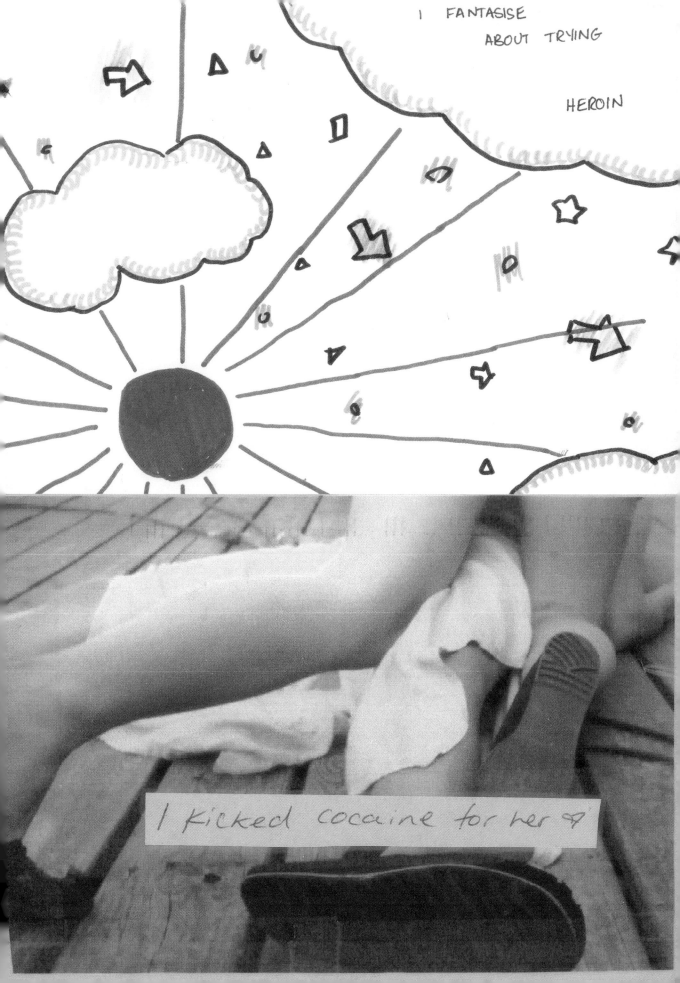

I wish I lived in an egalitarian hunter-gatherer Society.

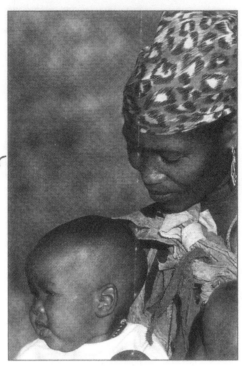

It seems so simple.

I wouldn't have general anxiety disorder or panic attacks anymore.

four pounds of meat for every man, woman, and child in attendance. Satisfied that he had found such an animal, Lee was very pleased with himself indeed.

It was not long before word of the purchase began to spread, and people began to approach him for confirmation of the rumor. Lee was only too pleased to confirm that he had, in fact, purchased a large and well-known animal from a neighboring group, and was indeed planning to slaughter and serve it to the Ju/'hoansi. He waited for the delight and gratitude he felt he surely deserved, but was taken aback by the reaction with which he was met instead. One by one, individuals approached him to offer nothing but chastisement for the piti-ful specimen he intended to serve. A close friend implored him to explain his stinginess: "What has happened to change your heart? That sack of guts and bones . . . will hardly feed one camp. . . Perhaps you have forgotten that we are not few, but many. Or are you too blind to tell the difference between a proper cow and an old wreck? That ox is thin to the point of death." (1979:156)

Lee was demoralized, and day after day, as the feast drew nearer, was warned that of course he must serve the beast, since it was already paid for, but not to expect much of a festive evening to follow, given the sorry offering that would surely send people home hungry. The feast came and went, and indeed the ox was fat, and served the people for two days and nights of revelry. But all the while the Ju/'hoansi were eating they were proclaiming their disdain for the thin, wretched ox. Realizing that he had been fooled, but not sure why, Lee pursued the matter. Finally he was told that the people had been acting in their characteristic manner, the way in which all hunters are treated despite the bounty they might bring home. An informant explained, "Yes, when a young man kills much meat he comes to think of himself as a chief or a big man, and

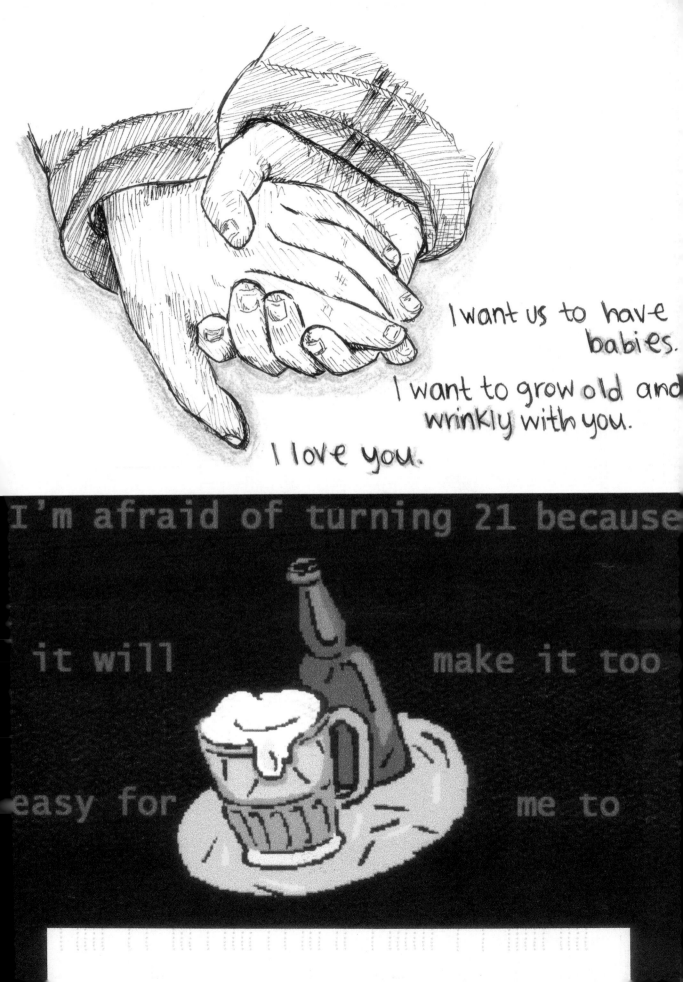

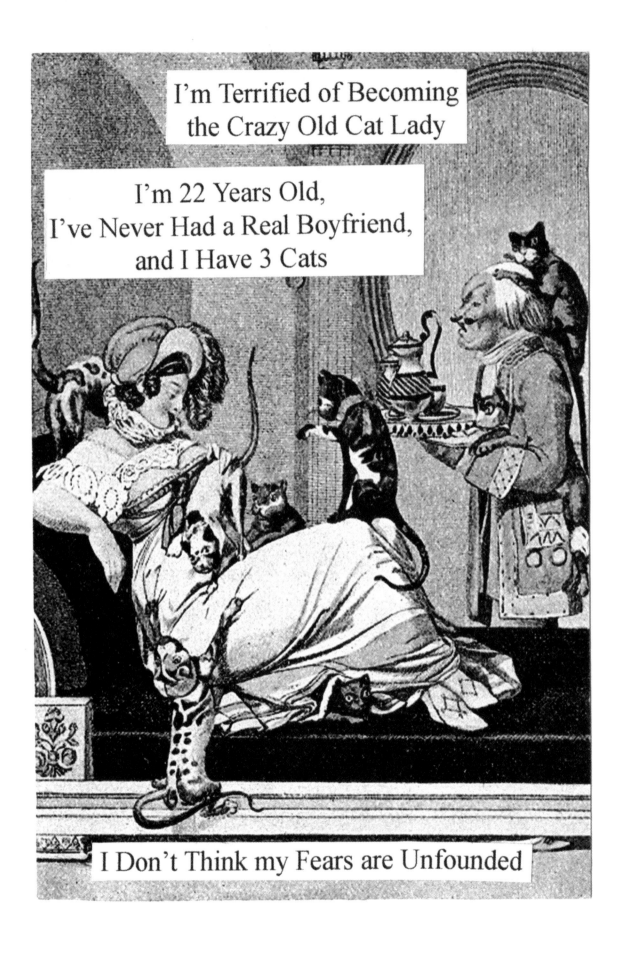

...WINE ...organized
... I WANT to say a big "Fuck You"
to this whole graphic design thing and move
to Africa where I can do something important
and beautiful.

(We forgot ...

I wish that every
human life might
be pure transparent
freedom.

SIMONE DE BEAUVOIR

I am quitting
my job in two
weeks. I don't have
another job lined
up. I am feeling
awesome and terrified.
This is my rebirth!

Tabula Rasa

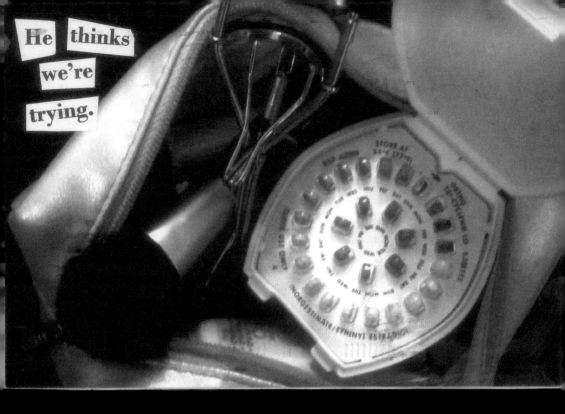

He thinks we're trying.

My best friend tried to rape me.

I'm now studying to be in the FBI to stop people like him.

FBI

you didn't ruin me.

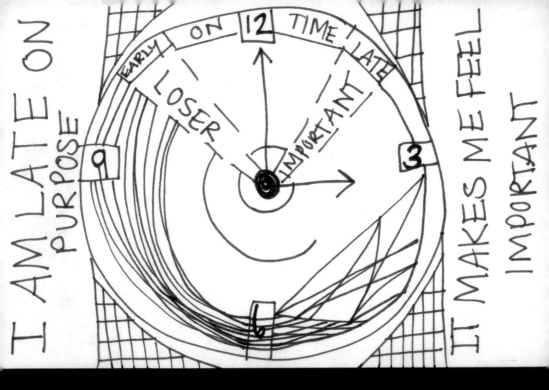

I AM LATE ON PURPOSE

IT MAKES ME FEEL IMPORTANT

I find a halved grapefruit to be one of the most erotic, beautiful, sensual, exquisite, disgusting, juicy, sinful, delicious, vibrant, sexual, elegant, tempting and lively gifts this world has to offer.

The most important thing
I realised lately is that
painful breakups, unrequited
love, shitty jobs and the
like help us to
BUILD CHARACTER
and that no matter how
bad it feels, we are much
better off because of it.

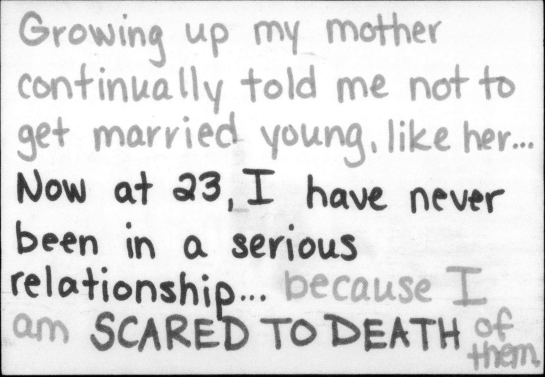

Growing up my mother continually told me not to get married young, like her... Now at 23, I have never been in a serious relationship... because I am SCARED TO DEATH of them.

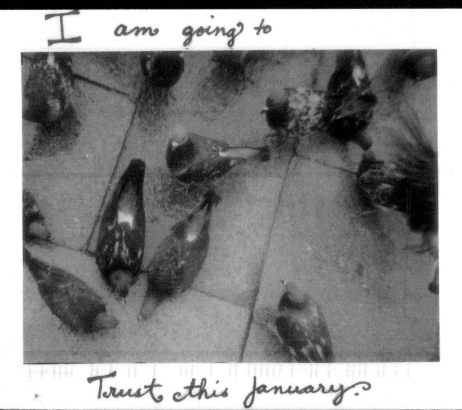

I am going to

Trust this january.

I just found
a spider on
my desk.

So I put it on my roommate's bed.

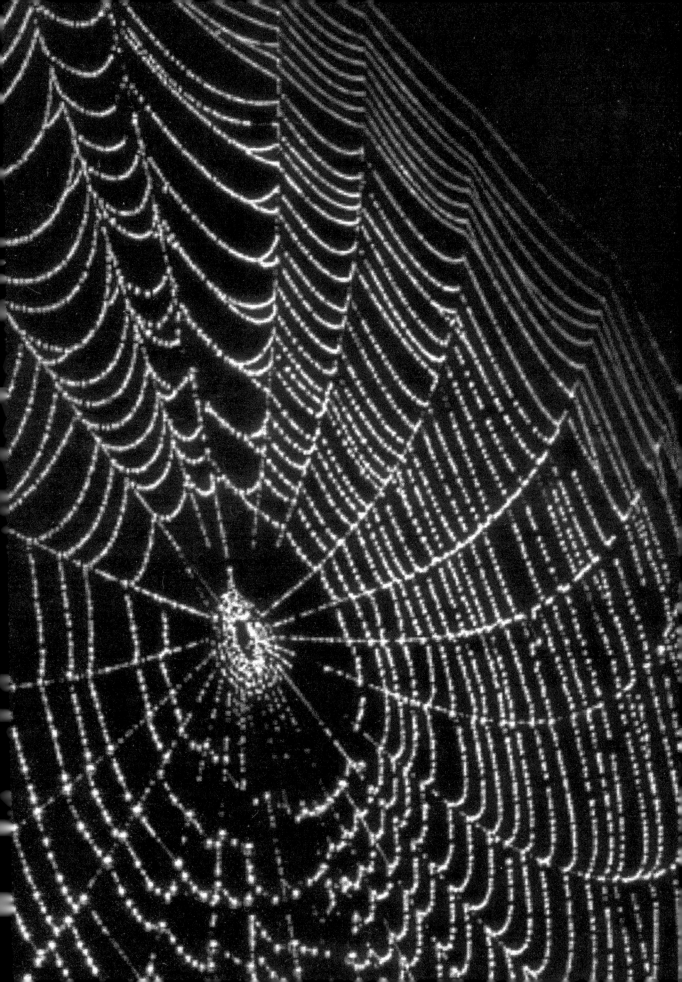

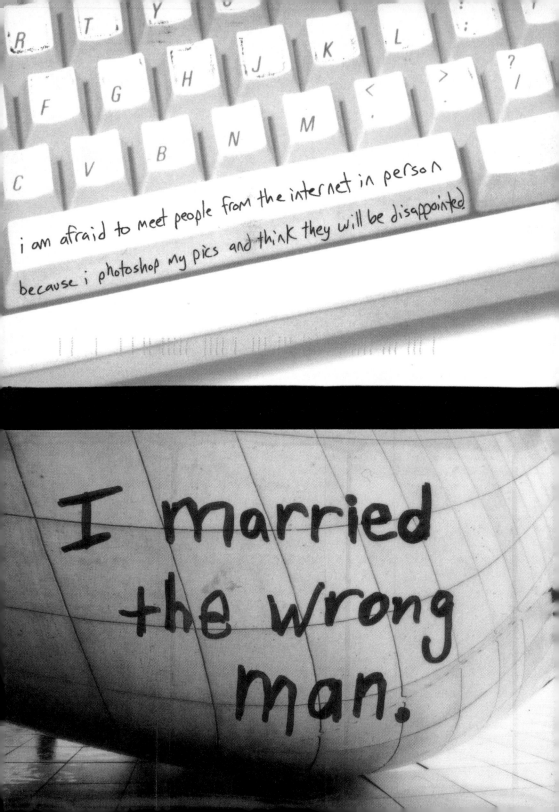

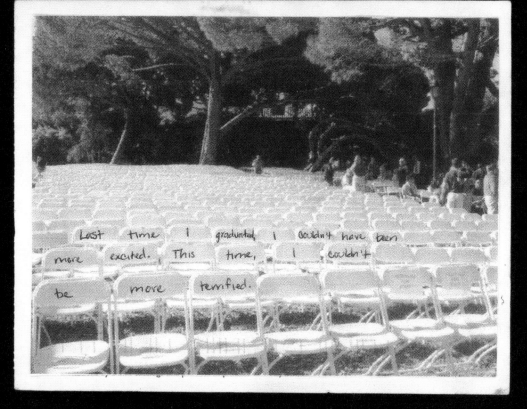

Last time I graduated, I couldn't have been more excited. This time, I couldn't be more terrified.

4	5	6	7
	have made		
		that mistake	
I never should			

11	12	13	14
I wonder how	long I'll regret	that decision.	

18	19	20	21

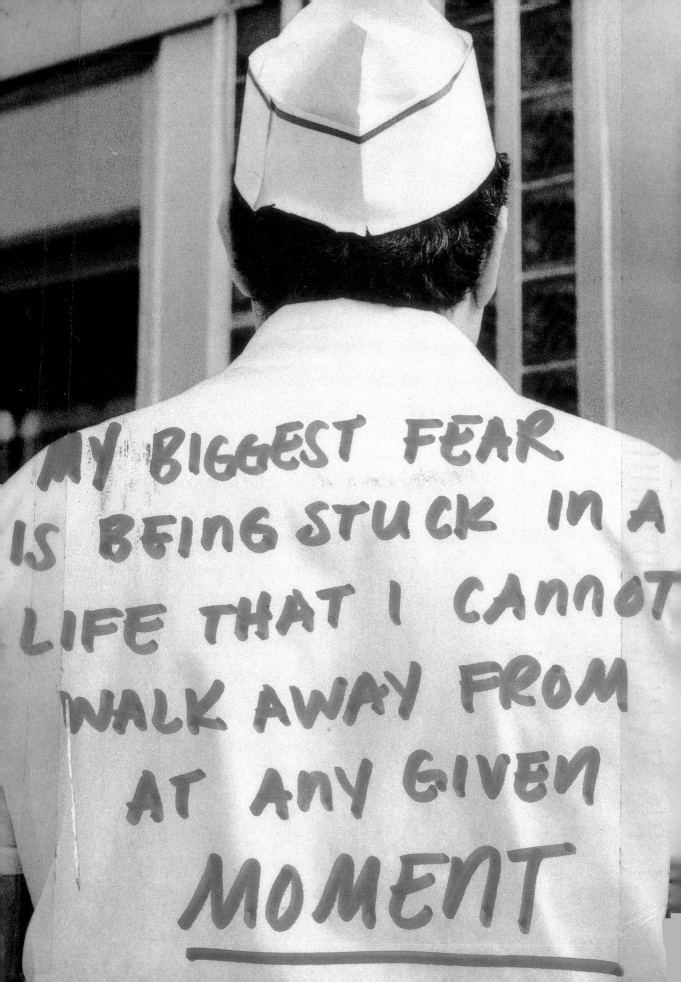

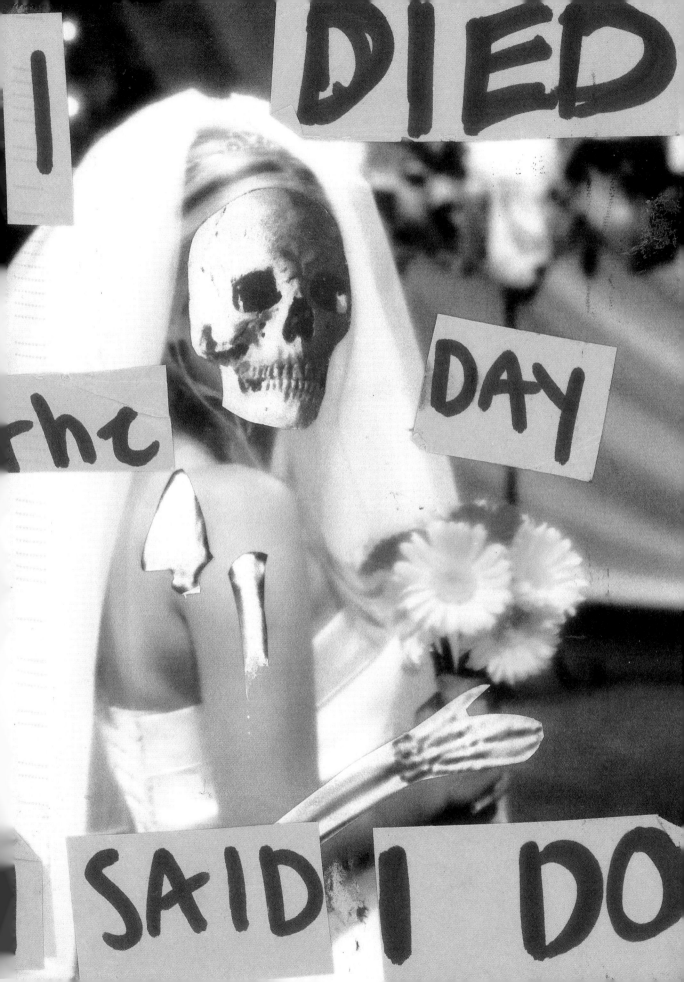

I never wanted to be married at this age.

PETITION FOR DISSOLUTION OF MARRIAGE

Case No.

25

Co-Petitioners

But I never thought I'd be divorced.

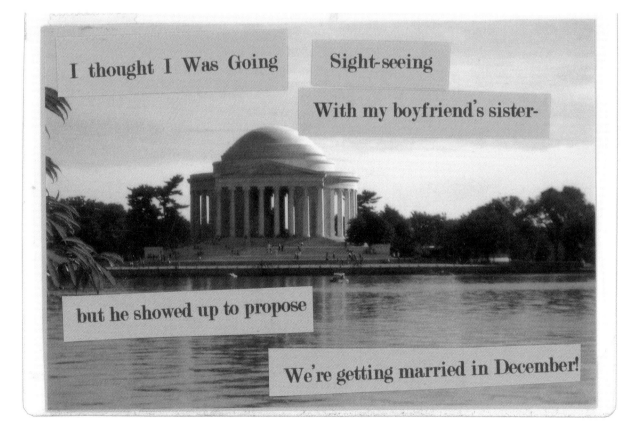

I thought I Was Going

Sight-seeing

With my boyfriend's sister-

but he showed up to propose

We're getting married in December!

I'm in a wonderful, loving marriage & we are still virgins and that's okey w/ me

My wife loves me.
After 25 years, I finally realized
that's the only reason I love her.

It's not enough reason to stay
and not enough reason to leave.

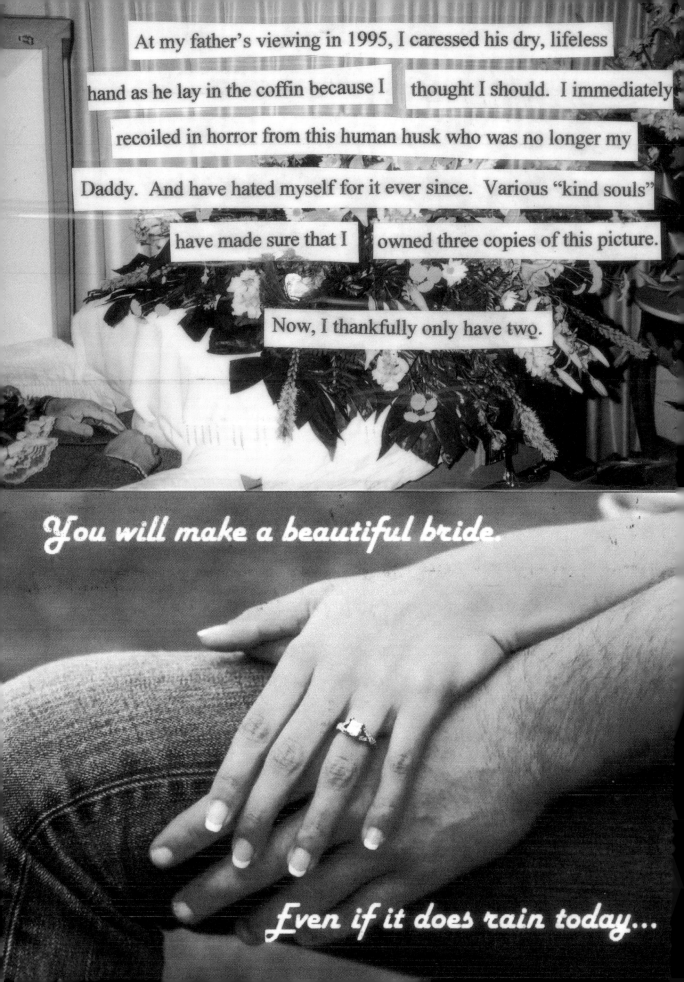

At my father's viewing in 1995, I caressed his dry, lifeless hand as he lay in the coffin because I thought I should. I immediately recoiled in horror from this human husk who was no longer my Daddy. And have hated myself for it ever since. Various "kind souls" have made sure that I owned three copies of this picture.

Now, I thankfully only have two.

You will make a beautiful bride.

Even if it does rain today...

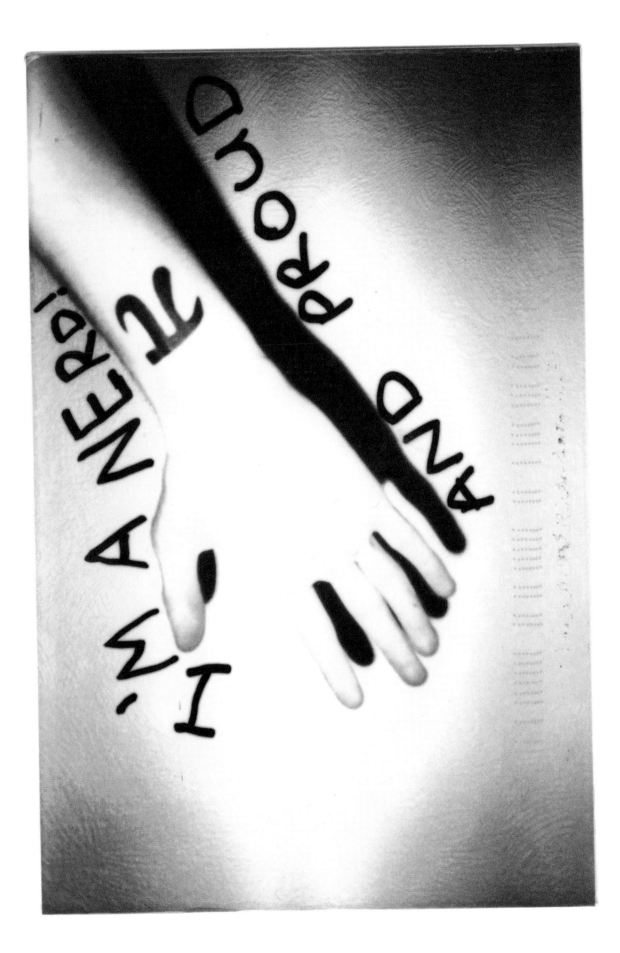

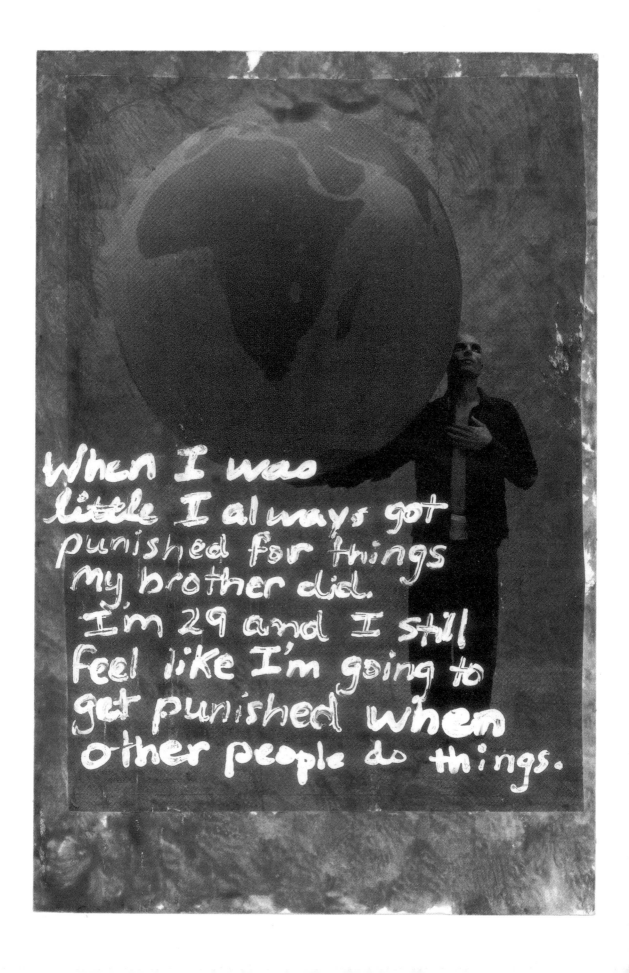

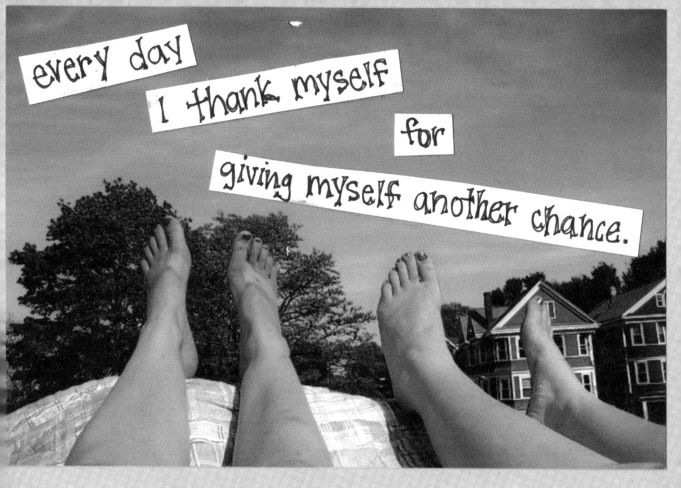

every day

I thank myself

for

giving myself another chance.

...eare Elizabeth Barrett Browning

I am an English teacher.
My students all made PostSecrets and wrote poems about their secrets.
I sent all their secrets to you, but I kept all the poems.
They are the most beautiful poems I have ever read.
(I love my job)

...ord Cennyson

Walt Whitman

John Keats William Wordsworth Langston
Hughes Percy Bysshe Shelley Anne Bradstreet
W.H. Auden James Wright William Butler
Yeats Edna St. Vincent Millay Ezra Pound
Sylvia Plath Geoffrey Chaucer T.S. Eliot Emily
Dickinson Seamus Heaney Homer William
Carlos Williams Dante John Donne Edgar
Allan Poe e.e. cummings William Shakespeare
Elizabeth Barrett Browning Paul Laurence

YOU ARE INVITED

FOR *I didn't really*

DATE *have a*

TIME *"work emergency."*
I just didn't

PLACE *want to face our*
old classmates

GIVEN BY *at your*
wedding.

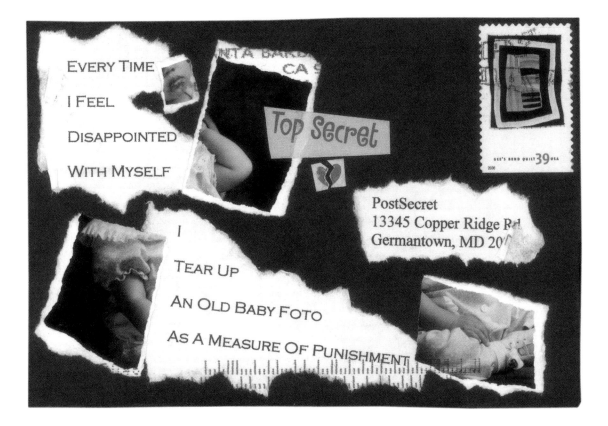

EVERY TIME

I FEEL

DISAPPOINTED

WITH MYSELF

Top Secret

I

TEAR UP

AN OLD BABY FOTO

AS A MEASURE OF PUNISHMENT

PostSecret
13345 Copper Ridge Rd
Germantown, MD 20

I will never miss anything more than this...

I wish I could interview your ex-wife and find out why she left

And see if they are the same reasons why I have considered leaving...

If it weren't for you...

I would never have studied another language for five years and
I would never have moved to Germany.

Even though you broke my heart...
Even though my fairytale will never come true... I still have to say

Danke.

I hope that someday
he'll bury an engagement ring
in the dirt for me to find!

i'm too scared of being alone to hold out for the best.

My mom had an affair with the first boy I ever kissed and I don't know who I'm more EMBARASSED for - me, him or her. ???

i have a void that can't be filled.

(not even by you)

my best friend once used me as an example of a "NON-TORTURED" artist. I could never bring myself to correct her.

Though my closest friends say they believe,

WRITING THE

BROADWAY

MUSICAL

I know I am
the <u>only one</u>
who truly believes
I can & will create
a great Broadway Musical
before I die!

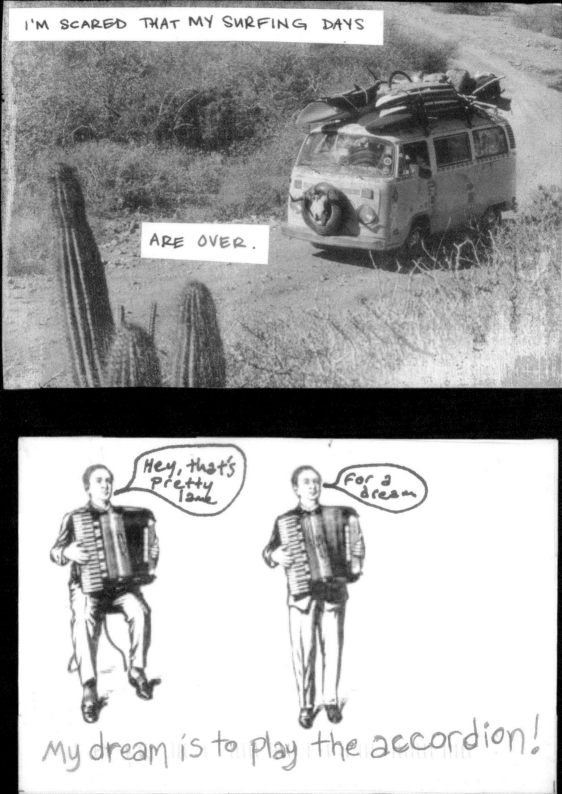

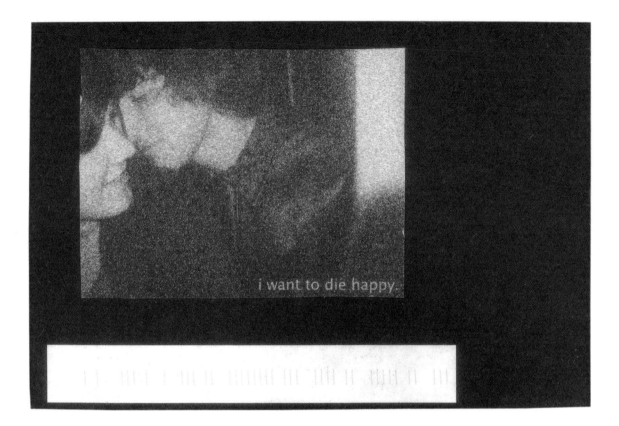

i want to die happy.

Do you want to know a secret?

I Am comforted by the Availability of Suicide

I'm finally on my way to becoming everything I've always wanted to be, especially MYSELF!

-----Email Message-----

My boyfriend and I knew we had to do something important or else our relationship would fall apart. So we took markers and wrote our deepest secrets on each

other's backs. I never read his secrets, and he never read mine, but the perilousness of such close contact between us and the other's demons was what we needed to save our relationship.

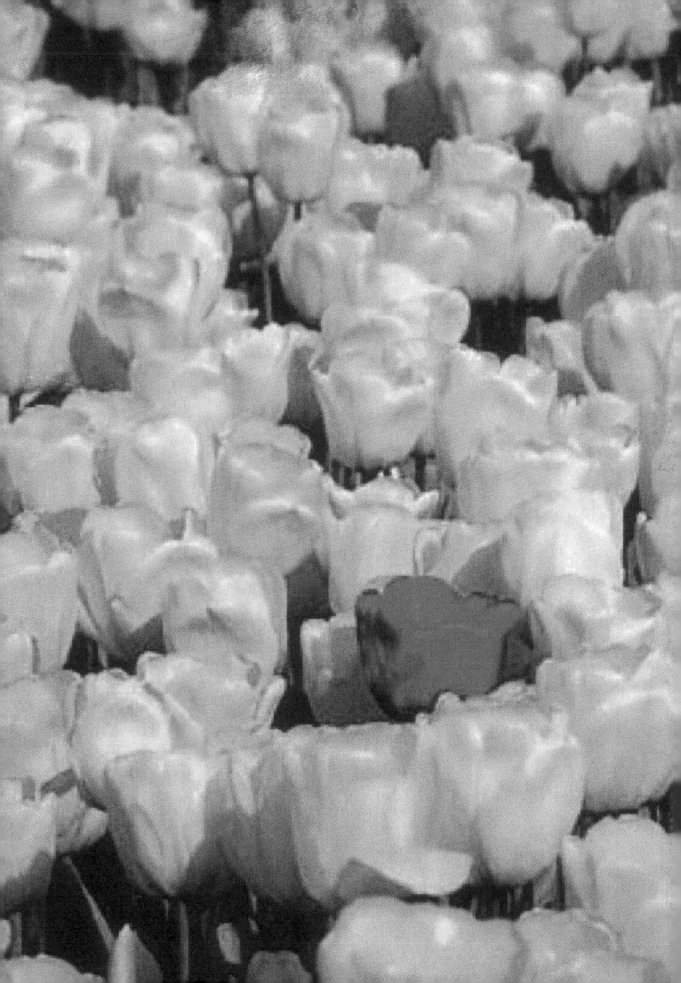

And no one knows except me.

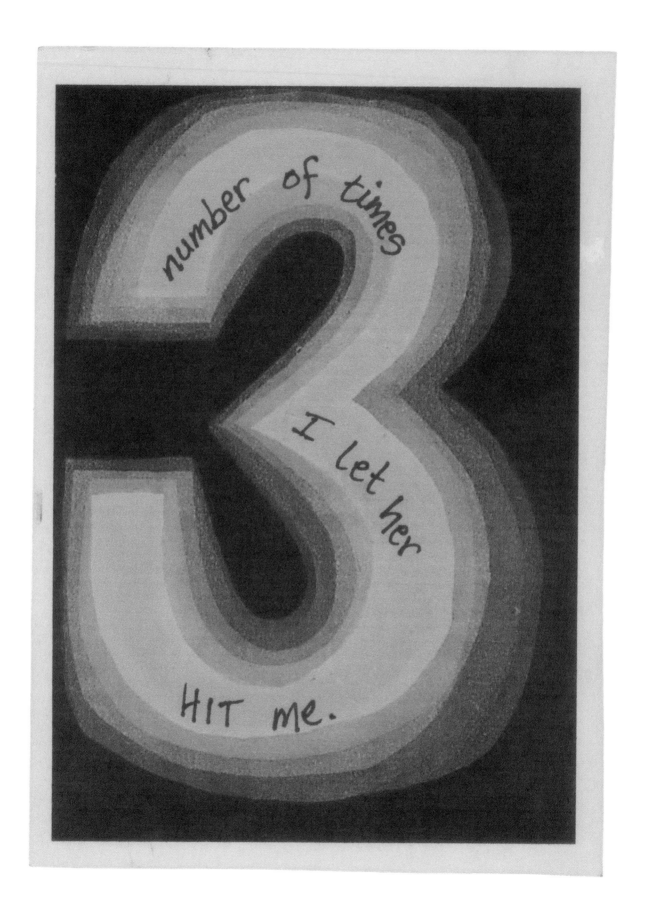

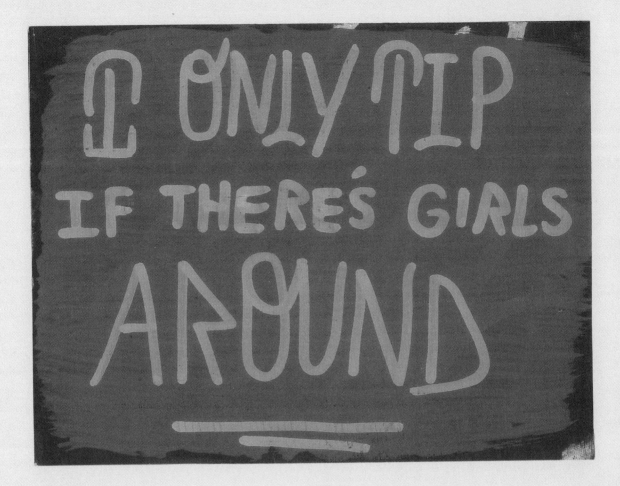

This morning I found a **WHITE** Pubic Hair !!!
(I'm only 33)

I MOVED HERE WITH A
MAN I DIDN'T LOVE SO
I WOULDN'T HAVE TO
ADMIT TO MY PARENTS
THAT THEY WERE RIGHT.

AND I STAYED FOR A
YEAR AND A HALF.

TULSA OK 743

03 DEC 2005 PM 5 L

GEORGE BALANCHINE
37 USA

PostSecret
13345 Copper Ridge Rd.
Germantown,
Maryland
20874

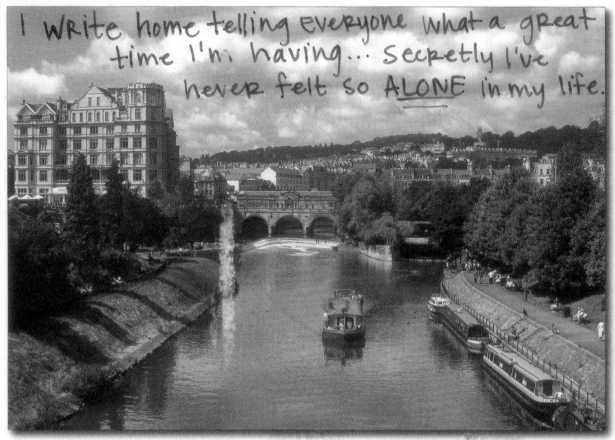

I write home telling everyone what a great time I'm having... Secretly I've never felt so ALONE in my life.

Bath

i always thought i'd travel alone, but things have changed

Let's go

Roma - Il Colosseo

I write songs about killing myself and play them for audiences that think they're about breakups and run-of-the-mill sadness. I just want someone to understand. Maybe then I wouldn't feel the need to write them.

Watching my husband play his guitar at church turns me on so much...

it distracts me from worshipping God.

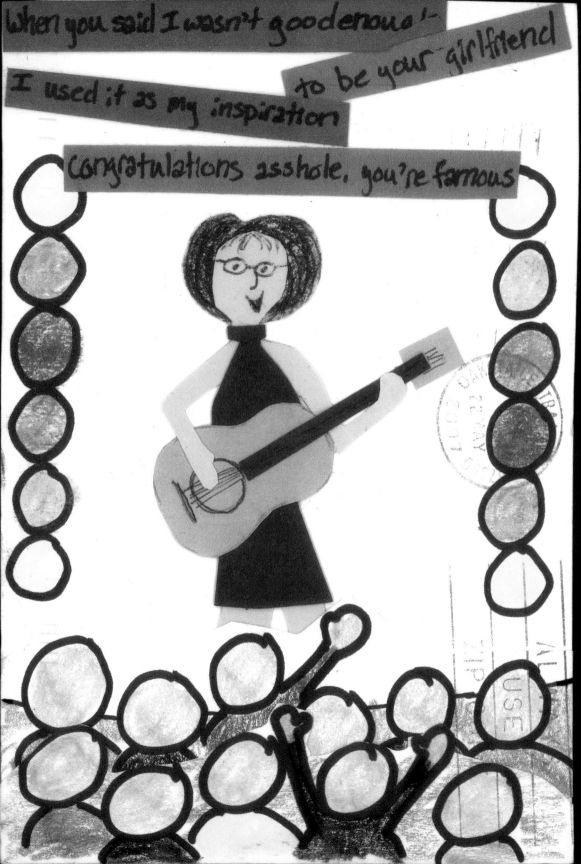

You probably forgot
how shitty he
made you feel.
Good.
You're worth being
happy.

JOHN LENNON & YOKO ONO
THE DAKOTA, NEW YORK CITY, DECEMBER 8, 1980
PHOTOGRAPH BY © ANNIE LEIBOVITZ

PROCEEDS FROM THE SALE OF THIS CARD DONATED TO AIDS ORGANIZATIONS

USA 39
2006

USA 39
2006

fotofolio.com

To:
Post Secret
13345
Copper Ridge Rd.
Germantown,
MD
20874

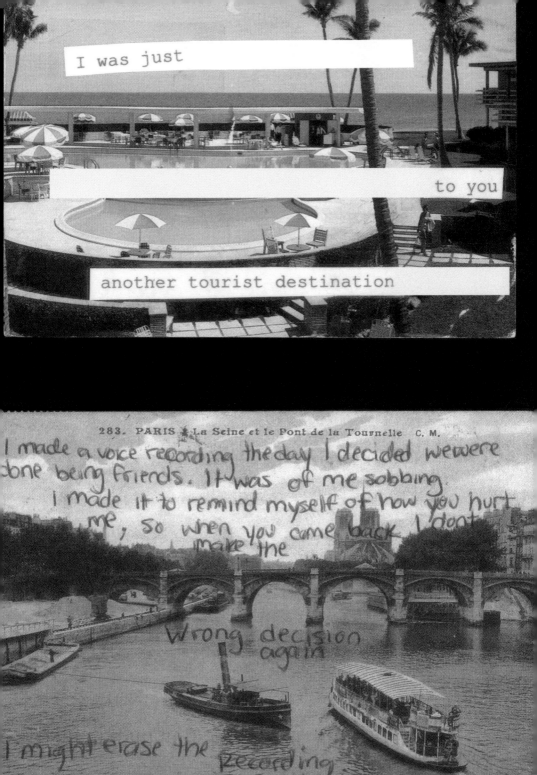

I was just

to you

another tourist destination

283. PARIS — La Seine et le Pont de la Tournelle C. M.

I made a voice recording the day I decided we were done being friends. It was of me sobbing. I made it to remind myself of how you hurt me, so when you came back I dont make the wrong decision again

I might erase the recording

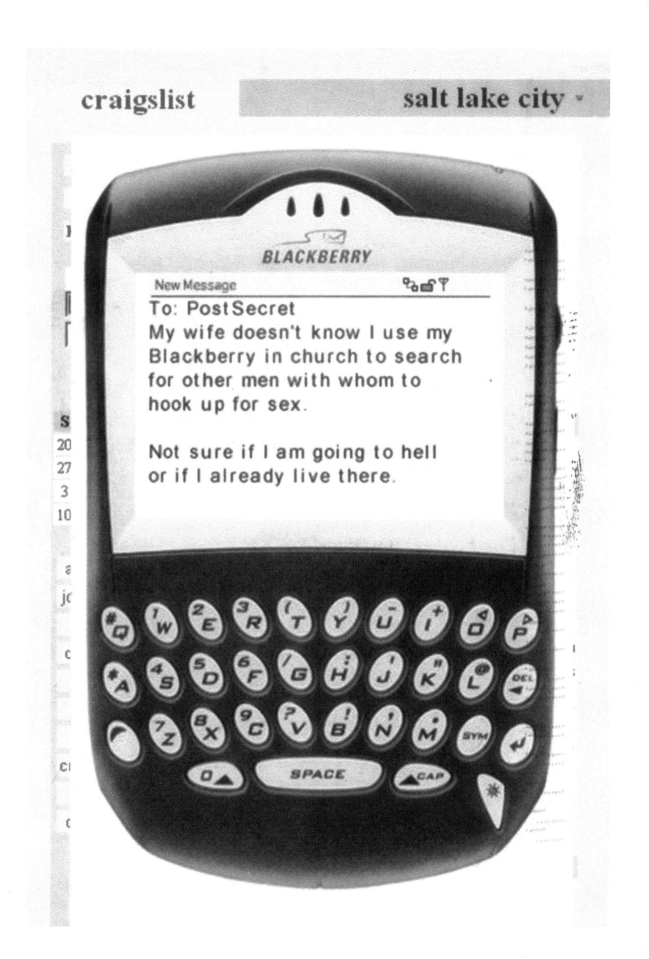

290A

290A-1 P
Angel Food

290A-2 U
Country Lane

290A-3 U
Fall Straw

There's a secret I can't bear to write.

But this card represents it.

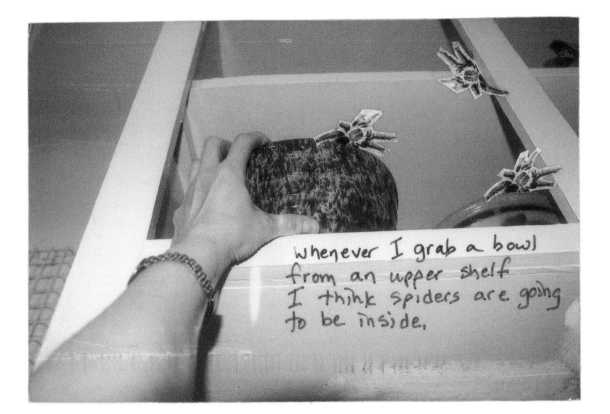

whenever I grab a bowl from an upper shelf I think spiders are going to be inside.

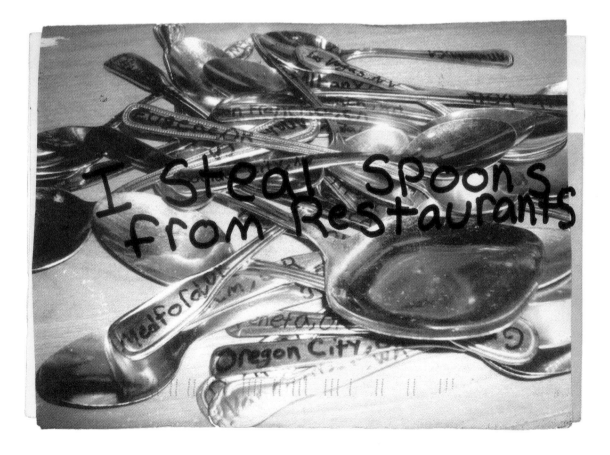

I steal spoons from Restaurants

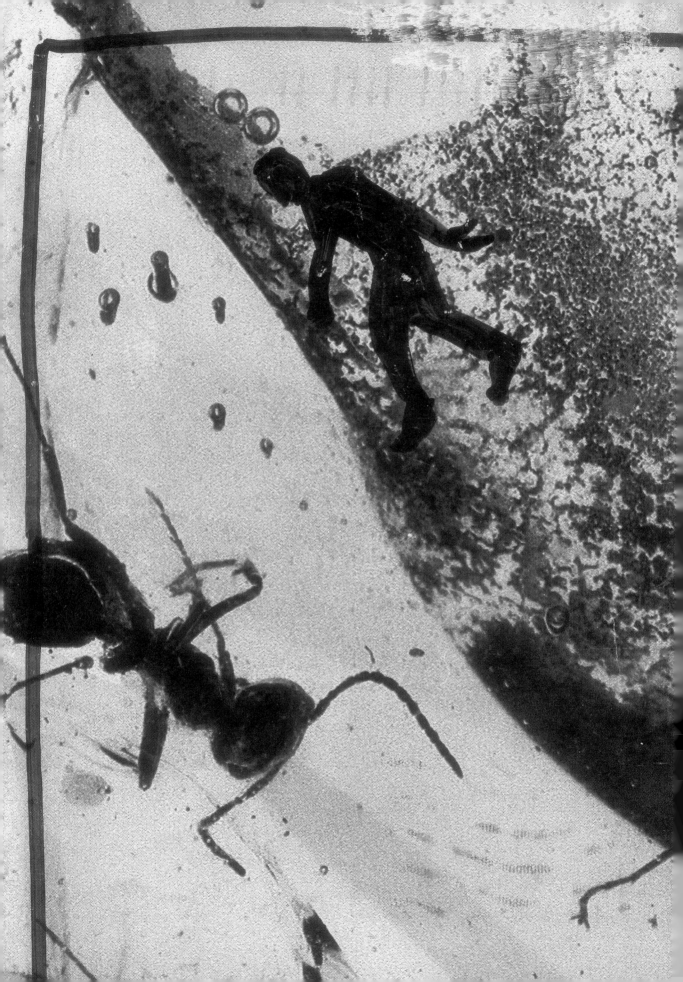

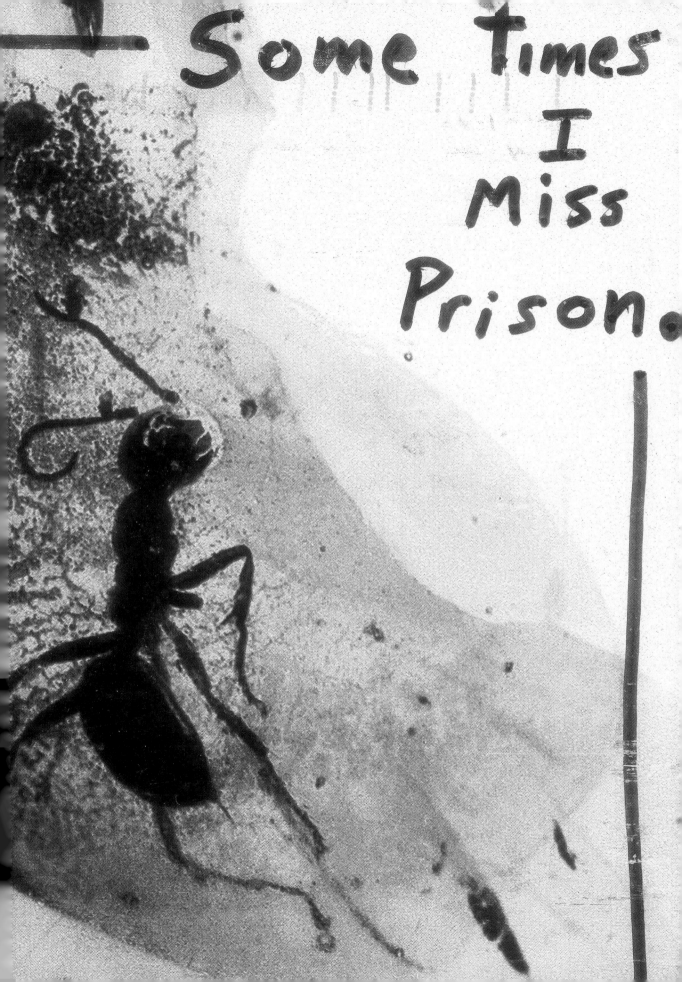

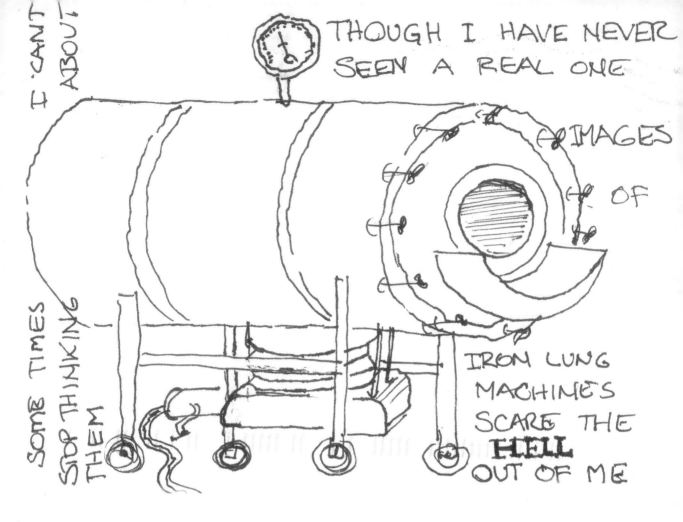

I CAN'T ABOUT

THOUGH I HAVE NEVER SEEN A REAL ONE

IMAGES

OF

SOMETIMES STOP THINKING THEM

IRON LUNG MACHINES SCARE THE **HELL** OUT OF ME

I eat spicy foods so that
it will hurt on the way back up.

I couldn't stop sobbing or look the nurses in the eyes during my 1st cervical exam.

They didn't understand, kept demanding " HAVE

YOU BEEN SEXUALLY MOLESTED."

FIG. 64.—BIMANUAL EXAMINATION OF PELVIC VISCERA.

Third and fourth fingers flexed upon palm and pelvic floor invaginated, adding an inch or more to length of fingers. Left view.

All I could choke out was "I don't know, I don't know!"
Ever since I've been wondering the same thing myself

I like to put a porn movie on really loud

And watch the golfers reactions

Just because I try not to talk
about it...
 does not mean I'm over it,
 that I feel better,
 or that I'm ever going to be okay.

I just don't want to be a
BURDEN.

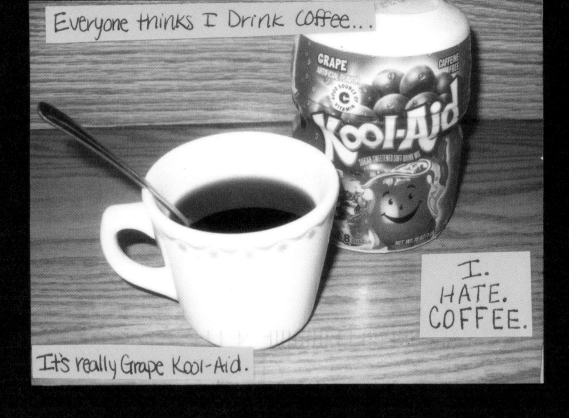

Everyone thinks I Drink Coffee...

I. HATE. COFFEE.

It's really Grape Kool-Aid.

PANTONE® 376 C

PANTONE® 295 C

I am a designer, but most of the time I feel like I'm faking it.

it sucks having your dad go to jail
when you are only in sixth grade

i still hold it against him..

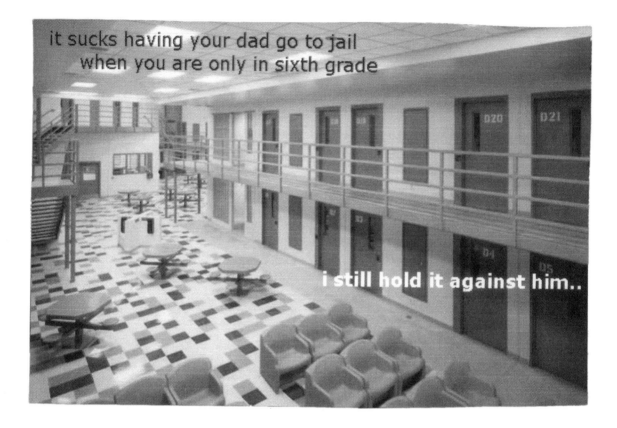

I'm glad he isn't alive to see me as a lesbian.

#1 Dad

I'm not ashamed ... but HE would be.

I Wish I Could Be

Someone's Hero

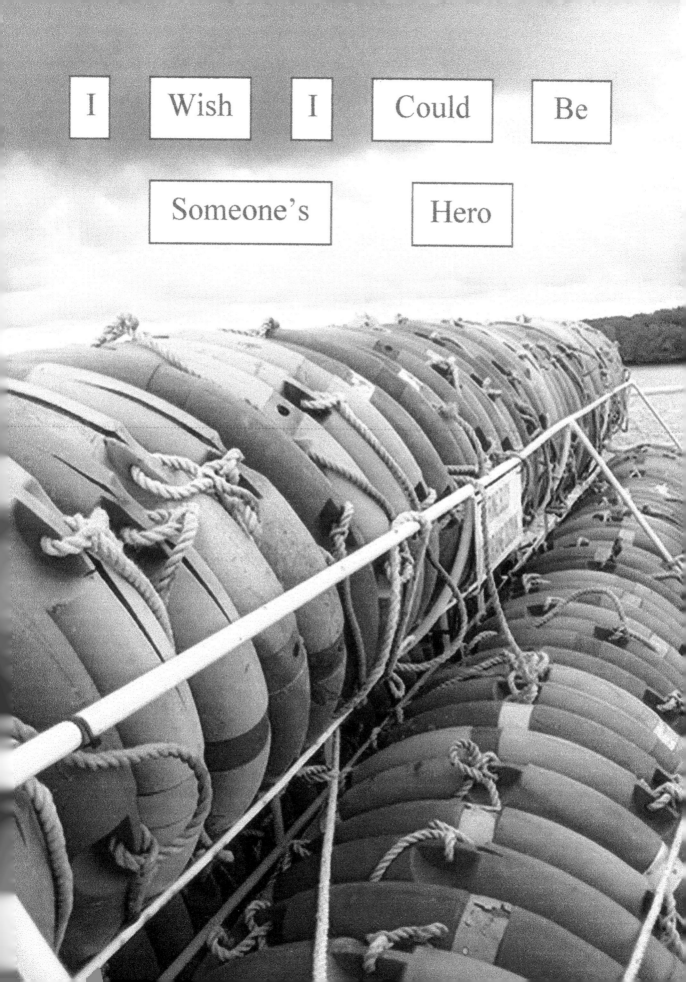

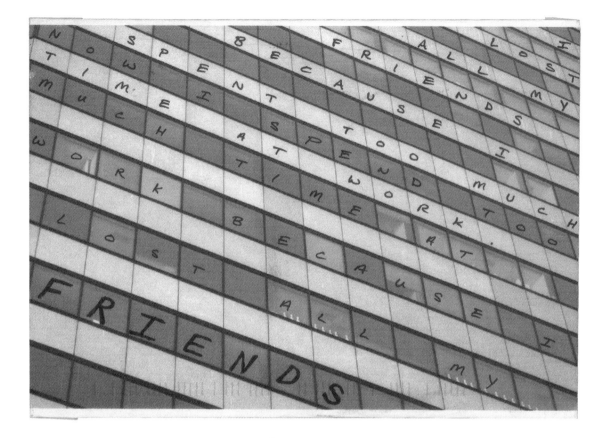

I LOST ALL MY FRIENDS BECAUSE I SPENT TOO MUCH TIME AT WORK. NOW I'M SPENDING MUCH TOO MUCH TIME AT WORK BECAUSE I LOST ALL MY FRIENDS

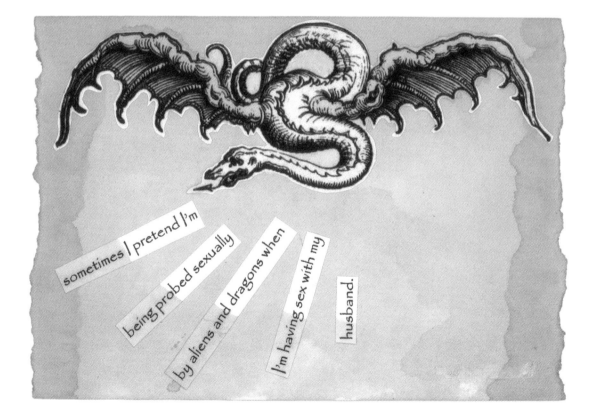

sometimes I pretend I'm being probed sexually by aliens and dragons when I'm having sex with my husband.

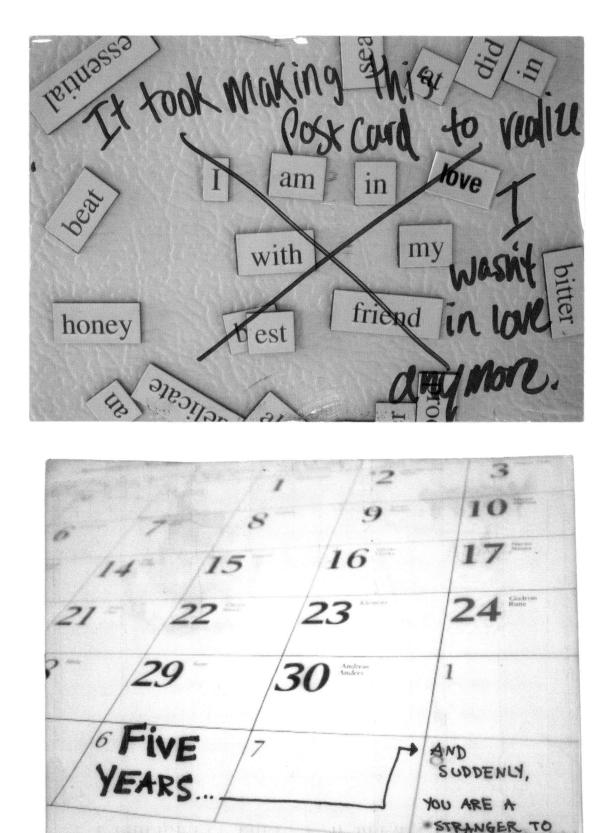

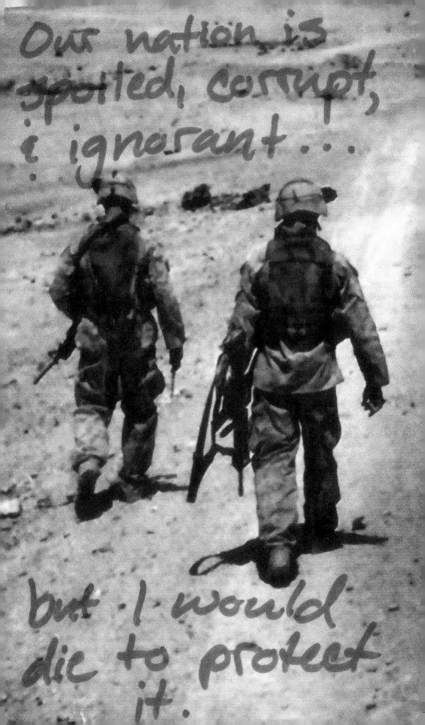

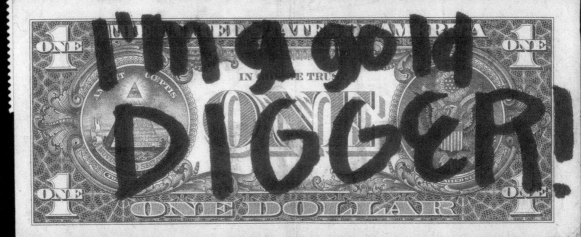

Every month I give away $100.00 anonymously

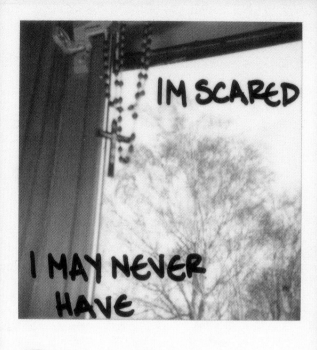

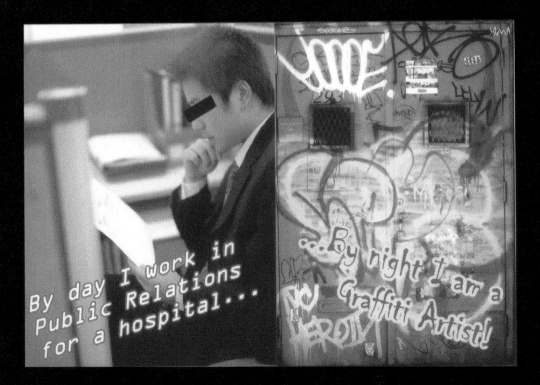

I can't decide if I've stayed in the same job for ten years

because of loyalty, stupidity, laziness, or fear.

STATE OF OKLAHOMA
CERTIFICATE OF DEATH

STATE FILE NUMBER

2. SEX	3. SOCIAL SECURITY NUMBER	4. EVER IN US ARMED FORCES?
M	NOT AVAILABLE	☐ Yes ☒ No

7. BIRTHPLACE (City and State or Foreign Country)

(Mo/Day/Yr) OKLAHOMA CITY, OKLAHOMA

8c. RESIDENCE-City or Town	8d. RESIDENCE-Zip Code	8e. RESIDENCE City Limits?
MOORE	73160	☐ Yes ☐ No

I NEVER KISSED MY SON

10. SURVIVING SPOUSE'S NAME (if wife, give name prior to first marriage)

☐ Unknown

AFTER HE WAS BORN

 one or more races to

(check the box that best describes the highest degree or level of school completed at the time of death.)

☐ 8th grade or less

☐ 9th – 12th grade, no diploma

Native

(Name of the enrolled or principal tribe)

☐ High school graduate or GED completed

☐ Some college credit, but no degree

☐ Associate degree (e.g. AA, AS)

BECAUSE HE WAS SICK

☐ Bachelor's degree (e.g. BA, AB, BS)

☐ Master's degree (e.g. MEd, MA, MS, MEng, MSW, MBA)

☐ Doctorate (e.g. PhD, EdD) or Professional degree (e.g. MD, JD)

NOT USE RETIRED.) | 17. KIND OF BUSINESS / INDUSTRY

, Zip Code)

AND I WAS SCARED RE, OKLAHOMA 73160

OF DISPOSITION (name of cemetery, crematory, other place) | 21. LOCATION – City, Town and State

HE DIED 2 HOURS LATER....... N, OKLAHOMA

FOR OR FAMILY MEMBER ACTING AS SUCH

24. FH ESTABLISHMENT LICENSE #

OF DEATH (Check only one: see instructions)

HER THAN IN A HOSPITAL:

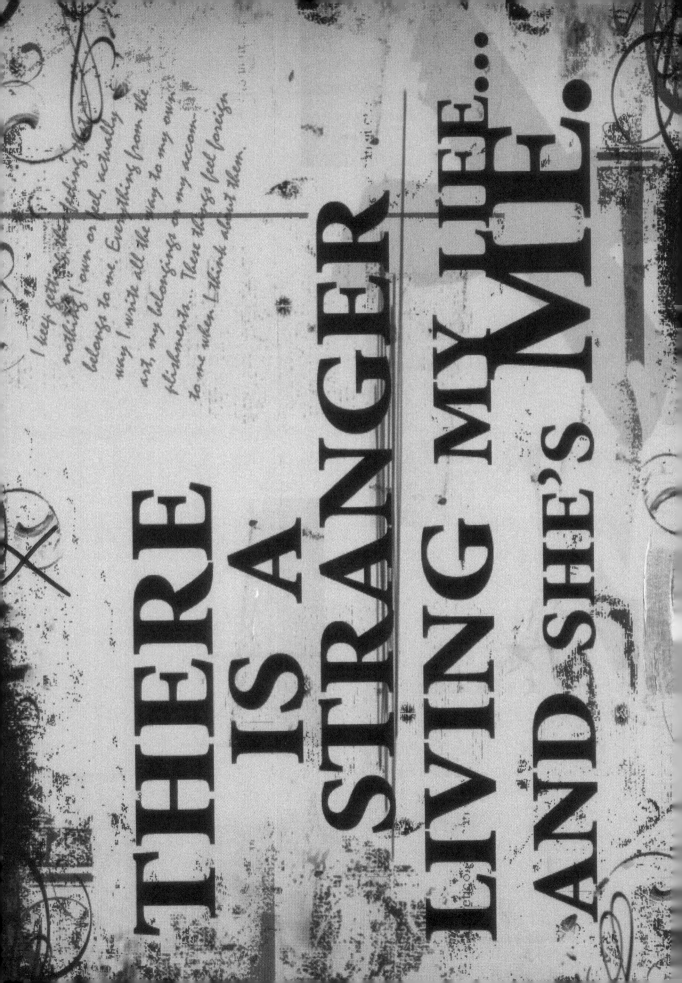

THERE IS A STRANGER LIVING MY LIFE... AND SHE'S ME.

I keep getting the feeling that nothing I own or feel, actually belongs to me. Everything from the way I write to the way to my own art, my belongings to my accomplishments... These things feel foreign to me when I think about them.

FOR NEW YEARS I DID NOT
GO ON A DIET INSTEAD I
THREW AWAY MY SCALE
ITS THE BEST RESOLUTION
I HAVE EVER MADE

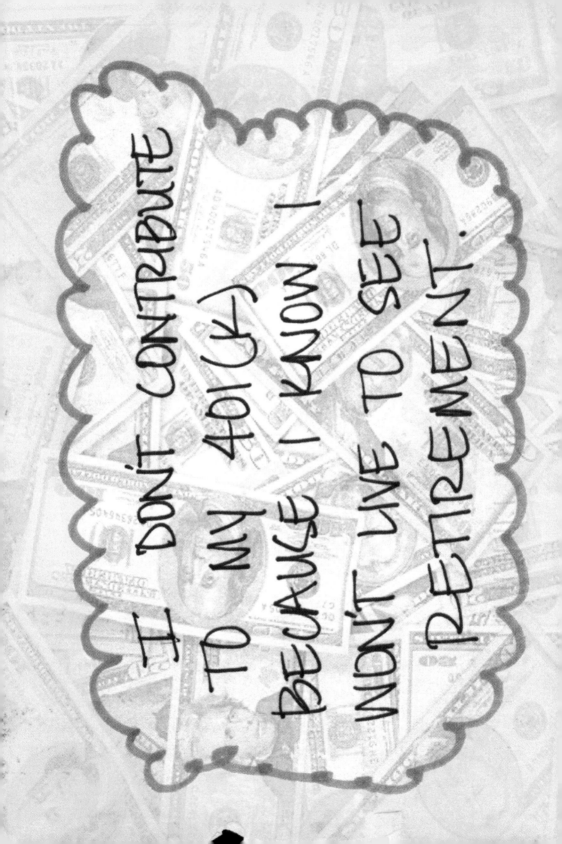

after sending
in my secret,
i don't feel
liberated,
released,
or more free.

i feel like i am just a
little bit emptier.

because
with so many secrets,

i don't know who i am
without them.

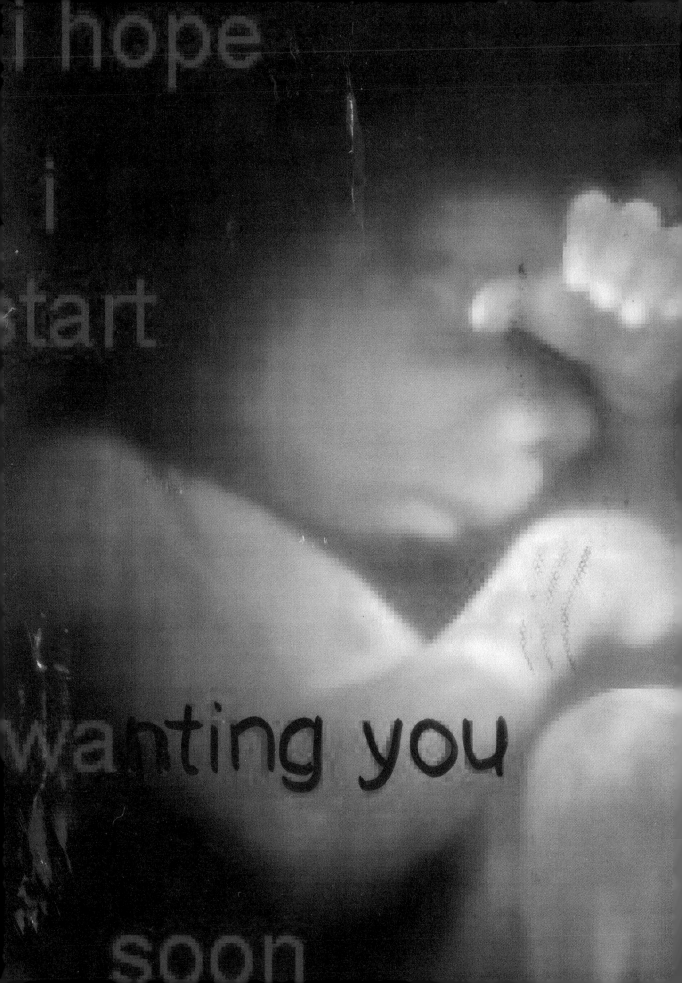

I am almost 40. I have average hair, an average body and average looks. As a result, I am invisible. No one ever notices me.

Everytime I go shopping, I steal something. A pack of gum or a $50 bottle of perfume.

If I'm buying something, you can be assured that I've taken something of higher value. I don't even try to be sneaky about it. I just pick what I want, put it in my pocket, and walk on.

Because I am invisible, nobody sees me or what I take.

I live in fear that I will be caught.

And that I won't.

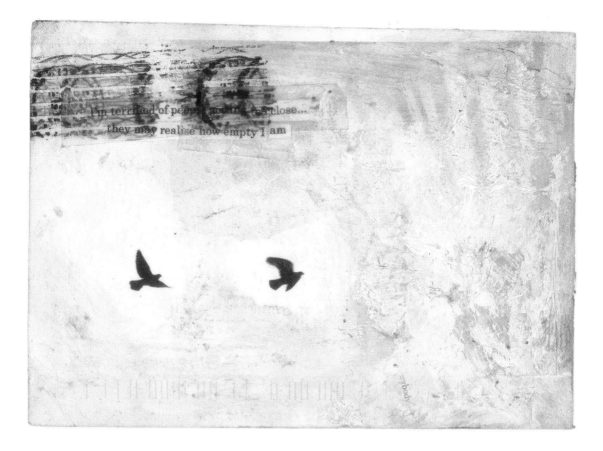

I'm terrified of people getting too close...
they may realise how empty I am

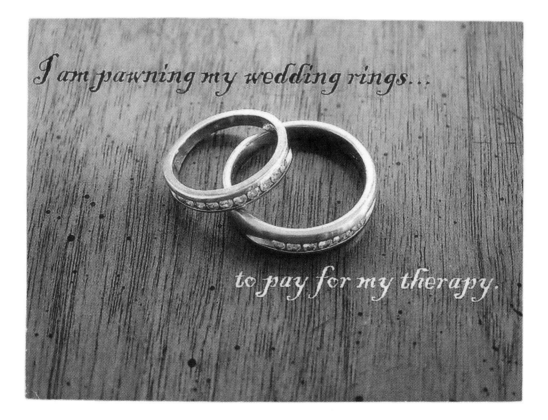

I am pawning my wedding rings...

to pay for my therapy.

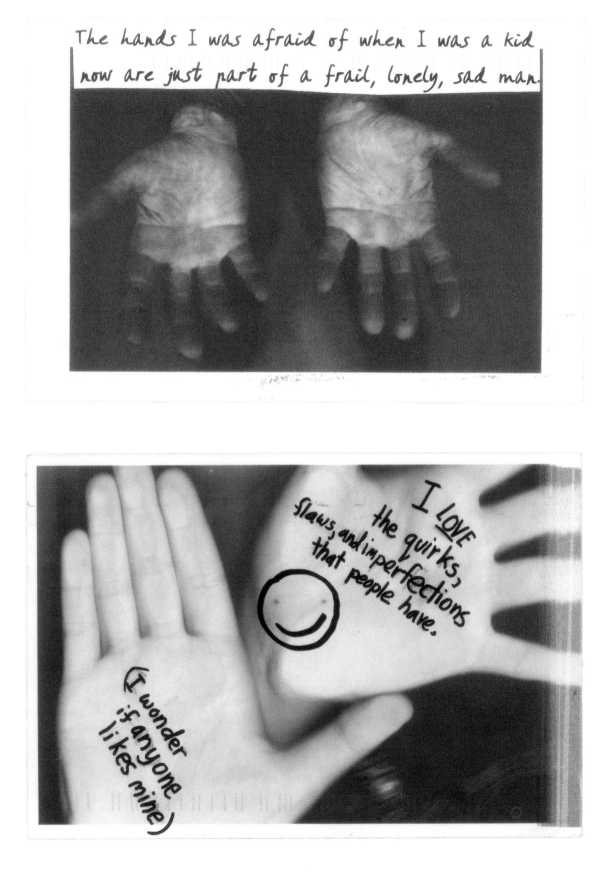

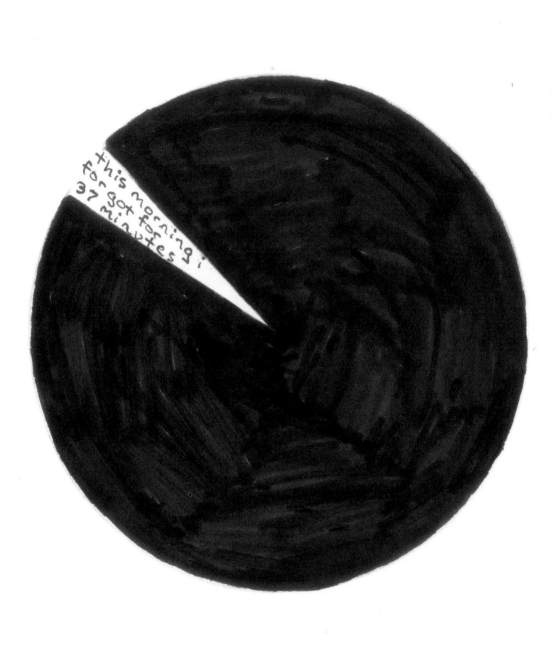

i'm trying so hard
to remember that
Life is
Beautiful.

Some day

I'VE GIVEN UP
HOPE THAT MY
SHRINK WILL
EVER FIND THE
RIGHT DOSAGE
OR COMBINATION
OF MEDS.

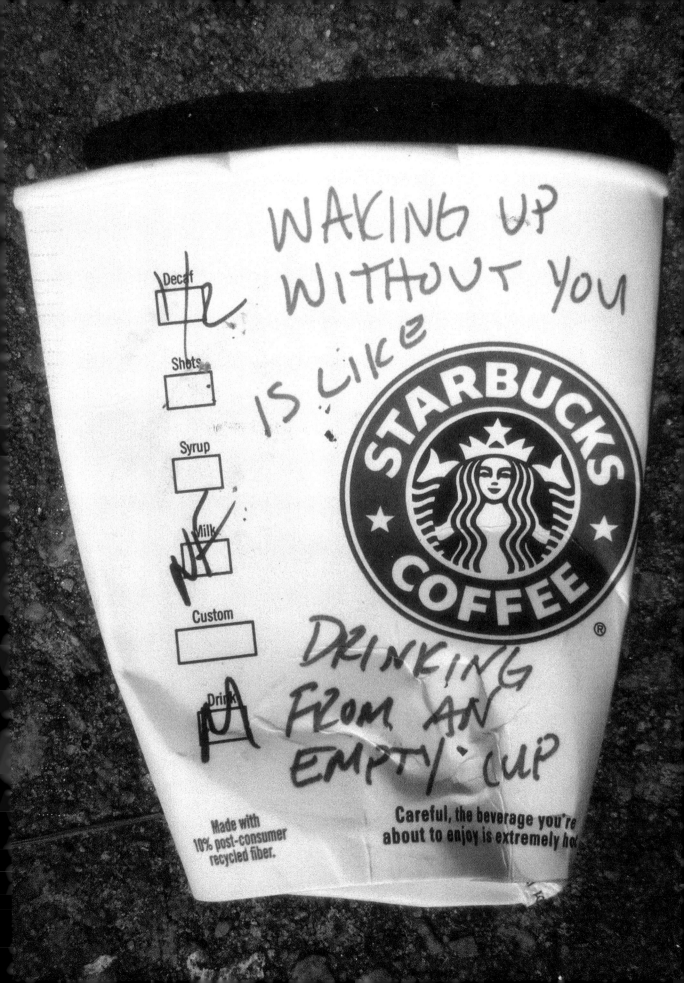

I took all the gifts you ever gave me and -shop window ledges· cafe tables· 7-11·

left them in public places around town. ·shelves at the grocery store· laundromat·

I like to think of how the people who ·by the sink in the restroom· gas pump·

picked them up felt lucky to find them. ·on a stack of returned books at library·

I know I feel lucky to be rid of them. ·ticket counter at the movies· post office·

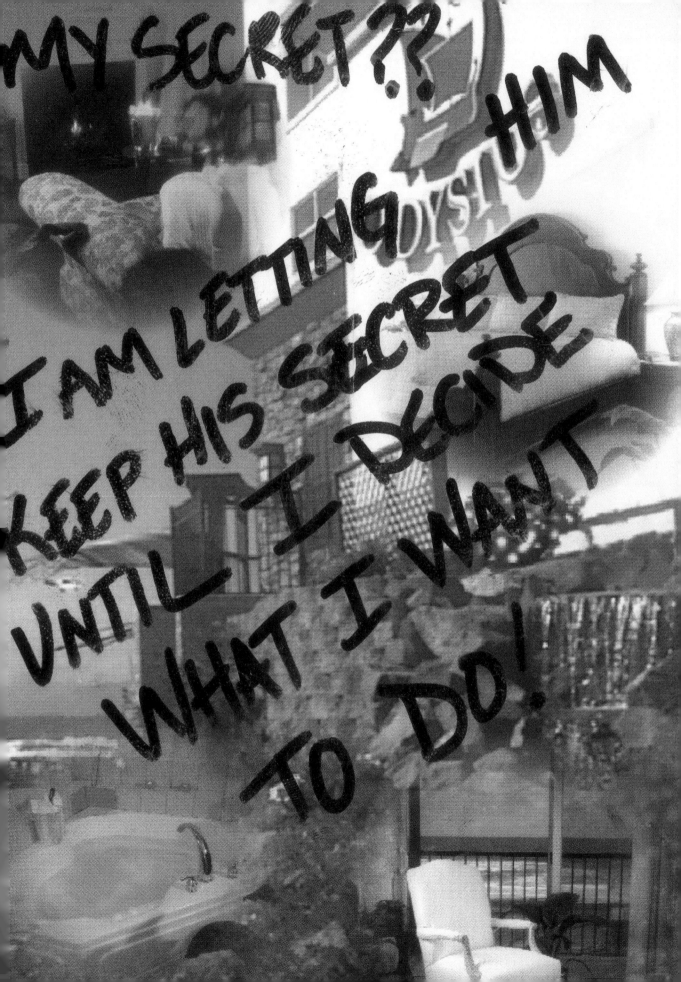

My firm forges client signatures
on documents.

I
Hate
My
Wife

My 10-yr-old
wrote this.

When I found
it I cried
because I don'
Know how to
fix it.

I'm failing
her.

1. Splatty
2. Poopy Gravy
3. Shit Cannon
4. The Shart
5. Ya Ol' Fuckpole
6. Dingleberry Tree
7. Farty Fanny
8. Diarrhea
9. Odor

These are the code names my best friend and I use when we talk crap about our family members. We are grown women with jobs and children.

Recipe for: INDEPENDENCE Serves: 1

Today I'm scheduling my first appointment with a therapist. This is **MY** life. I am no longer content living in a shadow.

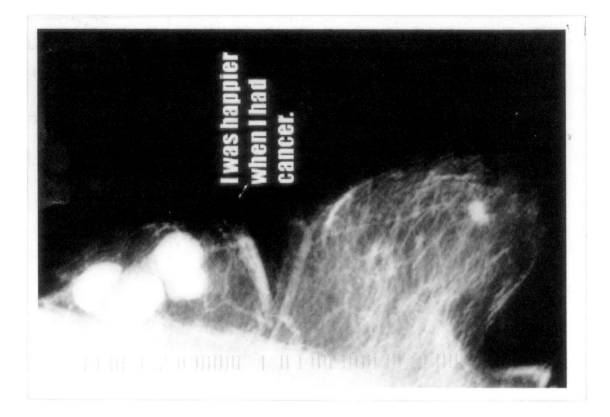

To my cancer —
You better not Kill me
before I get a chance to be
a spinal surgeon.

almost a year ago

thank you for always believing that i could feel better

—tried to kill myself.

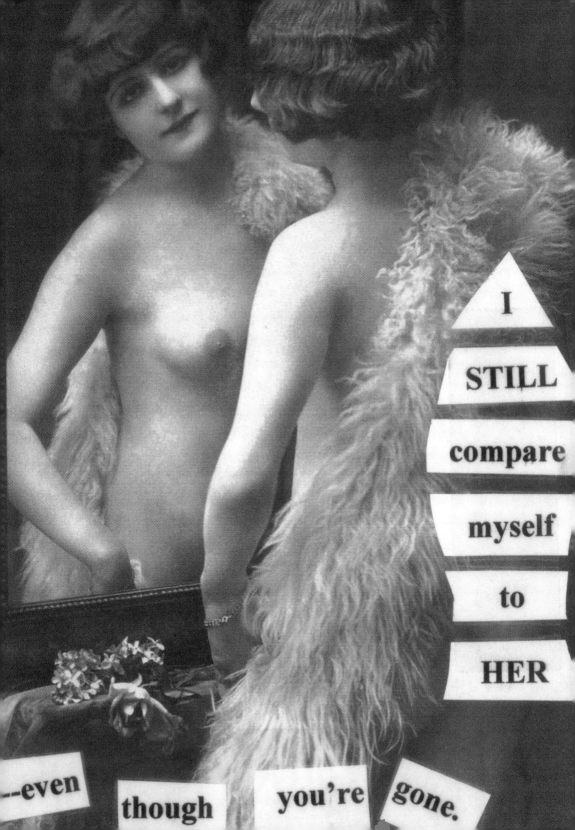

i've spent all this time making up in
personaility what i felt i
lacked in beauty.

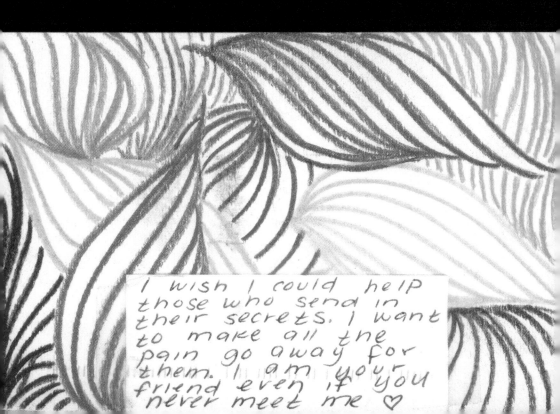

I wish I could help
those who send in
their secrets. I want
to make all the
pain go away for
them. I am your
friend even if you
never meet me ♡

I've had a PostSecret card in my bag for weeks. I kept meaning to send it in but just never seemed to get around to it. So I stuck it to the wall of a public rest room. I had a feeling of relief wash over me—it was wonderful to know the next person to use the bathroom would know my secret, and a tiny part of my burden was gone. Just out of curiosity I went

back in there at the end of the day. To my delight there were at least ten other secrets on the wall, all on pink Post-it notes, ranging from someone who had helped her elderly neighbor take an overdose when Parkinson's had got too much to cope with, right down to the lady who can't walk past cans of fizzy drink without shaking them up.

What a wonderful feeling!

P.S. I'm the fizzy drink lady.

I am an editor for a large online atheist newsletter... and I believe in GOD!!!

POSTSECRET

13345 COPPER RIDGE ROAD

GERMANTOWN

MD 20874 - 3454

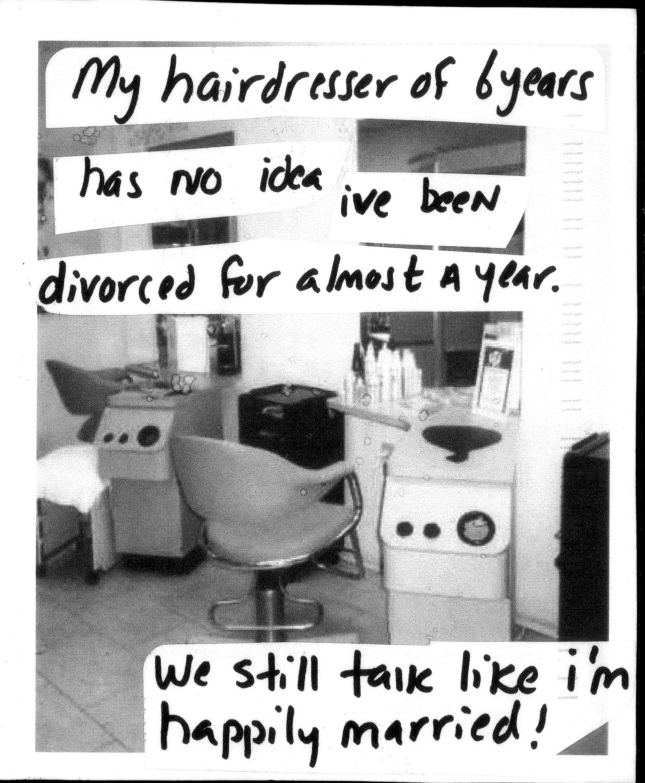

When I married my husband I knew *he* was the
luckiest guy in the world.....

17 years later, I've discovered that I am the
lucky one...

you are the worst thing
that ever happened to me...

...and I miss you so much

when we were in 2nd grade you said I

LOVELY ON THE INSIDE

walked like a chicken and

that I was fat

I STILL HATE YOU

and I still think I'm fat.

You're my wife's best friend,

Taxpayer Name	2. Business Name
You're manipulative,	arrogant, and don't

You're made me

Street Address	a. Street Address
want us to stay	married.

City/State/ZIP	b. City/State/ZIP
You've made me	so angry over

Social Security Number (SSN)	c. Employer Identification Number
the years.	I don

Occupation	d. Principal Bus Activity
know how to get back	at you,

Date of Birth	
so maybe this	

Marital Status
☐ Married ☐ Single ☐ Head of Household
☐ Divorced ☐ Separated

3a. Name of Spouse

will work.

Alleged Violation of Income Tax Law (Check all that apply).

False Exemption	☐ Unsubstantiated Income	☒ Unreported Income	☒ Failure to
False Deductions	☐ Kickback	☐ Narcotics Income	☐ Wagering
Multiple Filing	☐ False/Altered Documents	☐ Public/Political Corruption	☐ Earned In
Organized Crime	☒ Failure to Pay Tax	☒ Failure to File Return	☐ Other (Des

Unreported Income and Tax Years (Fill in Tax Years and dollar amount(s). if known. e.g.. TY2005 $

OH GEEZ! YOU'RE INVITED TO MY BIRTHDAY PARTY!!

i really miss these.

ho? ▓▓▓▓▓▓▓

hat? A SLUMBER PARTY! How cool is that! And then church in the morning.

here? My Casa! ▓▓▓▓▓▓▓▓▓▓▓▓ Ask if you don't know how to get there!

hen? This Saturday and Sunday. September 16th - 17th.

ny? To Celebrate ▓▓▓▓▓▓ Birthday!! Yay!

ne? 7:00 Saturday to 2:00 on Sunday

ing? MUNCHIES!! The necessities and something to wear to church and some dark clothes that
d hide you in the dark. And anything else you could possibly think of. =]

▓▓▓▓ ▓▓▓▓▓ & ▓▓▓, P.C.

TIME SHEET

	DATE		HOURS
DESCRIPTION OF SERVICES			HOURS
RIGHT NOW A CLIENT IS PAYING $225/HOUR FOR ME TO THINK ABOUT HOW BEAUTIFUL YOU ARE & HOW MUCH I LOVE YOU!			

This is the letter
that I'll never
have the guts
to send to you.
And
the one that
I'll regret
for the rest
of my
life.

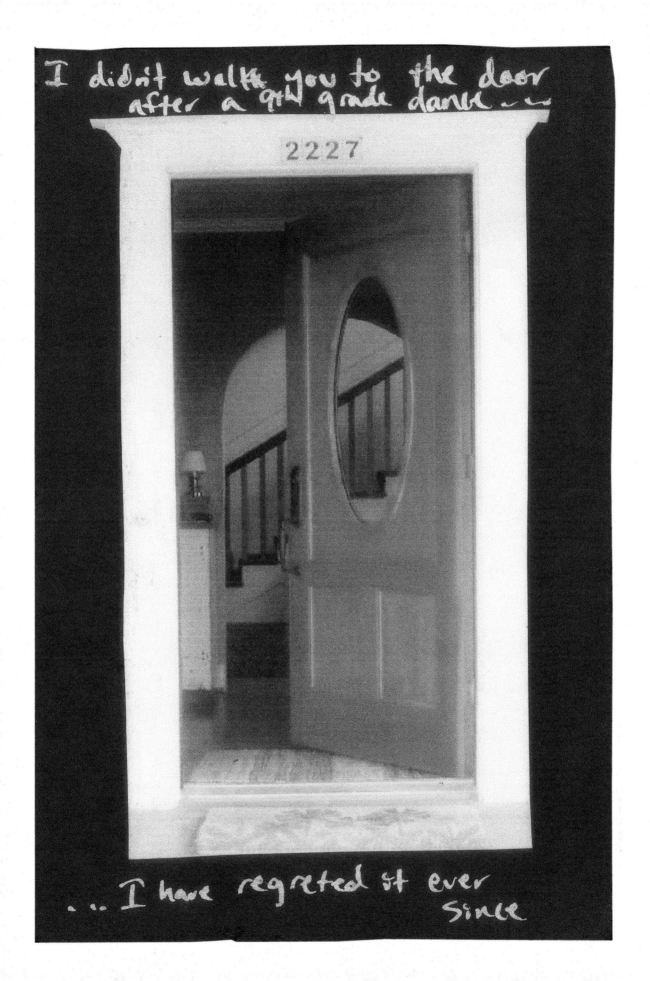

For decades critics have pigeonholed Madeleine L'Engle as a "Christian author", using the phrase as a judgment on her writing style and literary themes rather than a description about her as a person. L'Engle herself refutes this label, believing that Jesus was sent as a human example of how to live and that "a lot of Christianity today, organized Christianity, [she has] hardly heard of it . . . ester). Through the analysis of two of her best-known works *A Wrinkle in Time* and *A Wind in the Door*, I postulate that L'Engle . . . on by incorporating and accents . . . transcends religious, denominational boundaries. Dean Hughes says that "[t]here is a difference between a book that . . . hes on religious themes and a religious book" (14) accept a book may use or put forth religious ideas without being "Christian"—these two books clearly illustrate. L'Engle achieves this extraordinary mix through a combination of characterization and themes that relative confine of [?] include theory and a morality based of this point. "Christian" w that of the church is liberal without regard to denominational difference Fundamentalism a more restrictive form that implies acceptance of the Bible as historical, factual and literal. Some critics consulted fall into these categories themselves, while others use the terms in an attempt to categorize the messages of the books or describe the audience to which they might appeal. I believe nature of the stories helpful for the reader that may not be familiar with these texts. *Wrinkle* is the girl with and her younger brother Charles Wallace, a school friend named Calvin and a creatures Mrs Whatsit, Mrs Who and Mrs Which. They travel by means of a *tesser*, or "wrinkle", to save Meg and Charles Wallace's father from the dystopian planet Camazotz, which is covered by the Dark Thing, a shadow that disrupts the harmony of the universe. In the course of rescuing her father, Charles Wallace becomes a servant of IT, a human brain that does all the thinking for the planet. Meg goes back to save Charles Wallace by means of the one thing IT does not have – Love. *Wind*, published in 1973, continues the story. Meg and Calvin again join forces, this time accompanied by a time and space traveling "teacher" named Blajeny, a cherubim (singular) called Proginoskes, and the school principal Mr Jenkins, to save Charles Wallace who is seriously ill. Their 'mission' is a result of a medical problem with Charles Wallace's cells; within human cells are mitochondria and within the mitochondria are infinitesimal, independent cells called farandolae. Charles Wallace's farandolae refuse to mature or "root", thus causing his mitochondria to die. Meg and her friends are sent within Charles Wallace's mitochondria with the purpose of convincing the farandolae that if they do not root, Charles Wallace, and ultimately the farandolae themselves, will die. A major feature of these books is the roles of women. At the time *Wrinkle* was published, strong female characters were unusual, yet Meg uses both her strengths and weaknesses to succeed in freeing her father and brother. One reason for strong feminine characters was, as Ms L'Engle stated, 'I'm a female. Why would I give all the best ideas to a male?" (Edwards Award Speech). Meg's mother Mrs. Murry is a scientist like her husband and another unique female character for the time. The reader learns over the course of the two novels that not only does she hold two Ph.D.s but has won the Noble Prize in Physics. Carol Chase commends these anti-stereotypical views of early '60s women in a letter to L'Engle: I have become exquisitely aware of the fact that your books are woven out of all the little odd ideas, and dreams that make up the . . . pages of . . . of the theologic psychological logical fields . . . identif[y] feminist reality and is exclude Christianity classified of a product of the Christian faith. In fact, L'Engle's very feminist view of God as "*above gender*" (126) has also been a source of controversy. Because Biblical references give God a masculine identity, fundamentalist Christians categorically reject this view of the Deity and have used her statement as a source of controversy and denigration of L'Engle's work. William Blackburn sees *Wrinkle* as one with "moral issues . . . which "faces ethical . . . plus inevitably psycholog[ical] issue" "religion makes a that same as "Christian the contrary morality might be seen as linked to the particularly secular definition of what it is to be "American". In both *Wrinkle* and *Wind* Mr Murry works for the highest levels of American government, and although his work creates great stress on his family due to his absence (he was gone almost a year in *Wrinkle* and takes trips in *Wind*), the family stoically bears that stress because they are "very proud of him" (*Wrinkle* 49). In *Wrinkle*, Meg quotes the Declaration of Independence as a method of IT, and Charles Wallace being beaten up at school, more than once she claims that because "[t]his is the United States of America. They can't hurt him if somebody doesn't do something" (58). Blackburn disagrees with Meg's patriotic, if somewhat naive assessment, seeing American patriots in religious terms and stating "The possibility of a totalitarianism of the Lord's Chosen, i.e, a totalitarianism of the American right, never casts so much as the flicker of a shadow [in *Wrinkle*]" (124). He also believes that some elements of the dystopian planet Camazotz are allegorical to Cold War Russia (128). These observations give the book a more political than religious message, although the two are sometimes related in America.

[handwritten overlay:]
WHEN I WAS IN COLLEGE I MADE $ WRITING PAPERS FOR OTHER PEOPLE.

Now I'm a teacher & I feel like a hypocrite every time I give a Ø for cheating.

A Modern Fairy Tale

He had affairs. It killed her. She did and does love him.

He is disabled now. She is breadwinner and caregiver.

A tender and beautiful young lover entered her life.

Everyone is living happily, so far.

My husband gave me this card on my birthday

Your patience and your Kindness

can not be measured because

the value is too great

Thank you for making each
and every day so special

I can only hope to repay
the favor every day for
the rest of my life

Love,
Sharon

Six months later, he left me for someone ½ my age

I am

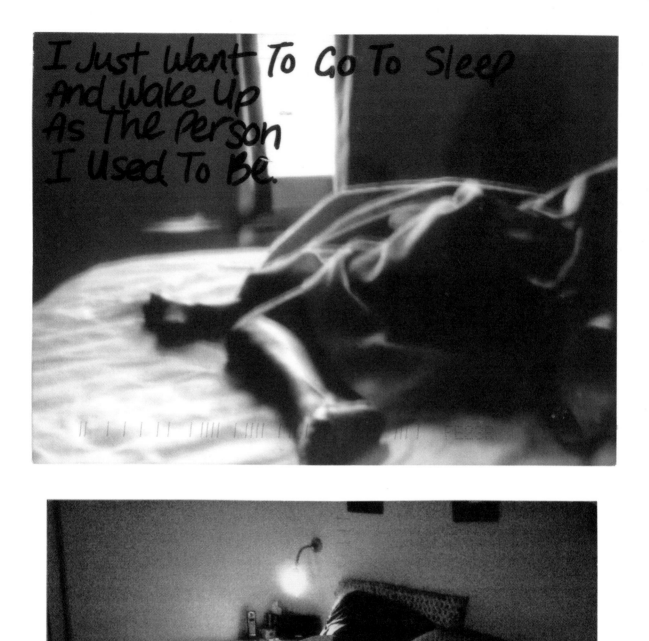

I Just Want To Go To Sleep
And Wake Up
As The Person
I Used To Be.

I don't make the bed after you leave, so that when I look at it, I feel the thrill of knowing how it got that way.

Thirty years ago I stole the pillowcase we shared, and have kept it unwashed ever since

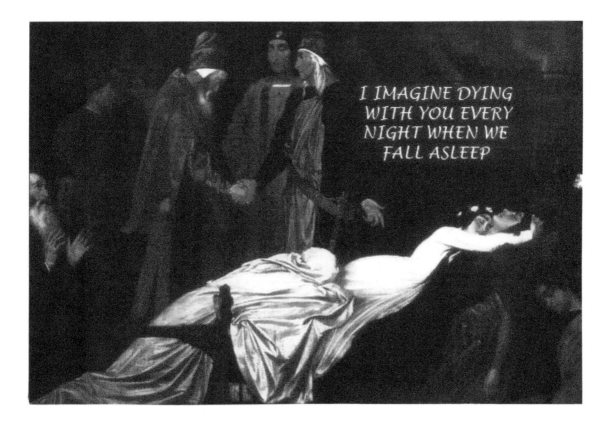

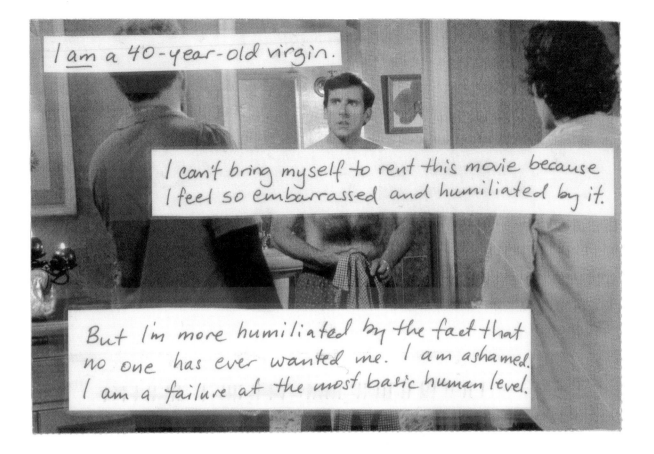

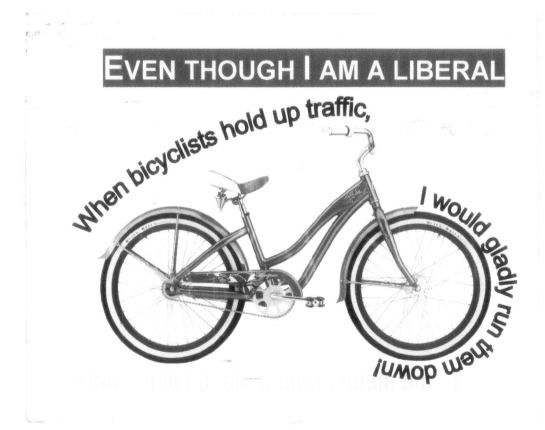

While my dad was dying,

I masturbated

to thoughts of his oncologist.

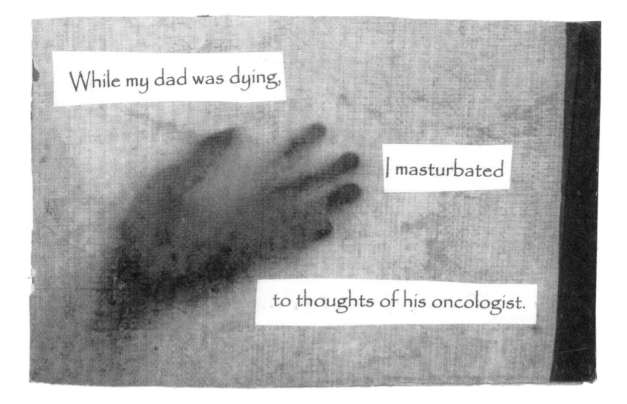

I ATE A CIGARETTE ONCE BECAUSE I WAS IN A NO-SMOKING ZONE.

Serial Killer

ICK!

SAN JOSE CA 951

11 OCT 2006 PM 1 T

He said he wanted to wait until he was married, but his body said otherwise. He said NO, but I climbed on top of him anyway and said "It'll be okay."
I'm sorry.

POST SECRET

13345 Copper Ridge Road

Germantown, MD 20874-3454

9 years ago I was raped. last night, it finally stopped hurting.

i think i'm ok now.

thanks for letting me tell my story.

you listened just right.

ü

We broke up 1 year ago today.
I had your baby in November.
It's a boy!
If you see this then you'll know
Otherwise I don't think I'll ever
tell you. I still love you but you
betrayed me. I can't forgive you

I ABORTED THE BABY
YOU NEVER KNEW ABOUT.

SOME TIMES I WANT
TO TELL YOU.

BUT I DOUBT YOU WOULD
CARE.

POSTAGE OR
NIXIE SECTION
DENVER, CO 80202

POST SECRET
13345 COPPER RIDGE RD
GERMANTOWN MD
20874

It seems like just
yesterday she was born. . .

She'll be 17 on Saturday

I am no where close to
being ready to let go

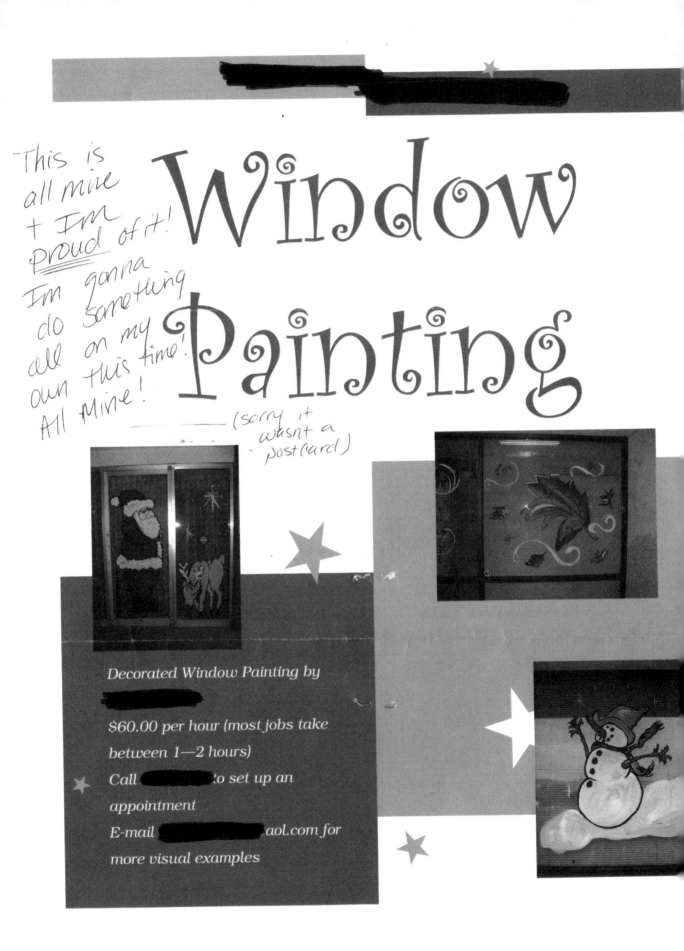

This is all mine + Im *proud* of it!
Im gonna do something all on my own this time!
All Mine!

———— (sorry it wasn't a postcard)

Window Painting

Decorated Window Painting by

$60.00 per hour (most jobs take between 1—2 hours)

Call _____ to set up an appointment

E-mail _____ aol.com for more visual examples

Vol 435 9 June 2005

nature

COMMENTARY

Scientists behaving badly

To protect the integrity of science, we must look beyond falsification, fabrication and plagiarism, to a wider range of questionable research practices, argue **Brian C. Martinson**, **Melissa S. Anderson** and **Raymond de Vries**.

Serious misbehaviour in research is important for many reasons, not least because it damages the reputation of, and

Table 1 Percentage of scientists who say that they engaged in the behaviour listed within the previous three years (n = 3,247)

	All	Mid-career	Early-career
...nts	0.3	0.2	0.5
...subject requirements	0.3	0.3	0.4
...ment in firms whose products are	0.3	0.4	0.3
...search subjects or clients that may be	1.4	1.3	1.4
...btaining permission or giving due	1.4	1.7	1.0
...l information in connection with one's	1.7	2.4	0.8 ***
...radict one's own previous research	6.0	6.5	5.3
...pects of human-subject requirements	7.6	9.0	6.0 **
...d data or questionable interpretation	12.5	12.2	12.8
...logy or results of a study in response to	15.5	15.6	9.5 ***
...lts in two or more publi...			3.4 **
...rship credit			7.4 ***
...logy or resu...			8.9 **
...ate tw...			12.2
			16.5
			7.3

or in reporting research results[1]. In 2002, the Federation of American Societies for Experimental Biology and the Association of American Medical Colleges objected to a proposal by the US Office of Research Integrity (ORI) to conduct a survey that would collect empirical evidence of behaviours that can undermine research integrity, but which fall outside the OSTP's narrow definition of misconduct[2]. We believe that a valuable opportunity was wasted as a result.

A proper understanding of misbehaviour requires that attention be given to the negative aspects of the research environment. The modern scientist faces intense competition, and is further burdened by difficult, sometimes unreasonable, regulatory, social, and managerial demands[3]. This mix of pressures creates many possibilities for

> "Our findings suggest that US scientists engage in a range of behaviours extending far beyond falsification, fabrication and plagiarism."

since
scienti...
by the...
we are th...
based on s...
sentative sa...
ment the o...

colleagues' behaviour[?], o...
non-representative samples...
Although inconclusive, previ...
the prevalence of FFP range h...
Our 2002 survey was based on la...
samples of scientists drawn from...
bases that are maintained by the NIH...

...hose
...ofessional
...tion response rate
...our approach certainly
...potential non-response bias.
...g scientists may have been less likely
...others to respond to our survey, perhaps
...or fear of discovery and potential sanction.
...This, combined with the fact that there is

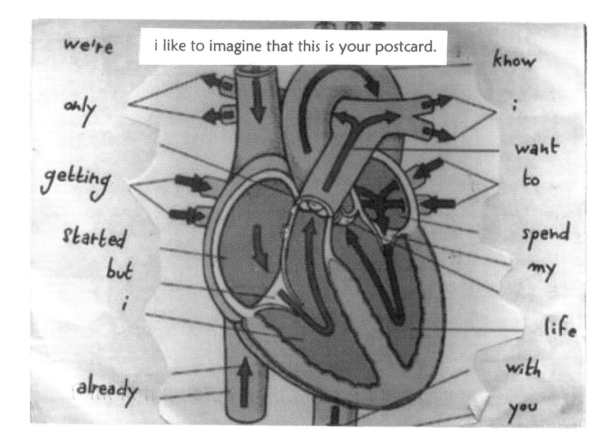

we're

only

getting

started

but

i

already

i like to imagine that this is your postcard.

khow

i

want

to

spend

my

life

with

you

my biggest
fear is not
death, but of
by chance running
into the family
of the boy whose
heart beats
inside my
body.

20874345446

lıl.lıllluılulılıılııllıllıllılılılılılılılılıl

On 10/28/1977 I had open heart surgery at 11 months old.

When I am depressed and think I want to die,
I think of the doctors that worked to save my life.

Thank you for the gift of life, so many times over.

EL CORAZON

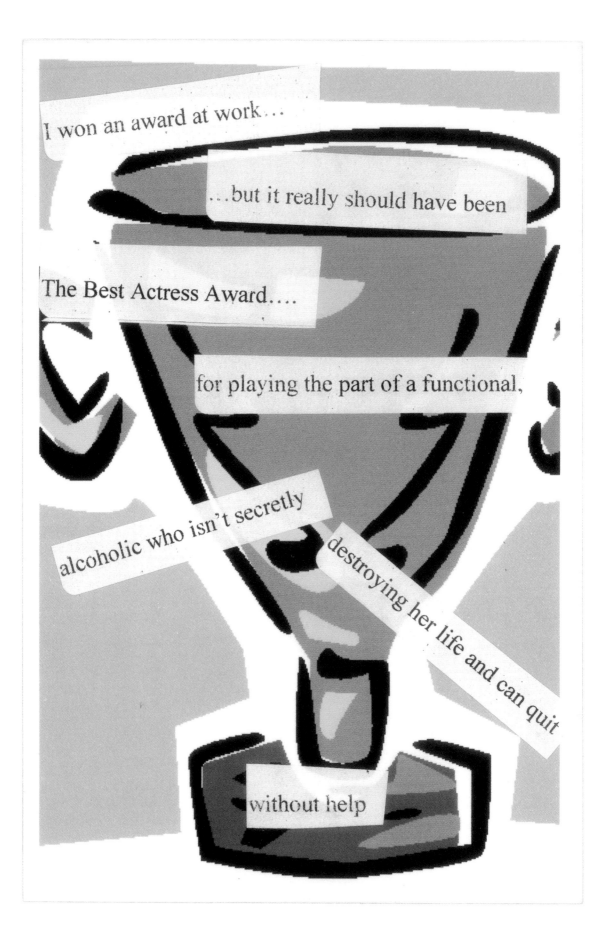

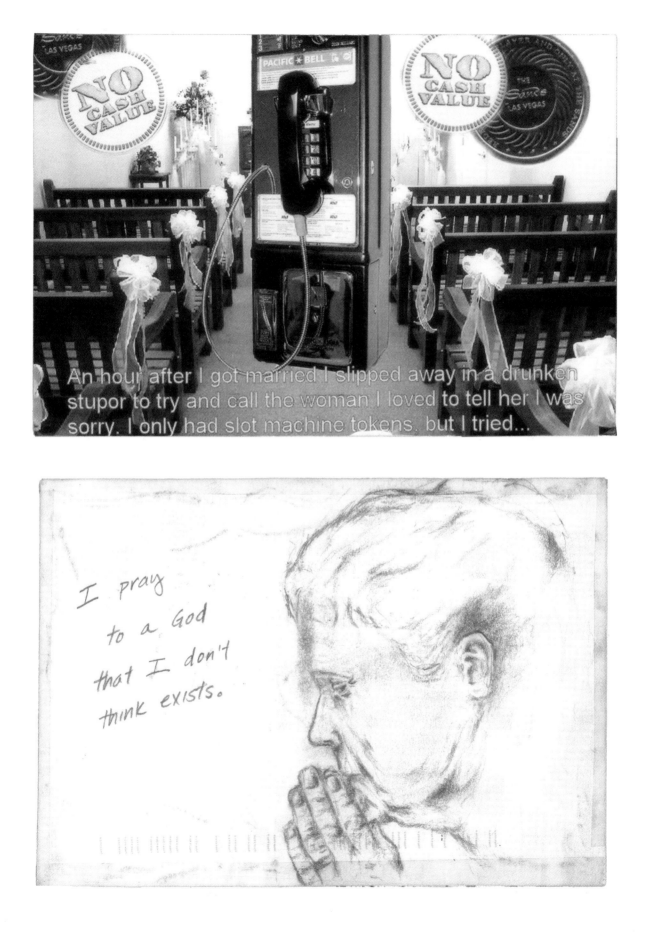

An hour after I got married I slipped away in a drunken stupor to try and call the woman I loved to tell her I was sorry. I only had slot machine tokens. but I tried...

I pray to a God that I don't think exists.

I long for something I can't understand and sometimes I feel like it will never come and then I get scared that this is all there is.

I still wonder how different my life would be if I had taken that sunrise walk with you.

I went to help them and they helped me in ways I didn't even know I needed.

some-times, i still have horrible nightmares about my late mother-in-law, even though we settled our differences before she passed on.

I'm turned on by injured women

I was too afraid last time to show you the truth.
I went on line & found someone with a "pretty" scar

This is what I really look like under my mastectomy bra.

It's not so bad

My mom always told me that I would regret all the horrible things I said to her.
She was right.

My best friend slept with the only man I ever loved.

Their son is in college now.

I still drive by their house.

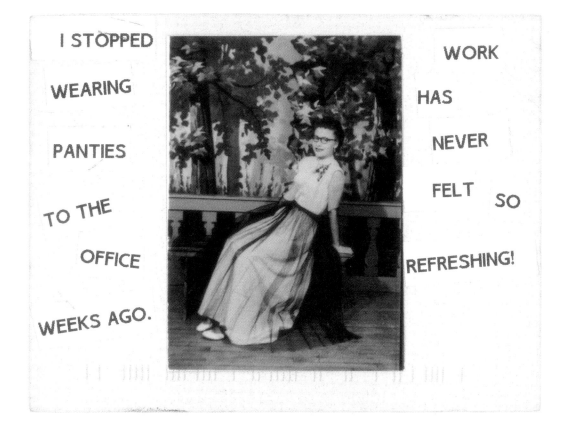

I STOPPED WEARING PANTIES TO THE OFFICE WEEKS AGO. WORK HAS NEVER FELT SO REFRESHING!

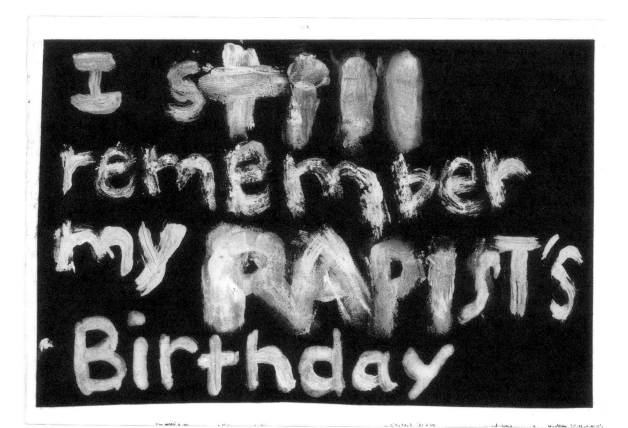

I still remember my RAPIST'S Birthday

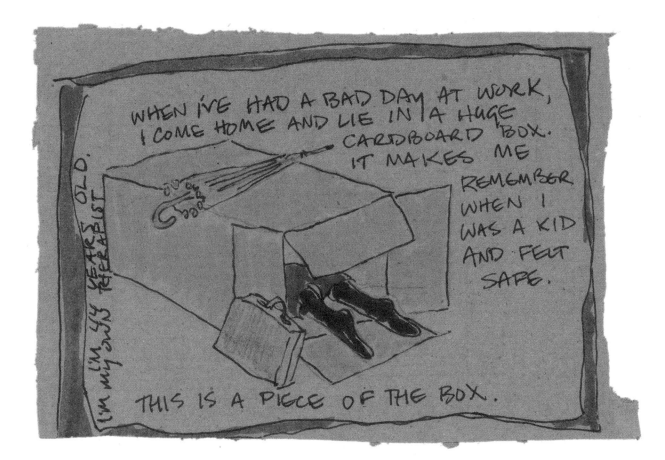

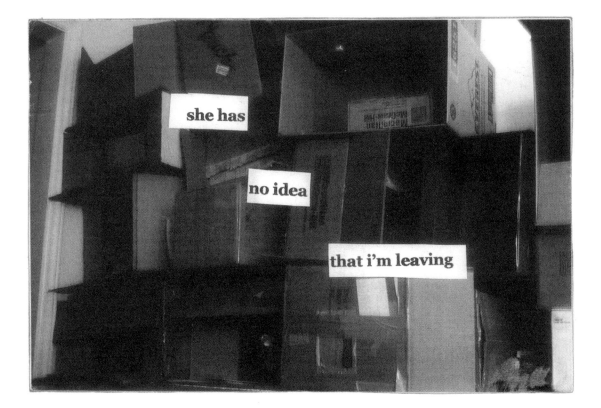

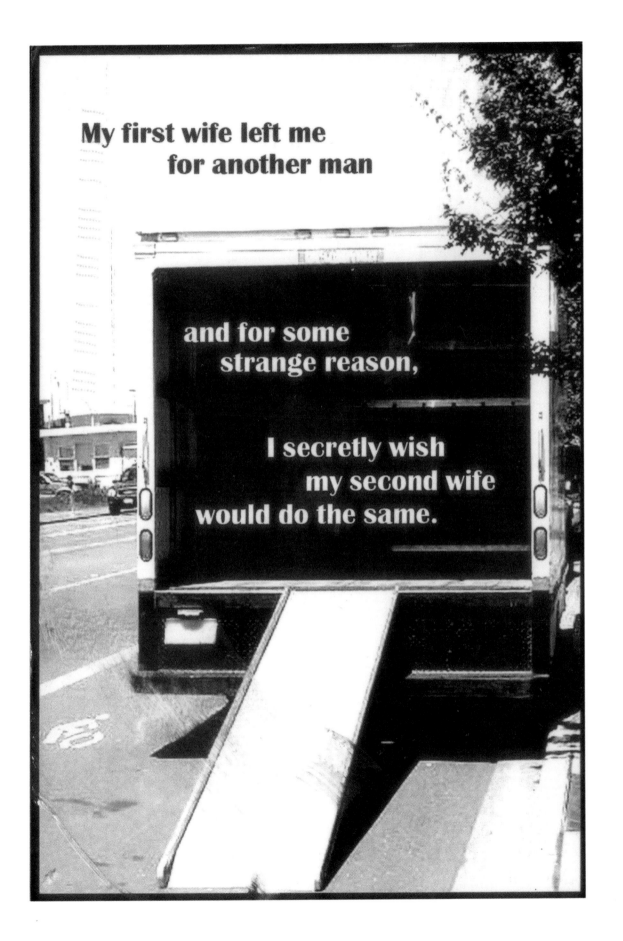

It was 1967, the Summer of Love. 3 of us had sex with your mom on my bed, resulting in your conception.

I Hope you are Well & Happy

Over a year later, and still to this day
Whenever music moves me with its beauty,
Be it sorrow or joy,
I can't help but to tie it to a moment
I spent with her.

I am a successful, well known Classical Music

..but I ONLY

listen To ROCK AND ROLL!

B A G A | B B B | A A A | B D D
I am sec-ret- | ly learn-ing | how to play | the gui - tar

B A G A | B B B B | A A B A | G
Just so I can | write our own per | -son – al love song_____ .

B A G A | B B B | A A A | B D D
Eve-ry where that | Ma- ry went, | Ma- ry went, | Ma- ry went,

B A G A | B B B B | A A B A | G D
Eve-ry where that Ma- ry went, | the lamb was sure to | go. It

Out of all the students who tried out for 5th grade choir, I was the only one who did not make it. It is my first real memory of shame. It seems like it should be a small and distant memory but I still won't sing, even in the shower.

I am afraid to discipline my kids because of the way my father disciplined me.

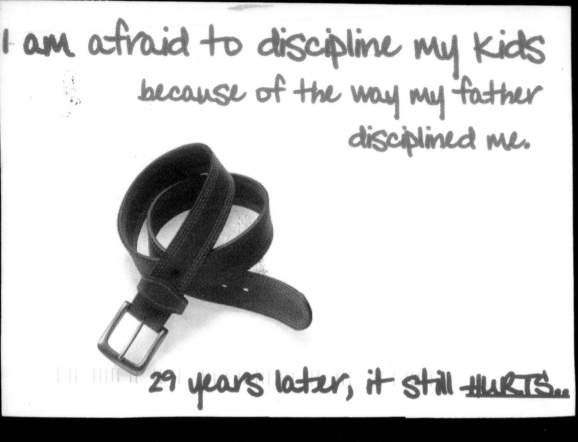

29 years later, it still ~~HURTS~~...

I hope it turns out to be cancer, so I'll finally have an excuse to slow down.

Uterus ——

Cervix ——

Vagina ——

If I AM TO LOSE MY MIND LIKE THEY SAY

WHY IS IT SO AWFUL FOR ME TO END IT ON MY OWN INSTEAD OF WAITING FOR THE INEVITABLE?

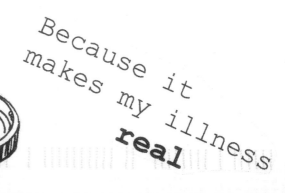

I don't take my medication...

Because it makes my illness **real**

I'm going to miss this.

I'M FALLING IN
LOVE ♡ ♡ ♡
WITH MYSELF.
I WISH YOU
WERE ALIVE
TO SEE THIS.

I LOVE
YOU.

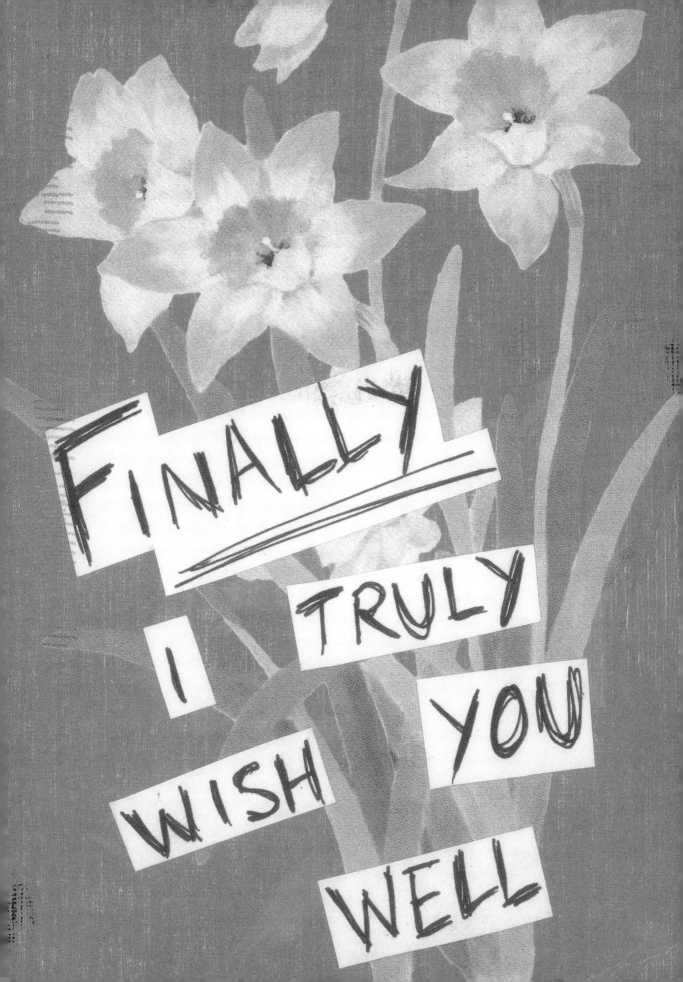

THANK YOU

-----Email Message-----

I was going to send you a postcard saying that since my father died I haven't dreamt about him. I want him to visit me in my dreams because I miss him so much and this is the only way I can see him again.

Instead of sending the postcard, I told my friend.

Last night I dreamt about my dad for the first time. I could feel his hand on my face as he told me how much he loves me and how he's watching over me.

Sometimes sharing your secrets makes your wishes come true.

Thanks for helping me to discover that.

HARRY
STONER

MARY
STOUDT

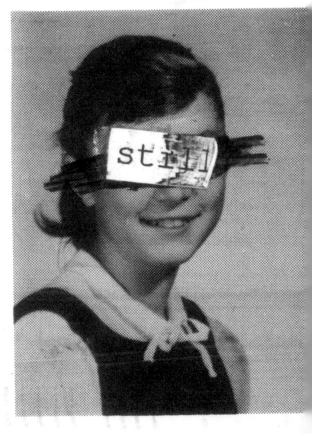

ROBERT
SWEIGERT

NANCY
THAYER

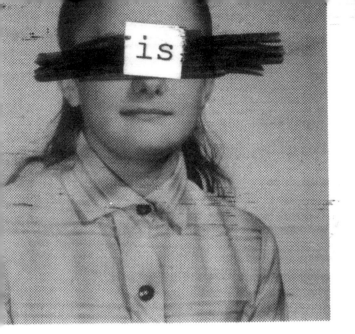

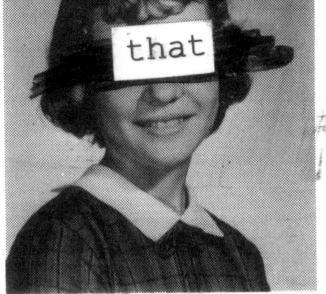

ELLEN
SUGGS

CAROL
SUTER

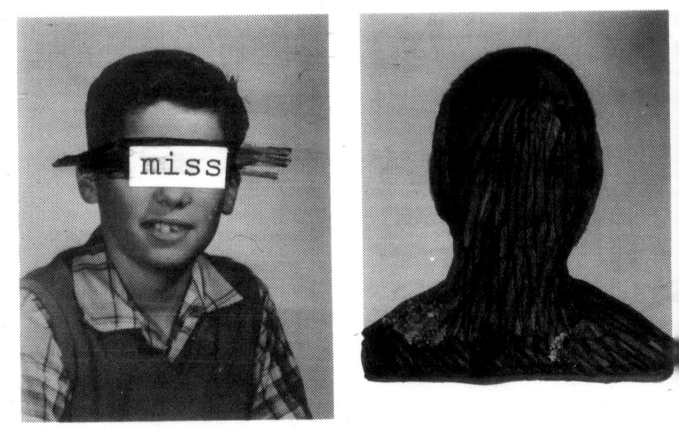

DALE
TODD

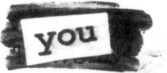

I'm 50 years old,
and I'm a
Virgin...
But I've met
someone special,
so I'm hoping....

FIFTY AND
FINALLY HEALED~
NEXT FIFTY ?
FANTASTIC~FINALLY!

PostSecrets
13345 Copper Ridge Road
Germantown, Maryland
20874-3454

I am fifty years old
and
piss in hotel sinks.

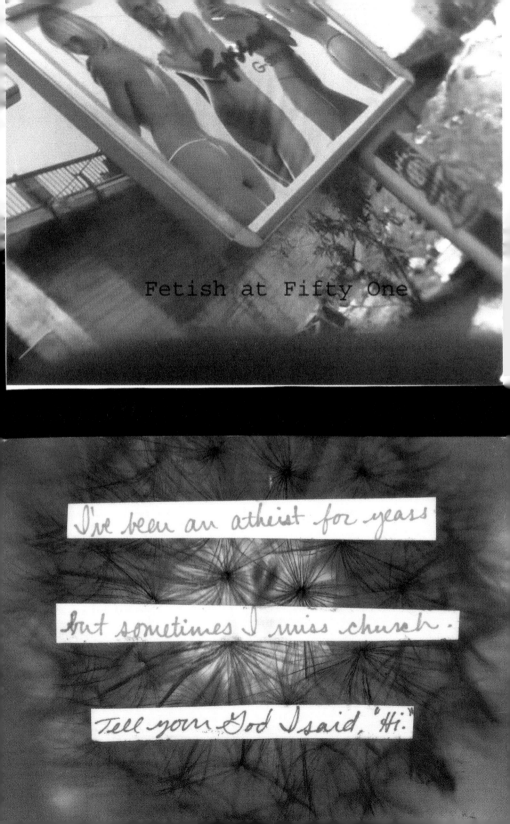

Fetish at Fifty One

I've been an atheist for years

but sometimes I miss church.

Tell your God I said, "Hi."

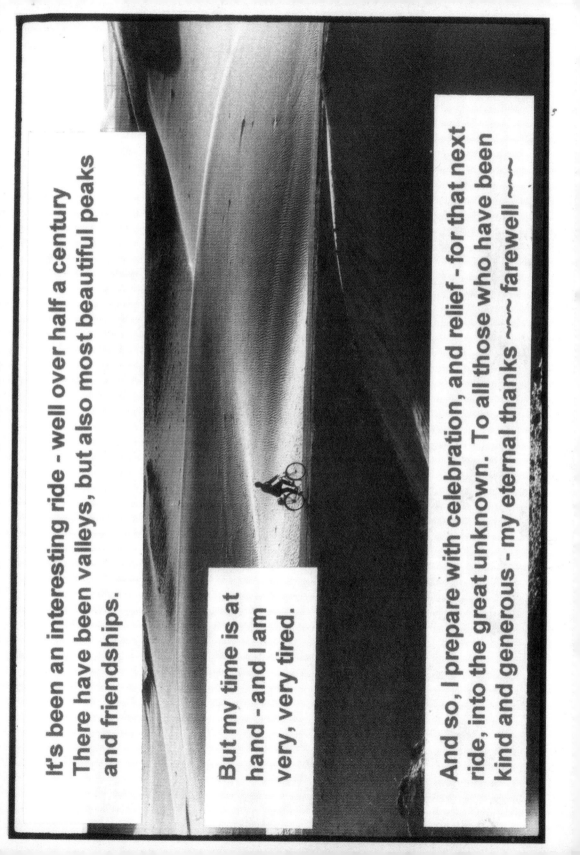

It's been an interesting ride - well over half a century There have been valleys, but also most beautiful peaks and friendships.

But my time is at hand - and I am very, very tired.

And so, I prepare with celebration, and relief - for that next ride, into the great unknown. To all those who have been kind and generous - my eternal thanks ~~ farewell ~~

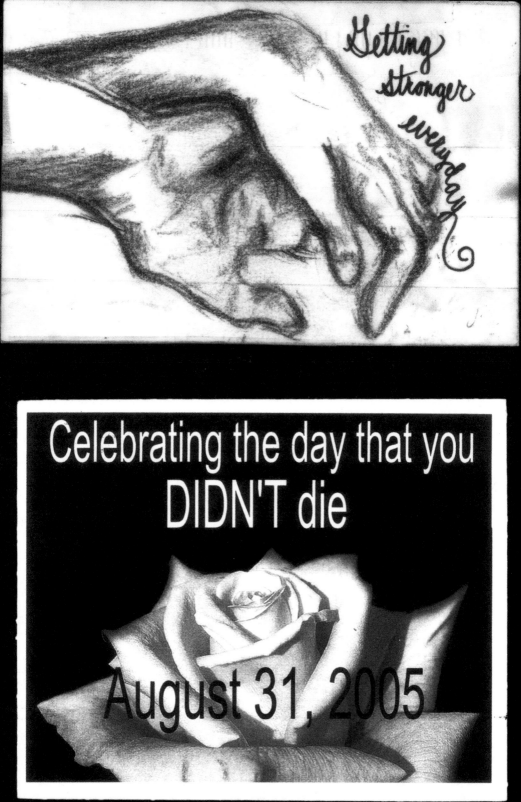

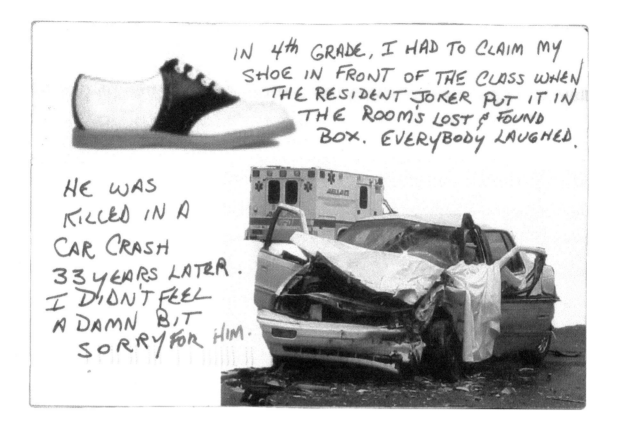

IN 4th GRADE, I HAD TO CLAIM MY SHOE IN FRONT OF THE CLASS WHEN THE RESIDENT JOKER PUT IT IN THE ROOM'S LOST & FOUND BOX. EVERYBODY LAUGHED.

HE WAS KILLED IN A CAR CRASH 33 YEARS LATER. I DIDN'T FEEL A DAMN BIT SORRY FOR HIM.

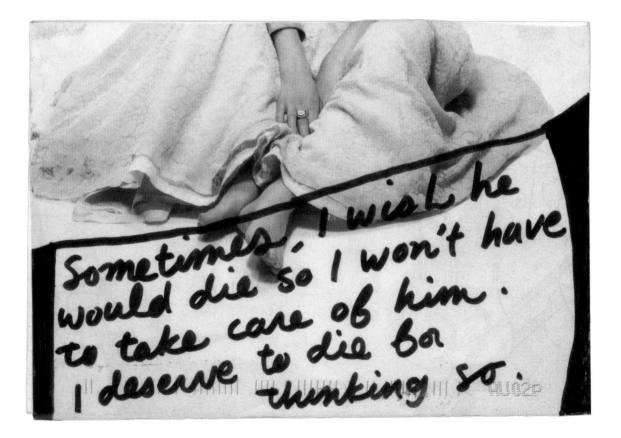

sometimes, I wish he would die so I won't have to take care of him. I deserve to die for thinking so.

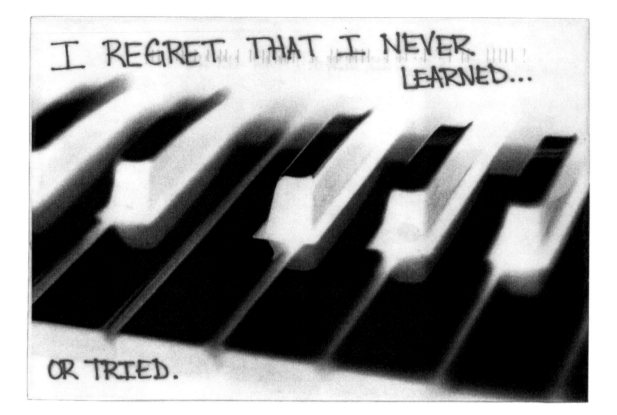

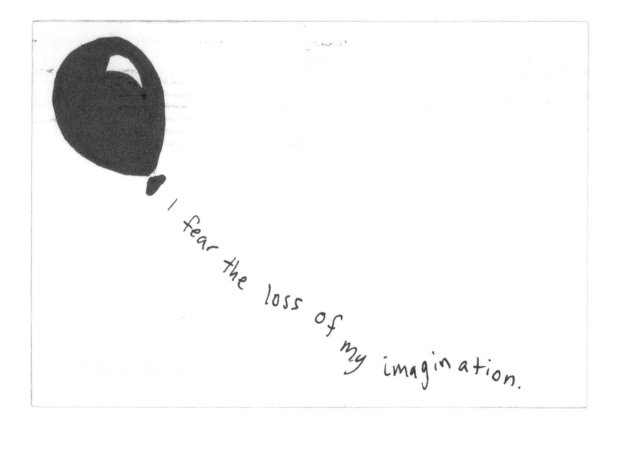

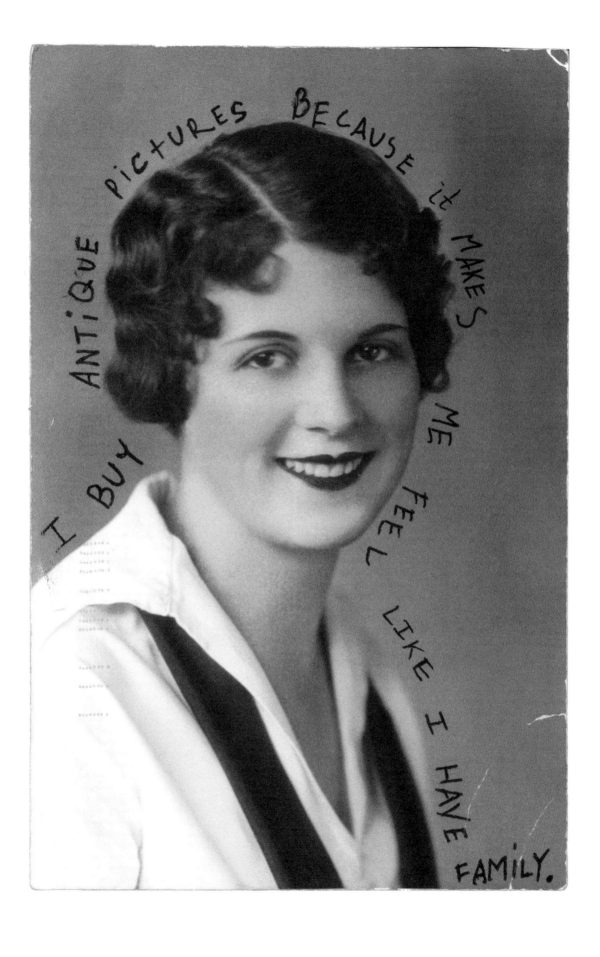

Christmas Eve 60 yrs ago my mother played an Angel in a Church Play, when it ended the Pastor RAPED my mother and at 13 she had a baby NOBODY believed her ... except the Pastors wife ... she knew

My mother Never told me until I was 45 yrs old. She thought I would treat her differently, I do!

I love her MORE than Ever

Thank you mom
For trusting me

I WROTE MY WILL TODAY,

NOT BECAUSE IT WAS THE
SENSIBLE THING TO DO -

BUT BECAUSE I AM WORRIED
ABOUT WHAT WOULD HAPPEN TO
MY PURSE COLLECTION.

When I was 17, I got drunk for the first time at a party and lost my virginity, in a barn...

Back then we didn't call it date rape... It was just being stupid...

Grandma died in a nursing home with a stranger caring for her. We visited and had our photos next to her bed.

I don't think it was enough.

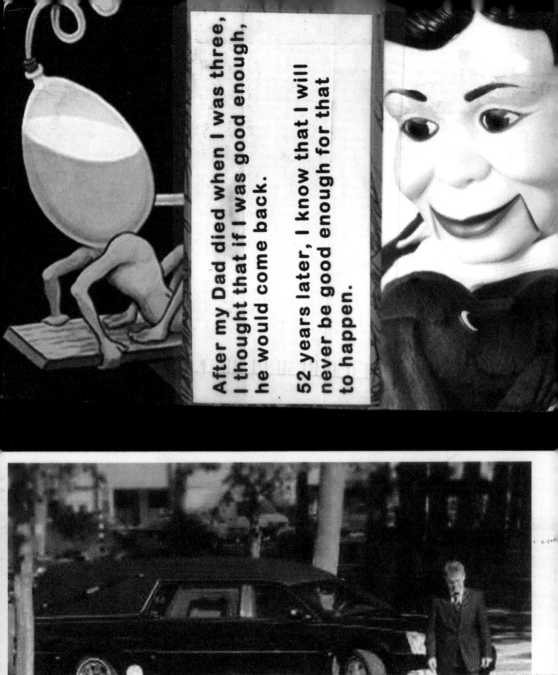

After my Dad died when I was three, I thought that if I was good enough, he would come back.

52 years later, I know that I will never be good enough for that to happen.

I realized at my Mom's funeral that I didn't know her very well. As her friends got up to share memories of her I found myself with a total new sense of grief. I wish I could have known her as a woman and friend, as well as Mom.

I MADE THE WRONG CHOICE!

This is the paper that was going to be wedding announcements.

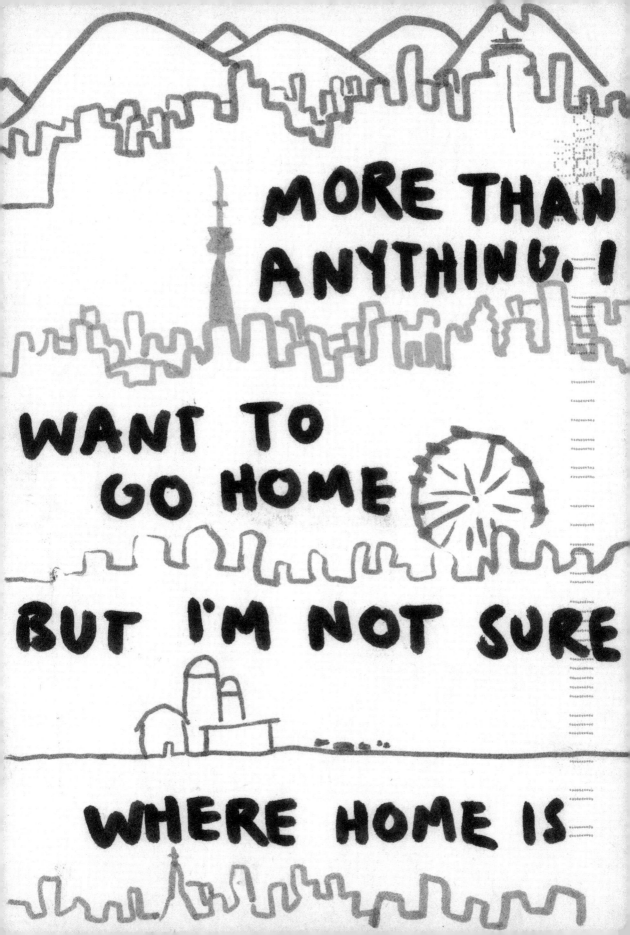

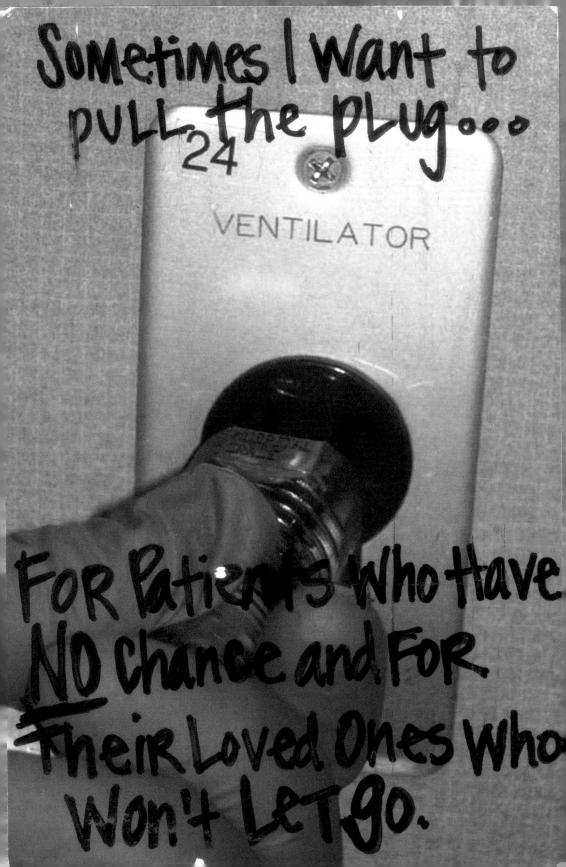

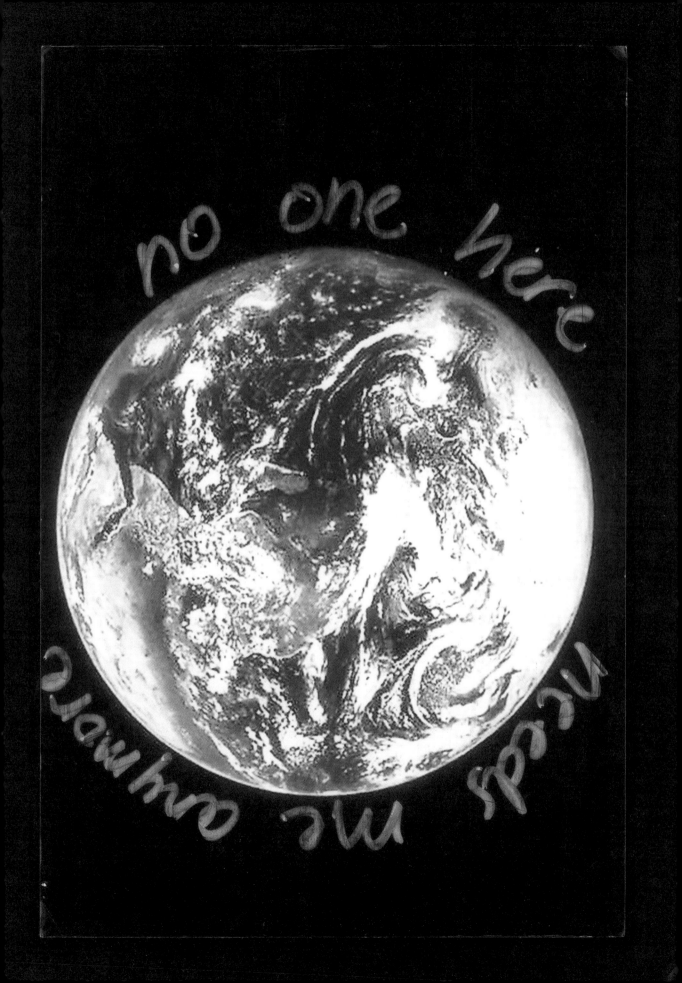

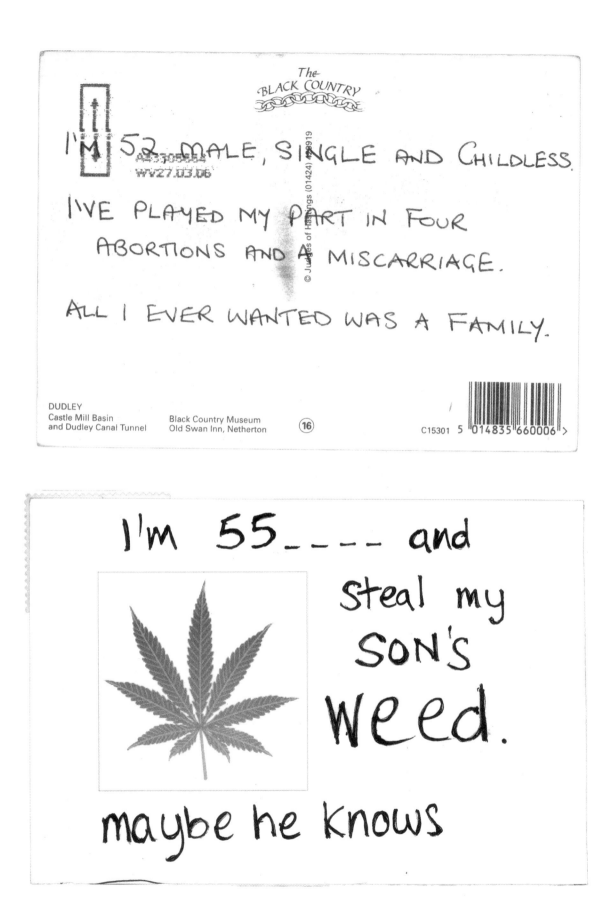

The
BLACK COUNTRY

I'M 52, MALE, SINGLE AND CHILDLESS.

I'VE PLAYED MY PART IN FOUR
ABORTIONS AND A MISCARRIAGE.

ALL I EVER WANTED WAS A FAMILY.

DUDLEY
Castle Mill Basin
and Dudley Canal Tunnel

Black Country Museum
Old Swan Inn, Netherton

16

C15301 5 014835 660006

I'm 55____ and
steal my
SON'S
weed.

maybe he knows

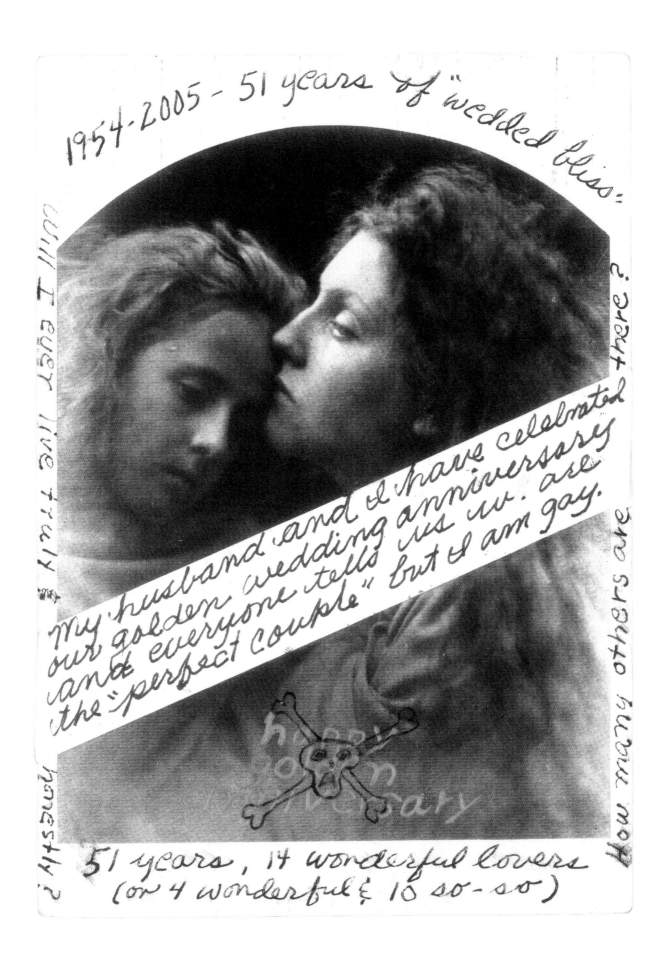

1954-2005 - 51 years of "wedded bliss"

will I ever live that truly? Honestly?

My husband and I have celebrated our golden wedding anniversary and everyone tells us w. are the "perfect couple" but I am gay.

How many others are there?

51 years, 14 wonderful lovers (or 4 wonderful & 10 so-so)

I have been planning my husband's funeral for 24 years.

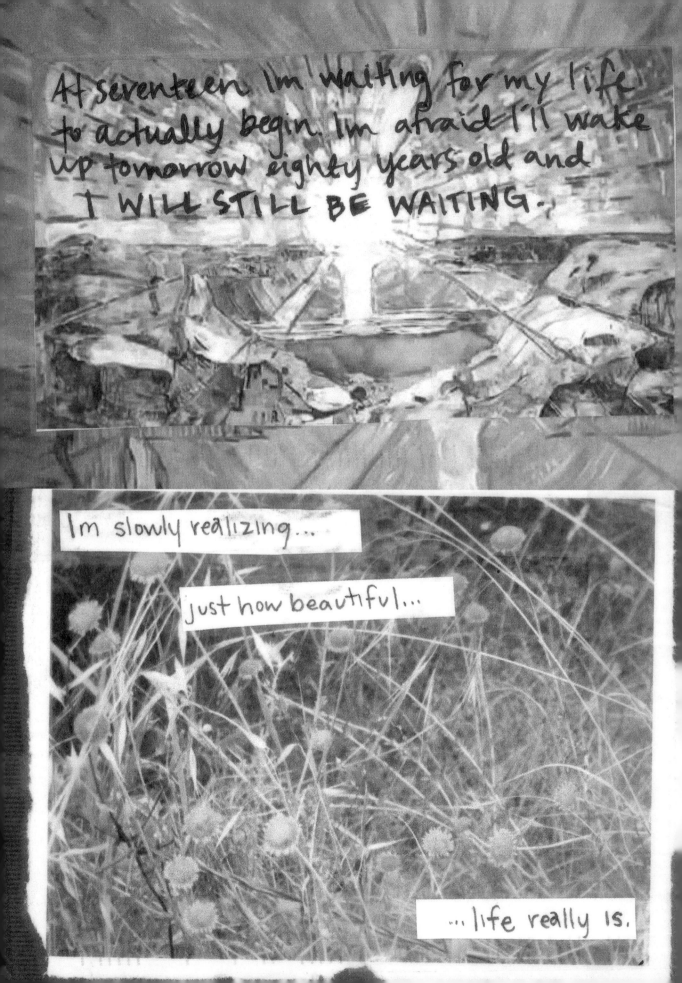

At seventeen I'm waiting for my life to actually begin. I'm afraid I'll wake up tomorrow eighty years old and I WILL STILL BE WAITING.

I'm slowly realizing...

just how beautiful...

...life really is.

I WONDER IF I'LL EVER BE HAPPY AGAIN
.

I WONDER IF I EVER WAS.

I want things back the way they never were.

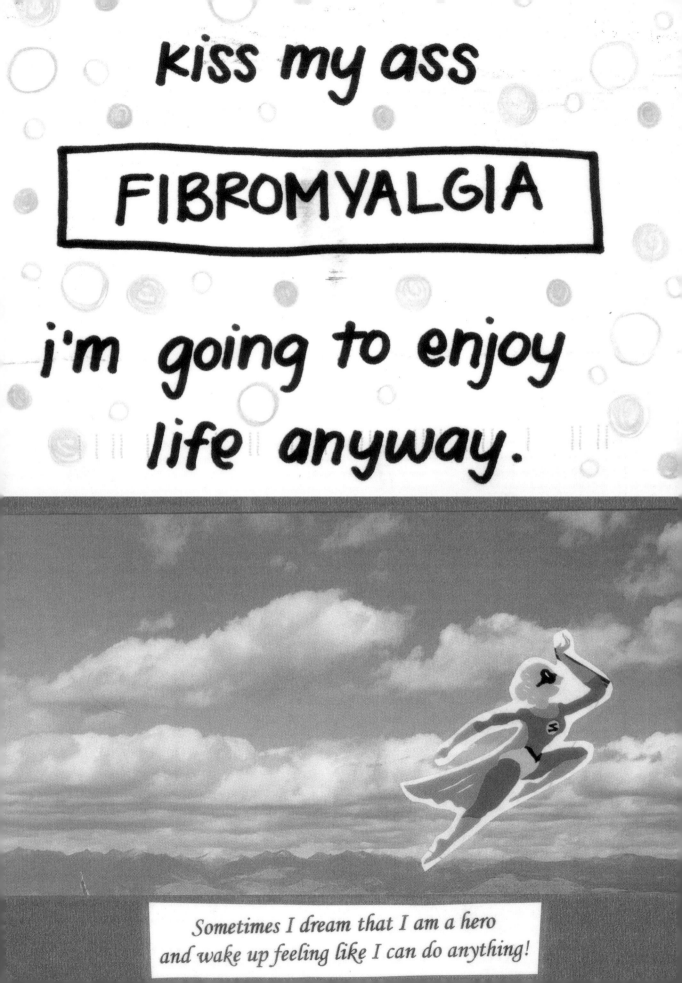

Sometimes I dream that I am a hero
and wake up feeling like I can do anything!

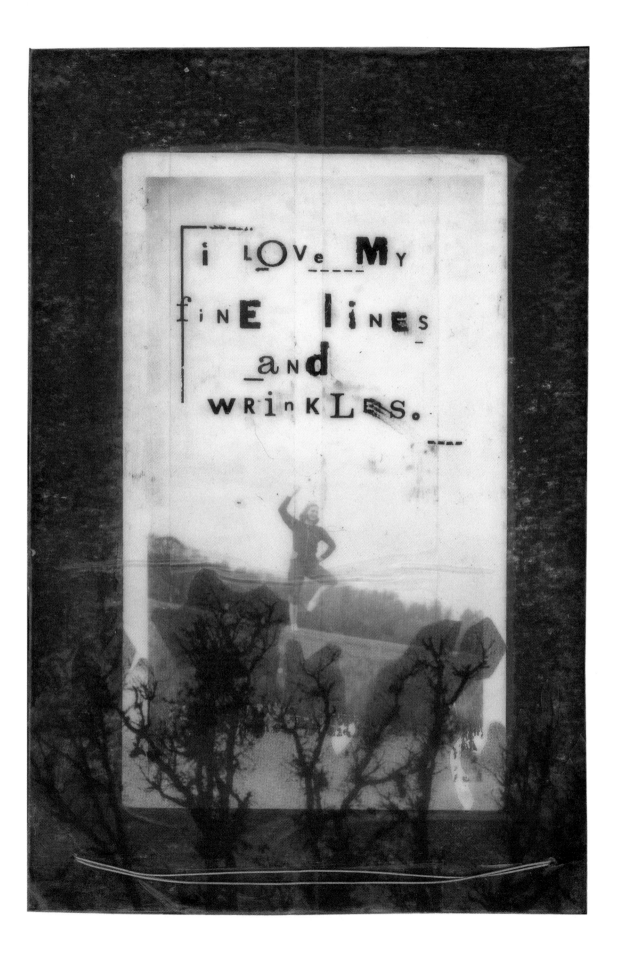

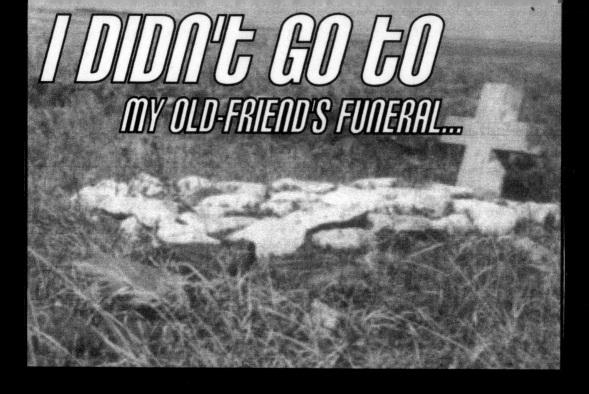

I DIDN'T GO TO
MY OLD-FRIEND'S FUNERAL...

An "evangelical" Friend of Mine,
Who is The Mother of Two
Daughters, President of her church
Group, and wife of a right wing
extremist, admitted She ALLOWED
her auto insurance agent To Bang
her up her Butt if he paid
her premium..... TWICE!

I remarried at 68 after my first wife died.
My "new" wife is very attractive and exciting.
I am very average looking. For the first
2 to 3 years we had sex up to 5-6 times
 every day. I know my wife enjoys it as much
as I do. I don't have anyone to tell this to
because it's very personal and they wouldn't
believe me anyway, but I just have to tell
someone before I die...

I will die

alone

and Happy

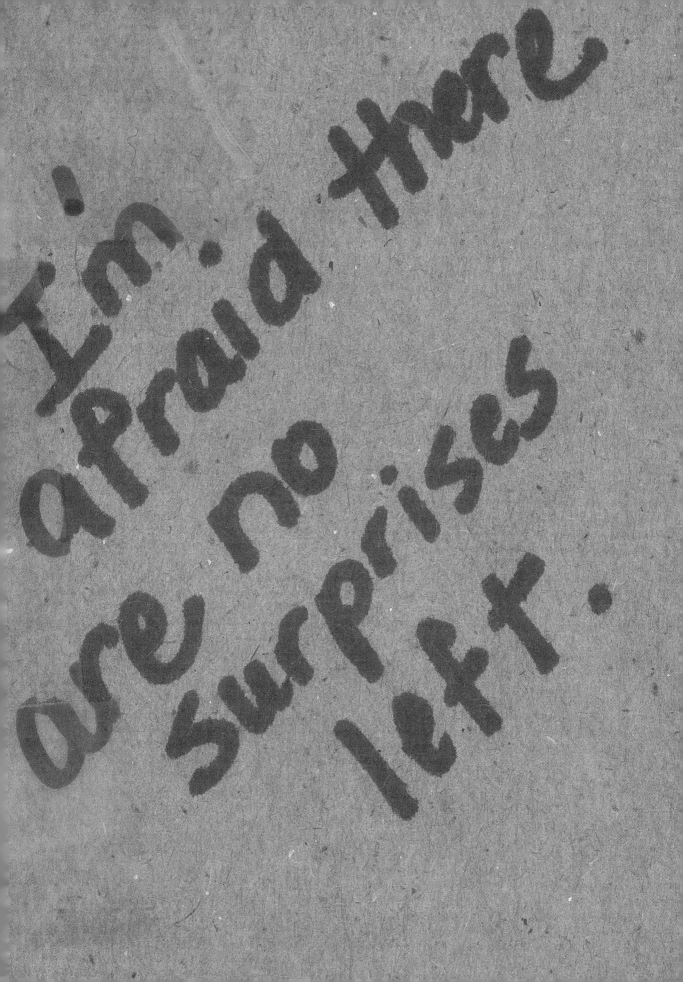

I'm afraid there are no surprises left.

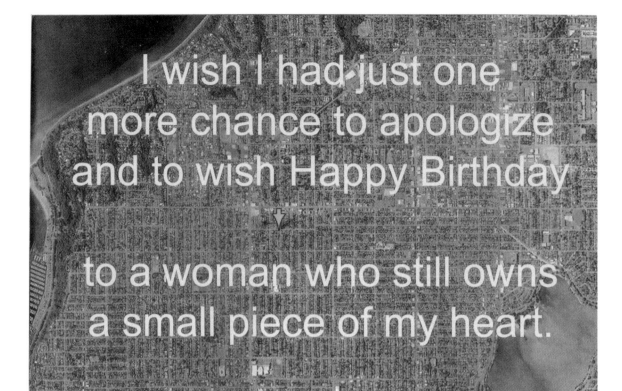

I wish I had just one more chance to apologize and to wish Happy Birthday

to a woman who still owns a small piece of my heart.

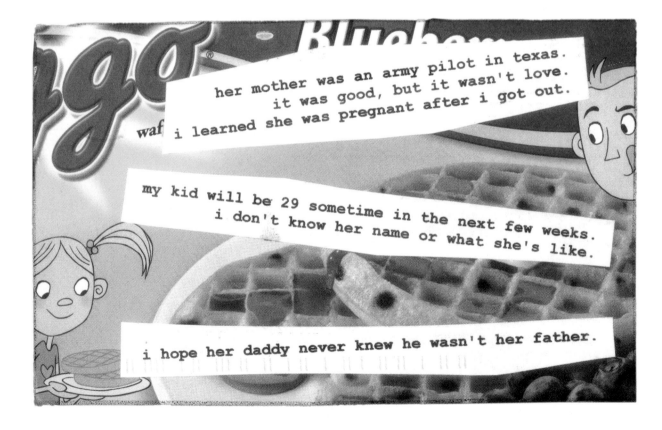

her mother was an army pilot in texas.
it was good, but it wasn't love.
i learned she was pregnant after i got out.

my kid will be 29 sometime in the next few weeks.
i don't know her name or what she's like.

i hope her daddy never knew he wasn't her father.

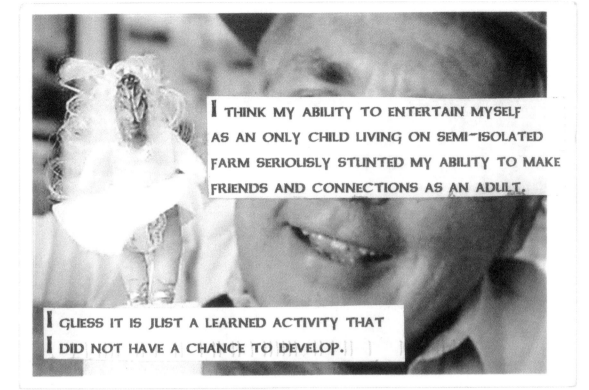

I THINK MY ABILITY TO ENTERTAIN MYSELF AS AN ONLY CHILD LIVING ON SEMI-ISOLATED FARM SERIOUSLY STUNTED MY ABILITY TO MAKE FRIENDS AND CONNECTIONS AS AN ADULT.

I GUESS IT IS JUST A LEARNED ACTIVITY THAT I DID NOT HAVE A CHANCE TO DEVELOP.

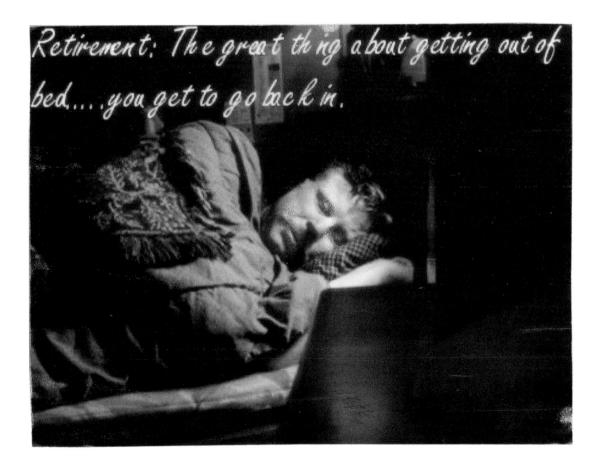

Retirement: The great thing about getting out of bed....you get to go back in.

I am Scared... to die with regrets

PUT-IN-BAY

I constantly lie to those closest to me.

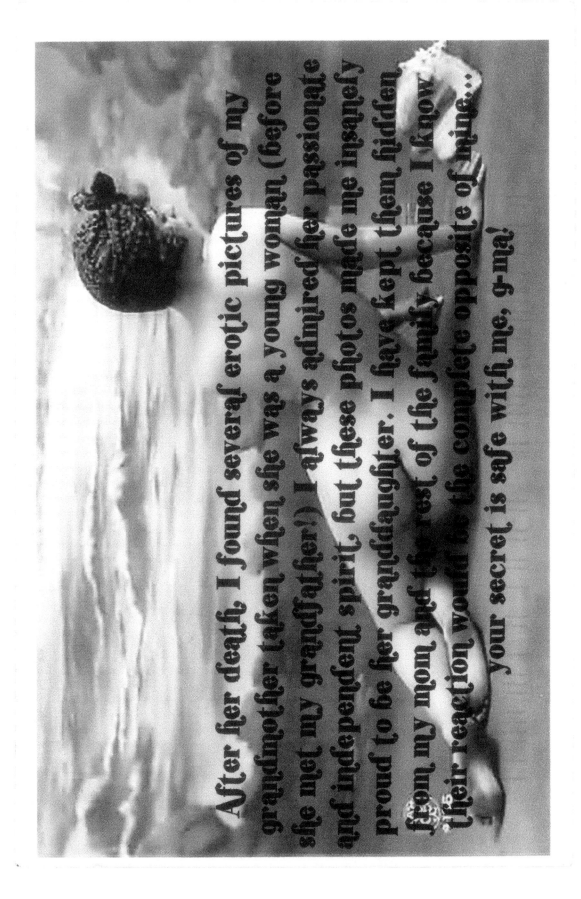

After her death, I found several erotic pictures of my grandmother taken when she was a young woman (before she met my grandfather.) I always admired her passionate and independent spirit, but these photos made me insanely proud to be her granddaughter. I have kept them hidden from my mom and the rest of the family because I know their reaction would be the complete opposite of mine... your secret is safe with me, g-ma!

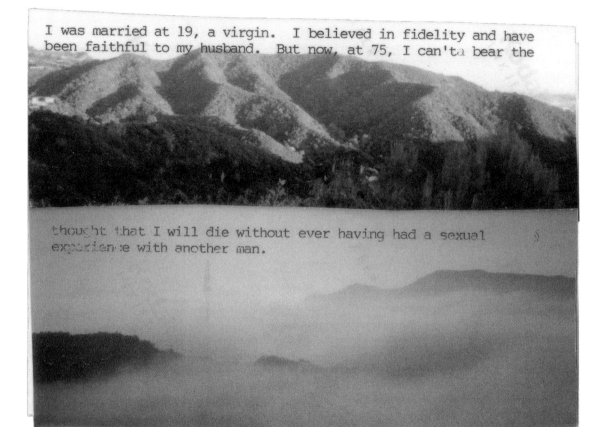

I was married at 19, a virgin. I believed in fidelity and have been faithful to my husband. But now, at 75, I can'ta bear the

thought that I will die without ever having had a sexual experience with another man.

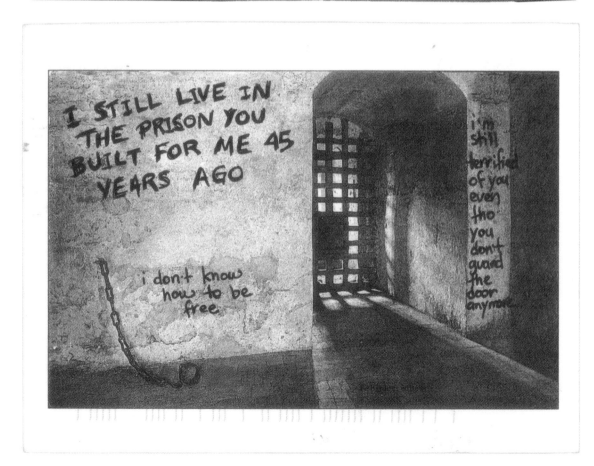

I STILL LIVE IN THE PRISON YOU BUILT FOR ME 45 YEARS AGO

i don't know how to be free

i'm still terrified of you even tho you don't guard the door anymore.

At sixteen, I was loved by the free spirit who came to live with us at the ranch in Central America. The joy lasted eight hundred seventy two days. That was 1950 in the jungles of the Pacific Seashore... My loveliest of secrets...

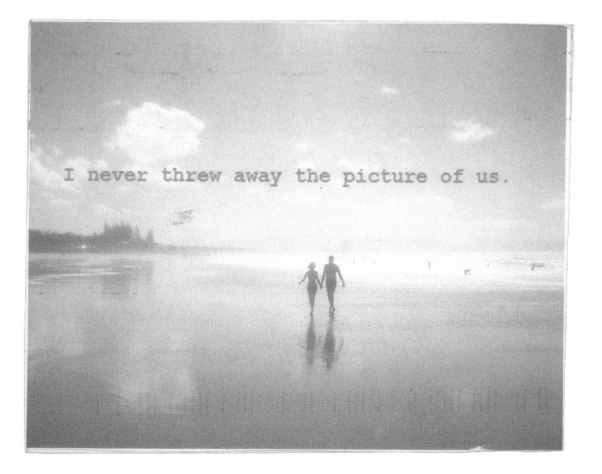

I never threw away the picture of us.

S MAR 25	APR 8	NOV 30	15
APR 10	APR 15	NOV 30	FEB 29
APR 30	APR 22	JAN 25	MAR 1 3
MAY 7	MAY 1 3	JAN 27	APR 3
MAY 14	SEP 17	FEB 10	SEP 1 1
OCT 29	OCT 13	MAR 3	OCT 2 3
NOV 5	NOV 3	MAR 30	OCT 3 1
NOV 12	NOV 10	SEP 20	DEC 11
NOV 26	NOV 24	OCT 6	FEB 6
DEC 3	DEC 15	OCT 25	OCT 5
JAN 14	MAR 9	NOV 1	DEC 1
FEB 4	MAR 17	NOV 15	APR 3
FEB 11	MAR 31	NOV 22	SEP
MAR 4	APR 13	NOV 29	MAR 10
MAR	MAY 5	DEC 6	APR 14
APR 1	NOV 9	JAN 24	
		FEB 7	

i didn't think time could change us.

PRINTED IN U.S.A.

The mouse and the m... cle

74-0317 co: Mom Morrow 12-5-79 left c.2

79-0317

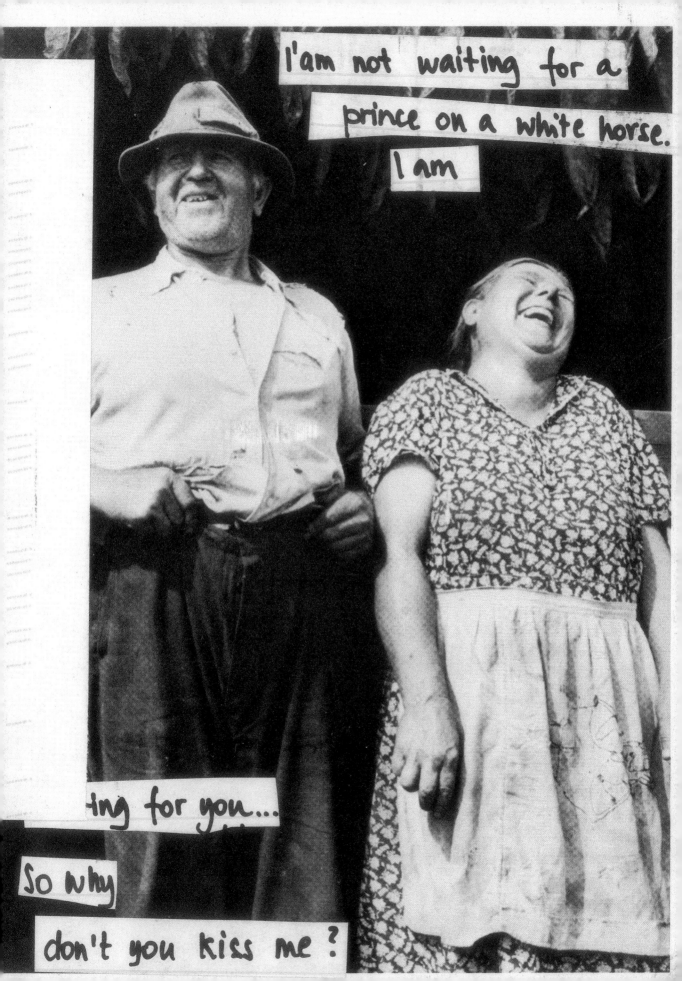

I never speak my mind. I'm afraid that I'll wait until I'm an old woman to tell people what I really think. Maybe no one will listen to me then, but I really look forward to being bossy and opinionated.

chuck theodore/rivendell Franconia, New Hampshire 03580-0

CANNON MOUNTAIN/WHITE MOUNTAINS

© 1995

3/30/05

POSTLAND ME 041
PM
64 31 MAR 2005

HAPPY BIRTHDAY 37 USA

Today is my birthday. No one but me knows how lucky I am and how content and happy I feel!

PostSecret
13345 Copper Ridge Rd
Germantown, MD
20874-3454

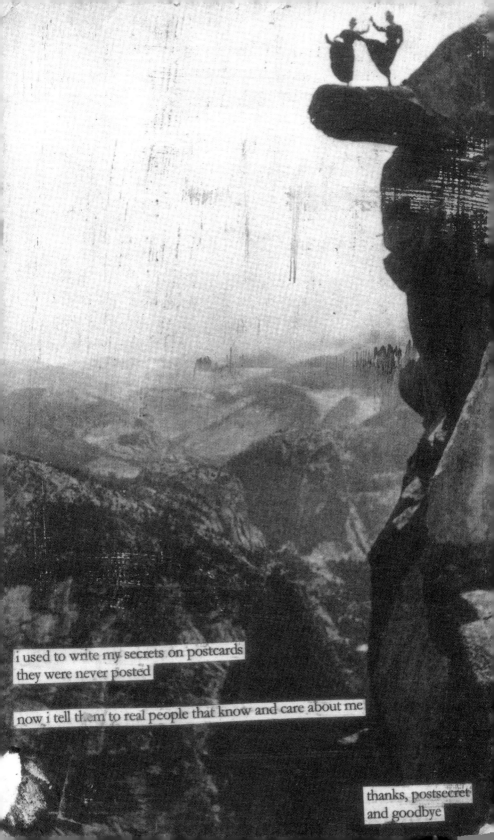

i used to write my secrets on postcards
they were never posted

now i tell them to real people that know and care about me

thanks, postsecret
and goodbye

Years later, I returned to where it happened. It looked the same except for a young tree that was growing nearby. I thought about burning or poisoning that tree but instead wrapped my

hands around its narrow living trunk and tried to pull it from the ground. Exhausted, I failed. It was then that I decided to share my story with my brother and friend. The three of us would return to uproot it.